ISLAMIC PATTERNS

An Analytical and Cosmological Approach

To the one God
and his messenger, the Prophet Muhammad,
to whom we owe Islam,
and to all those master-craftsmen,
known and unknown, who dedicated
their lives to beauty through the
arts of Islam.

ISLAMIC PATTERNS

An Analytical and Cosmological Approach

KEITH CRITCHLOW

THAMES AND HUDSON

Reprinted 1989

Thames and Hudson Inc., 500 Fifth Avenue, New York, New York 10110

Library of Congress Catalog Card Number 82-74543

Printed and bound in Yugoslavia

ACKNOWLEDGEMENTS

I should like to express my gratitude to all the following people who have, to a greater or lesser extent, known or unknown to themselves, helped me in the preparation and manifestation of this book; they are listed, not in order of importance, but rather in a sequence based on time and place:

My wife and family

Professor R. Buckminster
 Fuller
Rudolf Steiner
Dr E. Holiday
Professor S. H. Nasr
Dr N. Ardalan
Dr Hassan Fathy
Laleh Bakhtiar
H. E. Pahlbod
Dr F. Bhaghezadeh

Janette Jackson, and all the
 executive council of the
 Research into Lost
 Knowledge Organization
Titus Burckhardt
Frithjof Schuon
Martin Lings
Warren Kenton
Mrs E. Lloyd
Martin Green
David Batterham
Dr B. Shirazi

Thomas Neurath
Mark Trowbridge
Robin Middleton

Professor Peter de Franchia
Professor Thalis Argyropoulos
Bob Organ
Ronald H. Lamb
Roger Cook

Paul Marchant, for his pains-
 taking work on the
 drawings for this book

Carl Kowsky
David Tasker
Graham Chalifour
Graham Brand
Michele Jones

Also the following, whom I have had the privilege of teaching and who have since developed their own reputations in many fields:
David Green
Cliff Edwards
John Glover
Renato Pesci
Vivien Mullett
Alison Wales
Philip Winder

Jane Carroll
Richard Waddington
Llewellyn Vaughn Lee
Richard Twinch
Samar Danluji
Yanis Petsopoulos

Contents

Foreword

Ultimate Reality is at once Absolute and Infinite, the source of all being, of all consciousness and of all life. Itself beyond form, it speaks to mankind through revealed forms which, while externally bound and limited, open up inwardly towards the Boundless. Through revelations of this Word or Logos come into being the sacred traditions which although outwardly different are inwardly united into a Centre which transcends all forms. They are, however, the bridge from the periphery to the Centre, from the relative to the Absolute, from the finite to the Infinite, from multiplicity to Unity.

Islam is the last of the universal revelations of the present humanity and as such a re-affirmation of the primordial truth, of the Truth which has always been and will always be, namely the Unity of the Principle and utter dependence and in fact nothingness of all contingency before the blinding Majesty of the One who ultimately alone is. As the final assertion of the primordial revelation Islam is also a means to the rediscovery of the sacred character of the first of God's revelations which is the created order itself. Islam contains the means to enable man to see the forms of nature once again as the *vestigii Dei* and multiplicity as so many reflections of the Unity which is both the origin and end of the order of multiplicity.

Islamic spirituality could not but develop a sacred art in conformity with its own revealed form as well as with its essence. The doctrine of unity which is central to the Islamic revelation combined with the nomadic spirituality which Islam made its own brought into being an aniconic art wherein the spiritual world was reflected in the sensible world not through various iconic forms but through geometry and rhythm, through arabesques and calligraphy which reflect directly the worlds above and ultimately the supernal sun of Divine Unity.

There is within the spiritual universe of Islam a dimension which may be called 'Abrahamic Pythagoreanism', or a way of seeing numbers and figures as keys to the structure of the cosmos and as symbols of the archetypal world and also a world which is viewed as the creation of God in the sense of the Abrahamic monotheisms. It is this possibility within the intellectual universe of Islam, and not any external influences, that enabled Islam to develop a philosophy of mathematics akin to the Pythagorean-Platonic tradition of antiquity but in a totally sacred universe free of the nationalism and rationalism which finally stifled and destroyed the esoteric dimensions of Greek intellectuality. It is also this element innate within the structure of Islam which enabled the creation of a sacred art of an essentially geometric nature, and sciences of nature which sought to penetrate into the very structure of physical existence not by splitting the molecule and the atom but by ascending to the archetypal world of mathematics to discover the principal structures which are reflected within the very heart of matter. Islamic art is essentially a way of ennobling matter by means of geometric and floral patterns united by calligraphic forms which embody the word of God as revealed in the sacred book, the Holy Quran.

It is only during the past few years that at last a few scholars in the West are becoming aware of the fact that Islamic art is one of the most powerful forms of sacred art and not just abstract art in the modern sense of the word. Thanks to the efforts of a small number of authorities, foremost among them F. Schuon and T. Burckhardt, Islamic art is gradually coming to be understood for what it is, namely a means of relating multiplicity to Unity by means of mathematical forms which are seen, not as mental abstractions, but as reflections of the celestial archetypes within both the cosmos and the minds and souls of men.

The writings of Keith Critchlow are among the first in the West to analyze the geometry of Islamic patterns from the point of view of the metaphysical and cosmological principles involved. His research has already had a profound influence upon a group of young Western architects and historians of art. Now in the present work, the first of his extensive studies on the subject to appear in print, he presents for the first time to the world at large the blinding evidence of the metaphysical significance of geometric patterns in Islamic art. This study, which is based on years of research and quest in a world rarely penetrated before in the West, is therefore a basic contribution to both Islamic art and science. It is a key to the understanding of many aspects of Islamic civilization and also of the reality which both surrounds and transcends man.

Keith Critchlow is to be congratulated for composing a work which is an important contribution to the field of Islamic studies and also to the new and yet ancient search of discovering the nature of things in a manner that modern man had chosen to forget since he decided to substitute man-made learned ignorance for the perennial wisdom which has served as a guide to man over the ages. This work itself should be a means of awakening many people to dimensions of both art and science long forgotten but now sought by those who have become aware of the shortcomings of a partial knowledge of things which for some time has been parading as a totalitarian and all-pervading science. Keith Critchlow's analysis of the geometric patterns of Islamic art cannot but be an aid to the discovery of certain principles which do not only belong to Islamic art where they are most directly manifested but also, being in the nature of things, belong to men of all ages and climes.

Seyyed Hossein Nasr

Introduction

'Know, oh brother . . ., that the study of sensible geometry leads to skill in all the practical arts, while the study of intelligible geometry leads to skill in the intellectual arts because this science is one of the gates through which we move to the knowledge of the essence of the soul, and that is the root of all knowledge . . .'[1]

In order to understand the mathematical basis of Islamic pattern one must consider most carefully those primary moves of geometry which are all too frequently passed over lightly, or simply taken for granted.

The nature of origins or the creation point of a subject is grounded in mystery. The nature of a point — the simple, self-evident origin of geometry — is one such mystery: is it possible that a point 'has no dimension', except that it be a metaphysical point, and how can it occupy 'place' if space has not yet been created from its unfolding? Clearly there has to be a precise differentiation between physical and metaphysical, between idea and expression, yet both are embraced by one reality.

It has been suggested that this basic truth is reflected in both the opening words of the Book of Tao ('The tao that can be told is not the eternal tao')[2] and in the fundamental formula of Islam — 'lā ilāha illa 'llah' ('no divinity if not the sole divinity'). This formula consists of two pairs of words, each word representing a degree of reality, as well as each pair denoting the negation (nafy) and the affirmation (ithbāt) respectively; the negation refers to the manifest domain and the affirmation to the supraformal and the Principle together.[3] This supreme mystery, manifesting itself as paradox in the human mind to remind it of its inherent limitations, can be expressed variously as: no God but God; no part without whole; no reflection without source. It is no less applicable in the field of geometry: no dimension without all dimensions.

In our manifest world (the world of creatures) we observe things developing, having a duration and being reabsorbed. This elementary law of all phenomena can be symbolized geometrically in the way that space, seen as extension, is created by unfolding through the dimensions and can be 'folded up' again through the understanding of its nature. For instance, we take a point which, having emerged, proceeds to describe a line; the line moves laterally or in a curve to describe a plane; the plane rotates or moves in a further direction to describe (or create) the solid dimension — the third dimension — to which all phenomena of the manifest corporeal world (nāsūt) are subject.

If we take these moves into the three dimensions as being symbolic of the creation of space of our world, then it follows that we can reverse them in the folding up of the dimensions, leading us back to the point of unity or the indivisible. In terms of consciousness this can be described as the path of reabsorption, indicating the possibility of reconciliation between Knower, Knowing and Known, a convergence where subject and object are obliterated in unity.

'That shining point by its light has dominated all that is in the Creation, and by its effectiveness has penetrated every object of the phenomena. All that we have attributed to the Universal nature issues out from it.'[1]

In Chapter 1 we show illustrations of these first moves into the dimensions, starting with a luminous point; the first line is the extension from this point. The limits of this extension having been reached, rotation takes place to encompass the next domain — an area. With this enclosure formed, a cycle is completed, a 'world' in the form of a circle. The circle becomes the archetypal governing basis for all the geometric shapes that unfold within it, this two-dimensional world being one dimension nearer to the origin than is our solid 'world'. The circle's primary inherent quality is one of 'sixness', as will be demonstrated in terms of the radius and its relationship to the circumference.

From the basic circle and the hexagonal arrangement of a group of tangential circles of the same radius surrounding it emerge the three primary shapes: the triangle, the hexagon and the square. These three shapes are explored in detail to reveal their inherent structure, subdivision, proportional ratios and interrelatedness. From this last, which can be called the 'sociability' of the polygons, arises the set of eight semi-regular divisions of a surface, that is combinations of 3's, 6's and 4's in repeating patterns. These eight tessellations form the basis both for philosophical qualitative number patterns and for the mathematical foundation of the laws of repetition upon which Islamic geometrical art is founded.

The mathematical aspect of Islamic geometrical patterns has received scant attention in the West. Notable among the few scholars to have studied this subject in detail are F. Schuon and T. Burckhardt, both of whom have been a source of inspiration and guidance in my own researches, and J. Bourgoin, whose analyses of Islamic patterns were

1 From the *Rasa'il* by the Brotherhood of Purity, translated by S. H. Nasr.
2 See *The Way of Lao Tzu*, translated by Wing Tsit Chan, New York, 1963.
3 For a full development of this subject see F. Schuon, *Dimensions of Islam*, London, 1969, p. 146.

1 Lamha 33, from the *Lamahat* of Shah Waliyullah.

originally published in France in 1879[1] (references to pattern numbers in his book will be found in my own text, e.g. 'B.139', within square brackets).

The thesis of the present book is that these self-evident mathematical patterns with their esoteric philosophical values became the invisible foundation upon which the 'art' was built. This meant that the Islamic artist was not only versed in mathematics in the geometrical sense, but that mathematics was integral to his art as it was a 'universal' structure supporting the intuitive insights that characterize all true art. The great masters of this art were certainly motivated by and versed in spiritual disciplines that gave both content and meaning to their work and placed it in the tradition of aiding the viewer to raise his or her spiritual understanding. This latter quality is also found in the great Chinese and Japanese paintings of Southern Sung and later Zen respectively, in the yantras and mandalas of Hindu, Tibetan and Buddhist art, and in the sand paintings of the indigenous North American Indians. It can be found to underlie both Eskimo and Celtic art, and also occurs as far away as the Pacific Island culture, e.g. in the Malukian meander patterns. All these arts served as aids to an individual's spiritual wholeness through active or passive involvement.

Islam's concentration on geometric patterns draws attention away from the representational world to one of pure forms, poised tensions and dynamic equilibrium, giving structural insight into the workings of the inner self and their reflection in the universe. Curiously, modern atomic physics has confirmed the essential mathematical and geometric patterns occurring in Nature; not, however, in the philosophical sense of displaying the intelligence within and throughout all creation — the starting point of Islamic art — but in the purity of essential relationships which lie beneath the visual surface of our world. The significance from the Islamic standpoint is that, in the effort to trace origins in creation, the direction is not backwards but inwards. Whereas the experienced world, the world of manifestation, is of necessity 'in' the three dimensions of space, the paradisiac world, or world of motivating intelligences, exists only two-dimensionally, the principle being that as archetypes are 'released' from the limitations of existentiality so also is their confinement within the dimensions. In other words, as the intuitive mind, or the Soul, of an individual seeks sources and reasons for its existence it is led inward and away from the three-dimensional world towards fewer and more comprehensive ideas and principles. The two-dimensional nature of the paradisiac world is reflected in Persian miniatures, which were painted in flat planes, without the perspective of a three-dimensional world; it is also the fundamental difference between medieval Christian art and so-called Renaissance art. In his *Oriental and Christian Art*, Ananda Coomeraswami has been the most eloquent modern spokesman on the issue of what is 'real' art, not just the art of 'irrational pleasure'.

Western conditioning on the validity of perspective and chiaroscuro has been the basis of the condemnation of Islamic art as decorative. Sadly it is our own lack of effort and insight that is at fault, not being concerned enough to seek the spiritual and philosophical reasons for the nature of the art of Islam with its unique integration between controlling laws and the beautiful variety of patterns and colours.

Islamic art is predominantly a balance between pure geometric form and what can be called fundamental biomorphic form: a polarization that has associative values with the four philosophical and experiential qualities of cold and dry — representing the crystallization in geometric form — and hot and moist — representing the formative forces behind vegetative and vascular form. The one aspect reflects the facets of a jewel, the purity of the snowflake and the frozen flowers of radial symmetry; the other the glistening flank of a perspiring horse, the silent motion of a fish winding its way through the water, the unfolding and unfurling of the leaves of the vine and rose. In mankind this polarization is characterized by the rigidity and geometry of the skeleton on the one hand and the flowing, ductile, fibrous muscular system which activates it. In Arabic calligraphy, epitomized in the sacred art of the Quran, not only is this polarization seen at its greatest extreme in the flowing and Kufic styles, but amongst the flowing styles (of which there are twelve distinct varieties) the polarization can be seen between the verticality of the upright *aleph* and the rhythmic flow in the horizontal direction of the other characters, starting with *bey*. It has been suggested that *aleph*, as the ontological axis, can also be interpreted as the creative ray which initiates existence at the diacritical point of *bey* and thence proceeds to expand horizontally with the lateral gesture of the second character. By this the fundamental three-fold nature of reality is established — the descent of the light, the expansion into creation and (in the symbolism of the written words of Quran) the means whereby the 'light' returns to its source.

The Islamic art of geometric form, then, can be considered the crystallization stage, both of the intelligence inherent in manifest form and as a moment of suspended animation of the effusion of content through form. This book is primarily concerned with geometrical form as it relates to the circle — as the circle is the symbol *par excellence* for the 'origin' and 'end' of both geometric and biomorphic form. At the same time all those rhythms in flowing line that we recognize as the intervals in everyday life — breathing, blinking, heartbeat, digestion and so on — reflect our intimate connection with the cosmic rhythms of day, month and year. The circle is also, then, the primary cosmological symbol, one of wholeness and unity.

1 *Les Eléments de l'art arabe: le trait des entrelacs*, Paris, 1879; plates reprinted under the title *Arabic Geometrical Pattern and Design*, New York and London, 1973.

1 The Point of Departure

The manifestation of an action, object or thought (if it can be defined) necessitates a point of origin or departure, in relation both to the manifestation itself and to the person who is conscious of its emergence.

The point of emergence does not necessarily reveal its causation either in the field of its emergence or in the mind of the viewer. In the mind the point represents a unitary focus of conscious awareness; in the physical world it represents a focal event in a field which was previously uninterrupted.

In the first group of four illustrations, the point is shown as a white spot and serves as a symbol for unity and source. In terms of geometry it represents the centre — the elusive controlling point of all forms.

If the manifestation of the point is indicative of a departure from its source, then direction is implied. Direction in space is qualitative, and hence the first departure or line path from the point is qualitative. Homogeneous space is a contradiction in terms — if it is to be measured — the proof of this lying in the need to relate measurement to quantitative space: a measurement is only possible between two points (the ends of a line-path); hence direction must precede measurement. Once a direction is taken in space, that direction depends on a choice having been made and thus homogeneity is by definition cancelled. From the outset space definition is qualitative. The line-path can be taken as representing the point 'externalizing' itself. A line, i.e. when a point has moved outside and away from its original position, symbolizes the polarity of existence, although it consists essentially of three elements — two ends and a relationship between them.

Having a limited departure from the point of origin, polarity expresses itself in the relationship of the central (essentially passive) 'original' point and the outer projected (active) point. This expression forms an arc with the line representing our original departure as radius.

The arc implies the control exercised by the centre point and expresses the demarcation of the active outer limits; the movement expresses an expansion. As the arc closes, another primordial 'threeness' becomes evident: a centre point of origin (the controlling element); departure from this centre as direction or field; and boundary to the domain.

The centre is always hidden inasmuch as our point of origin, as it appears on the page, when investigated closely constitutes in itself a field or domain, the centre of which will continually elude 'placing' in the strictest physical terms. Even the most elementary particles of the atomic nucleus surround an unmanifest centre. For practical purposes, however, we place the still point of our compasses on the centre and move the other to inscribe an arc. This ideally expresses both symbol and actuality.

Once the enclosing circle is completed, a unity is obtained; this reflects the unity of the original point. The circle is not only the perfect expression of justice — equality in all directions in a finite domain — but also the most beautiful 'parent' of all the polygons, both containing and underlying them. Outside the concept of time, the circle has always been regarded as a symbol of eternity, without beginning and without end, just being. As a symbol *within* the limits of time, or rather subject to that condition of existence, it passes around just as the active compass point returns to its first position it necessarily passes over it and in principle establishes a helix — the expression *in* time of the circle. The circle expresses 'threeness' in itself, i.e. centre, domain, periphery; and 'fourness' in a manifest context, i.e. centre, domain included, boundary, domain excluded.

The point as symbol for unity and source.

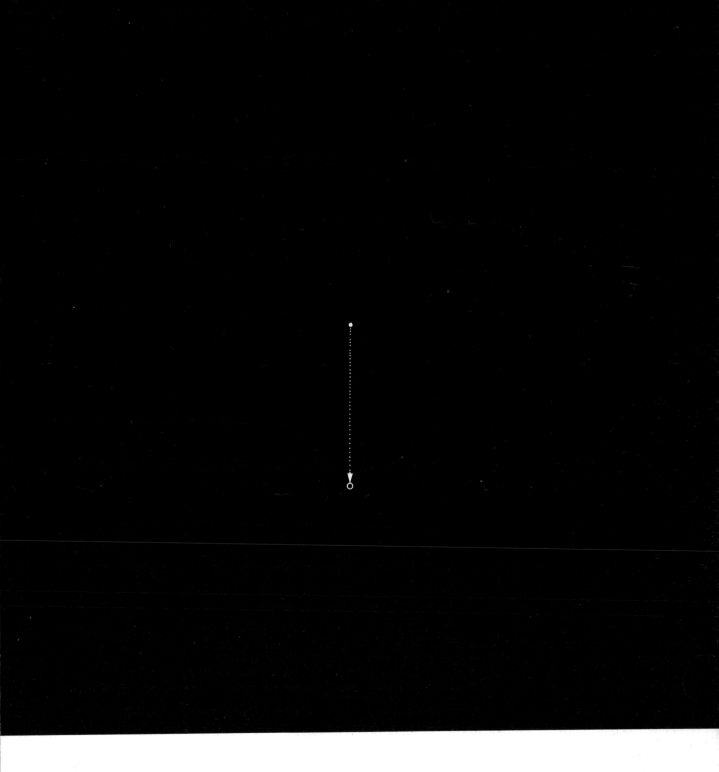

The first move, creating a line.

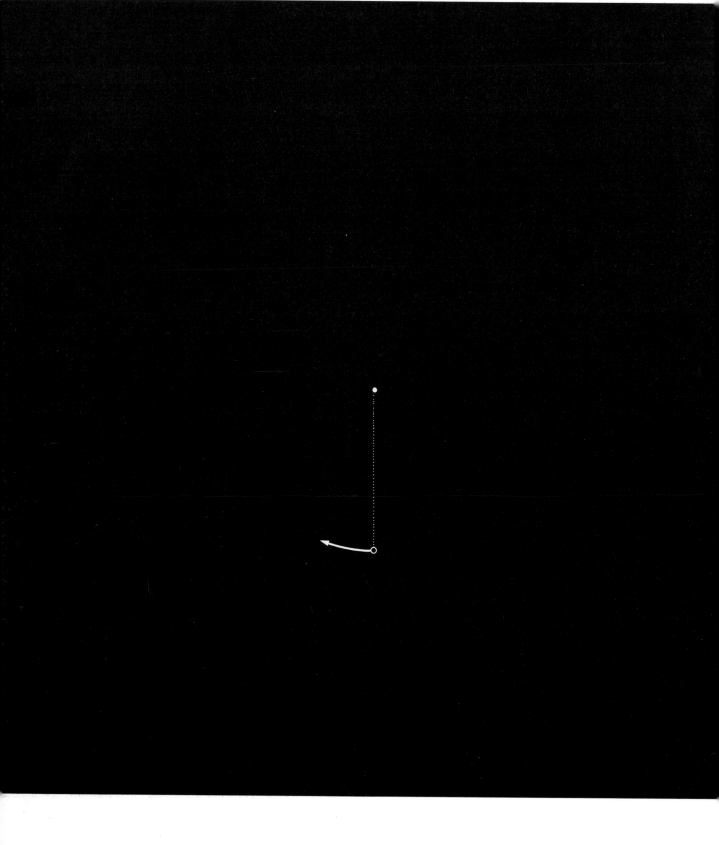

The second move, the arc creating a boundary.

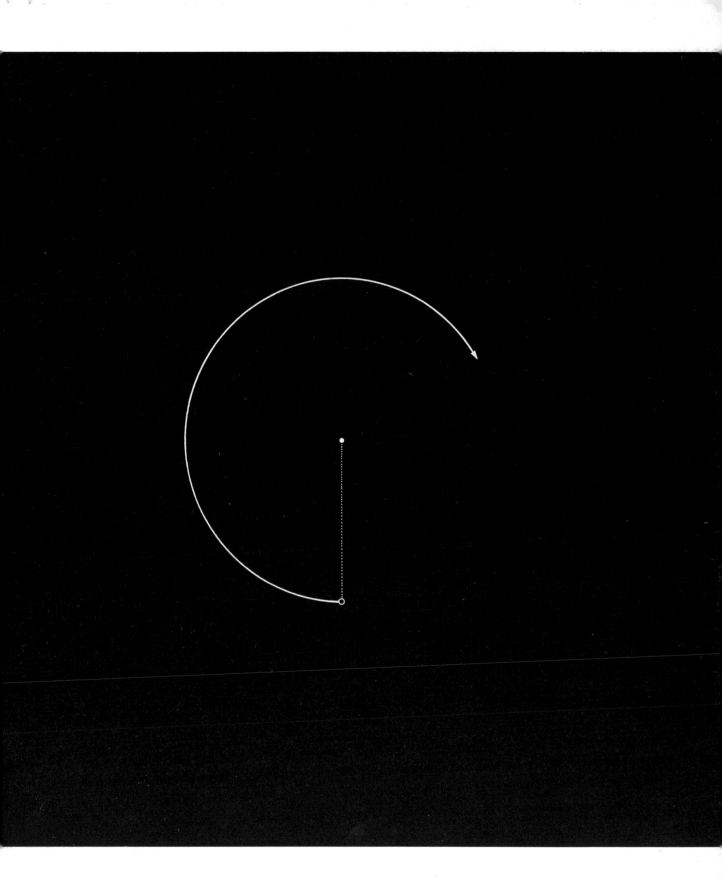

The closing of the circle to form a domain.

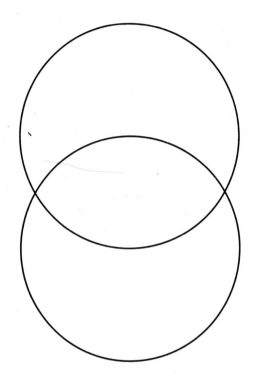

Having established the existence of a unity between the point and the circle, we can express the process of departure or externalization, again in terms of the whole circle.

As that which is departing or 'externalizing' from the original circle proceeds on its course, a series of significant arcs are formed.

The most significant of these in our present context is the half-way point (above, right), the last position at which the departing circle has contact with the centre of its origin.

This position holds essential symbolic value inasmuch as it represents a union of an origin and a manifestation where the centres of both coincide with the peripheries of each, and the amount manifest of the departing circle exactly reflects the amount remaining of the original one. Also the departing circle has moved away by exactly the same amount as the original circle had 'moved away' from its hidden centre in order to establish itself.

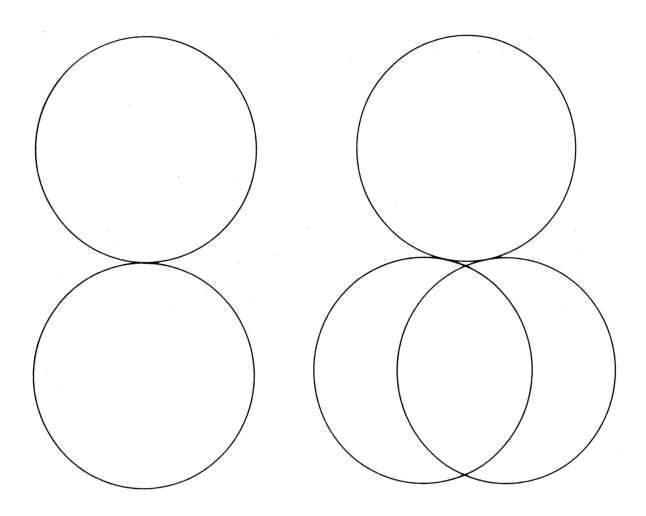

Two circles exactly represent the completion of the reflection of the departing circle from the original one.

Here (above, left) the connection between the two has been reduced to a point of contact, in its own way reflecting the source of the original circle. It is from this point, strictly speaking, that measurement can be identified as it is the 'between' of the two primary unities and therefore represents the first measurable distance, i.e. from centre to centre.

Curiously, the figure can be read as another expression of 'eternity' in the form of infinity as meniscus. This can be seen to be relevant to the figure if the path is taken as a continuous flow, say from the top, although (as with the circle) the beginning can be anywhere, down right through contact point, down further left around bottom circle, and

back right up through contact point again left to top. This is a symbol of a path equally traversing origin and manifest reflection — the invisible but implied inseparable relationship — as the boundaries of each circle belong in this sense to both. Strictly speaking, we have only established one direction in the externalizing of our prototype circle.

To establish a finite primordial *area* we can polarize the exteriorized circle by a lateral expansion. We will keep this expansion related to the origin by keeping all three peripheries in contact and thereby the expanding centres on an arc determined by the centre of the original circle.

The expansion between these polarizations of the lower circle will pass through a series of significant arcs on its way to a state of equilibrium and maximum expansion.

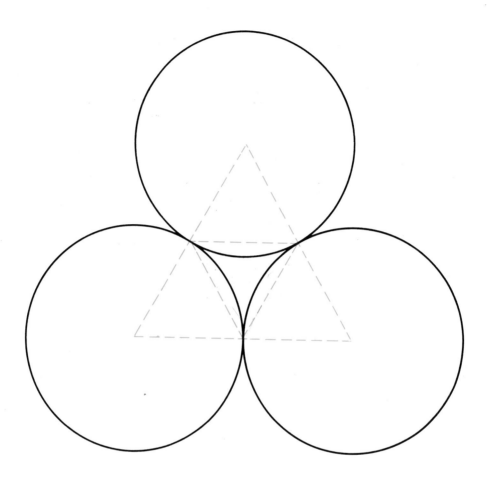

When maximum lower expansion has been established all three circles come to rest with their outermost points just touching; in this way the principal polygon, the triangle, is established. The directions between the centres are three as are the points of contact but the relationships between centres and points of contact are nine, and these bound four triangles having the primary radius as their sides.

The triangle is thus the first polygon, the minimal expression of an area, and the simplest figure to which all other polygons can be reduced. It is also symbolic of the minimal needs of consciousness (i.e. Knower, Known and act of Knowing), as well as the minimal description of the basic biological needs: ingestion, absorption and excretion.

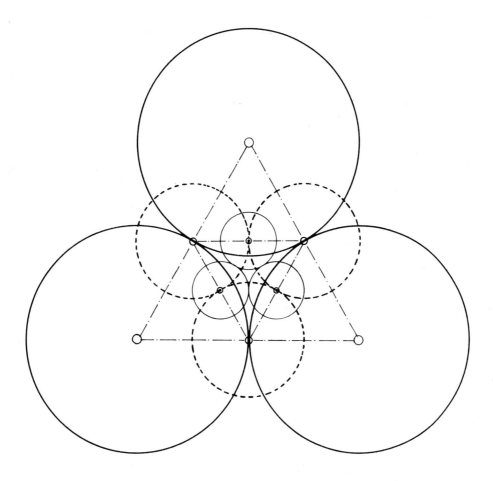

The three circles, when completed in a regular relationship to each other, express the equilateral triangle by the relationships of their centres, of their outermost boundaries and of their points of contact. If we take the points of contact as new centres of domains and draw circles (shown in broken line) with a radius half that of the three larger circles, we arrive at an exact repeat of the original pattern of circles in an inverted arrangement. This process can be repeated, with further circles with radius half that of the second group, to produce a pattern conforming exactly to the original large group, and it demonstrates the principle of controlled proportional increase or diminishing in an arithmetical sequence. In each case the triangle increases to double or diminishes by half. The relationship, however, between the centre of one of the larger circles and the next smaller circle opposite it is $\sqrt{3}$ in relation to the radius of the larger circle taken as unit edge length. Thus a harmonic series will also be present in the sequence.

In the process of expansion, each additional manifest circle can be expressed as a lateral polarization of its predecessor.

In terms of our originating circle, it would be more appropriate from this stage onwards to change our axis of viewing and consider the lateral expansion in the horizontal plane with our originating circle representing the central vertical axis.

The fourth circle, following the principle of the third when at rest, triangulates with the first and third circles. This is a mirror reflection of the relationship between the first three circles. At this stage there are eight triangular radial relationships implied. As the fifth circle arises a further pair of reflection axes occur, and the radial implied relationships increase to twelve triangles.

As the rotational growth pattern continues, the sixth circle establishes the first parallel axis to the primary three circles as the furthest limits of the opposite side of the centre circle have been reached. The relationships between points of contact increase to sixteen radial triangles.

The seventh circle completes another unity.

In terms of the bifurcating circles around our central prototype circle the sixth peripheral circle exactly contacts the first peripheral circle. This establishes a primordiality of six possible outer reflections of a primary, or seventh central originating, circle.

Between centres there are six major line relationships; between points of contact and centres there are twenty-four radial triangular relationships.

From the primary and principal unity, the circle, the second unity was the triangle and the third unity, if we may so use the phrase, was the 'hexagonal' group of seven circles.

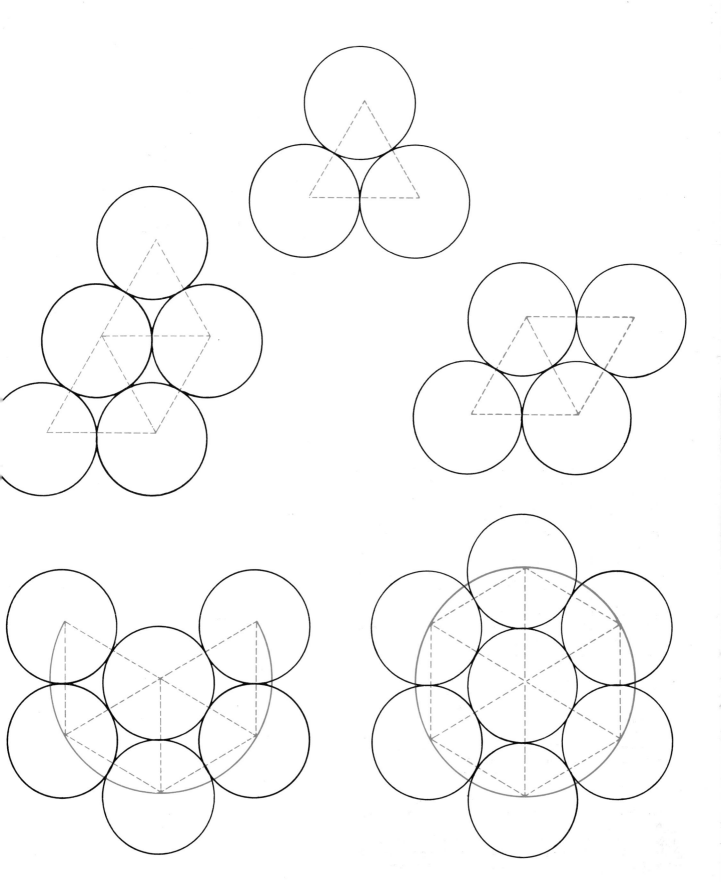

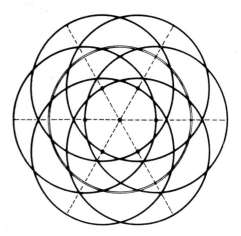

The growth in the numbers of circles from their originating centre has been shown one at a time.

We will now examine a form of simultaneous expression of direction. Each of the six possible directions from the centre will manifest itself at the same time. As before, our starting point is the primordial circle – a symbol of simplicity and plenitude.

The first stage in the simultaneous expression is the establishment of three axes of expansion and six directions of departure or reflection.

As the circles differentiate from each other without departing in principle from the central prototype, they establish intersections of confirmation of the three axes.

The diagram above serves to express in its own terms the energization of the externalizing of the centre into the six directions – both as fact and as symbol.

Opposite

The second stage of expansion (top) has been arrested at the critical phase where each of the six externalizing circles has reached the equilibrium state of being exactly half-way. The six centres are exactly equidistant both from each other and from their source.

This point in the flowering of the circle is beautifully expressed in the pattern formed within the centre circle.

Right from the inception of this movement outwards, seven distinct circles were manifest. At this stage twelve radial triangles are present to reflect the equilibrium of the six moving circles.

Although in principle the outward movement of the six reflections is uninterrupted and continuous, there are bound to be significant stages of development. Stage three (below, left) is another of these: here alternate circles are in contact at their outer points. This gives rise to two intersecting sets of three: our primary and primordial triangle reflecting on itself symmetrically.

This stage also represents a kind of opening in the perimeter of the centre circle which is now cut in twelve places (in six pairs). By joining up these pairs across the diagram we accent this opening up of a central domain which is 'clear' of all the departing circles. The result is three pairs of parallel lines intersecting to form a star hexagram at the centre.

As the parting circles move further into their own individuality the fourth stage is reached (below, right) when the overlapping (or undifferentiated) parts of each circle remain, arcs describe exact square and triangular relationships for the first time.

This stage is reached when the arcs cutting the perimeter of the centre circle (which became twelve) are exactly equidistant from each other. The departing six divide the centre into twelve exactly equal intervals.

This results in the central space being defined as an exact hexagon with sides equal to the twelve-fold division of the primary circle. By linking all the points of arc intersection an indefinitely extending pattern emerges made up from the exact balance of triangles, hexagons and squares.

This integration of the three primal regular shapes that can fill a plane has significance both as a symbol and as an archetype of fundamental surface pattern.

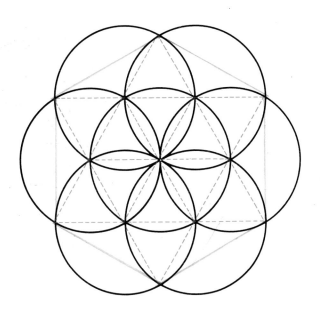

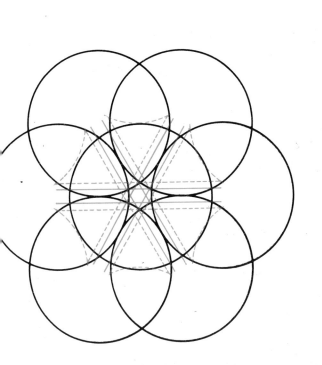

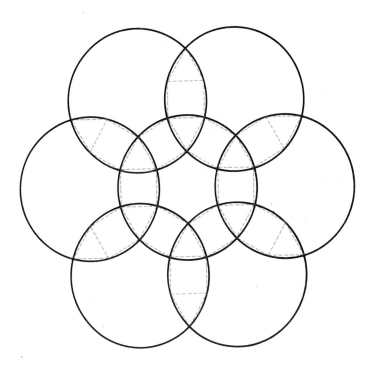

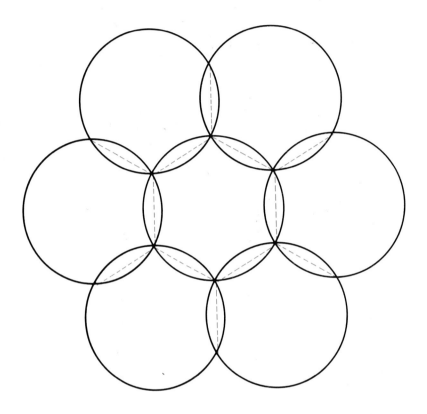

The fifth stage of expansion is represented by another coincidence of arcs in equilibrium. At this point in the expansion, as the circles leave their origin, the remaining part of their circumference within the centre circle is one sixth. This is also the exact amount of periphery by which they are linked to each neighbour. Each circle departing remains related both to its two neighbours and its source by one sixth of its boundary and therefore is half-clear in the outermost sense.

The number of intersections of the arcs has now fallen dramatically, to a total of twelve. When these are joined the relationships demonstrate the six-fold nature of each circle and the fundamental hexagonal division of a plane once again.

If the hexagons were completed in each case there would be a total of seven in this diagram — six around the original central hexagon.

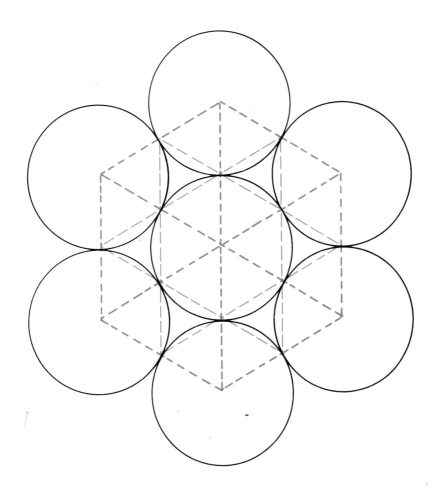

The final condition of the simultaneous reflection of a circle in six directions occurs when each of the outgoing reflections simultaneously becomes independent of its two neighbours, and when, without losing contact with each of the three neighbouring circles, each one becomes its own unequivocal self.

So far the symbolism has been considered as a horizontal phenomenon with the centre (controlling) circle representing the vertical axis; at this completion stage the axis of the image is changed so that we have three circles, one above the other, now to be considered the vertical axis for the purpose of our proposed symbolic interpretation.

The centre circle loses none of its significance as the fulcrum, but in this situation it becomes the balancing point between manifestation below and metaphysical origins above, represented respectively by the lower circle (the *sensorial* world) and above as the upper circle (the world of *being*).

On this universally applicable framework of essential geometry we propose to symbolize the Islamic perspective.

2 The Manifestation of Shape

Symbols can exhaust verbal explanation but verbal explanation can in no way exhaust symbols — symbols are directed toward undifferentiated unity, while verbal explanations involve never less than two — the donor and the recipient; even if they become the same there still exists the separation of reference: the subject itself and the explanation.

Pattern like number, is one of the fundamental conditions of existence and is likewise a vehicle of archetypes. As arrangements both emerge from simplicity and unity and return towards it, they exhibit some fundamental relationships which become hierarchical.

We have seen that the first differentiated *area* to be described is a triangle; also that the hexagon represents the third 'unity' and second shape. We can now see that the square emerges as a product of our basic pattern. Hexagon and triangle are dual and complementary, the one co-existing within the other. The square is self-reflecting and self-dualling as squares emerge from the centre of a square matrix. These three basic shapes are used to symbolize the square of earth or materiality, the triangle of human consciousness, and the hexagon (or circle) of Heaven.

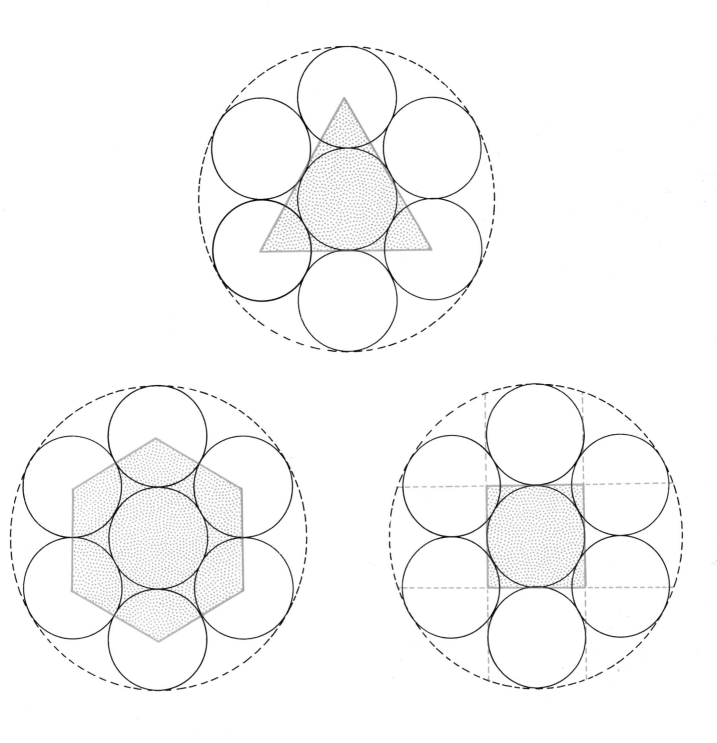

The equilateral triangle, the hexagon and the square are the three primary plane shapes which will independently fill a surface without leaving any gaps. Each shape has its own archetypal behaviour in terms of itself and, in different ways, within its own matrix.

Hexagons with their 'sixness' and six-sidedness can give rise to different smaller or larger patterns by surrounding each point and with a smaller similar figure so that each has a common edge with its neighbour; this implies an indefinitely small and large growth system.

The triangle also has many ways of reflecting itself and reproducing itself in a similar manner. It also creates further triangles by forming a link between opposite points of a pair, so that a pattern of six triangles in hexagonal form has two such larger triangles within it. The square also has different ways of relating different coincident matrices of itself to itself, both at 45° and orthogonally.

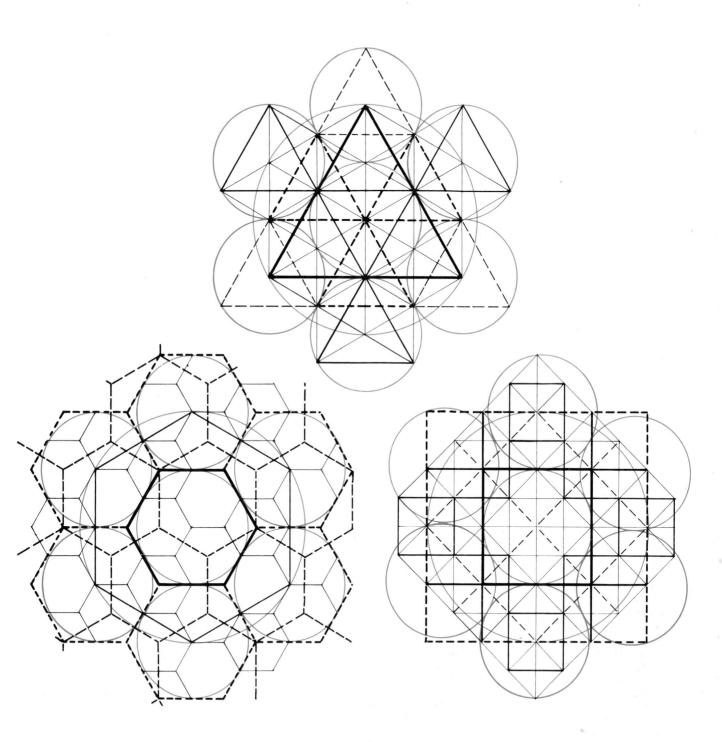

Strictly speaking, by the most elemental method of geometry using a circle and two straight edges, the first shape to emerge can be demonstrated to be the equilateral triangle, as a product of the unitary figure, the circle. As we propose to follow the build-up from the ground, we will start from the square, the symbol of physical experience and the physical world and totally dependent for its construction on the circle.

Drawing A starts with the basic circle, the compass point is placed at the top of this circle at x and, without altering the radius (or compass opening), the first arc (1–1a), is inscribed. Next, starting with the compass point on 1, point 2 can be cut off, followed (with the compass point on 2) by point 3. By joining points x and 3 a vertical axis is obtained. To establish the cross axis at 90° an arc is struck (from the top of the vertical axis) with a radius larger than that of the original circle but smaller than its circumference (4). A second arc (5) is struck with point 3 as its centre and, by joining the points of intersection, points 6 and 7 are obtained on the perimeter of the circle. Lines joining the point x to point 7, 7 to 3, and 3 to 6, and finally 6 to the original point x give us the square within the circle.

Drawing B demonstrates similar bisectors for each edge of the square to obtain the 45° diagonals.

Drawing C shows the eight points linked into two inter-secting squares together containing an octagon.

Drawing D demonstrates diminishing squares and the natural division of a square in its dynamic aspect, i.e. point upwards.

Drawing E demonstrates the same principle edge down, in passive aspect; the square is sub-divided into sixteen (4 × 4).

Drawing F shows harmonic diminutions of the dynamic square (diagonal) inside the passive square giving rise to $\sqrt{2}$ harmonic ratios.

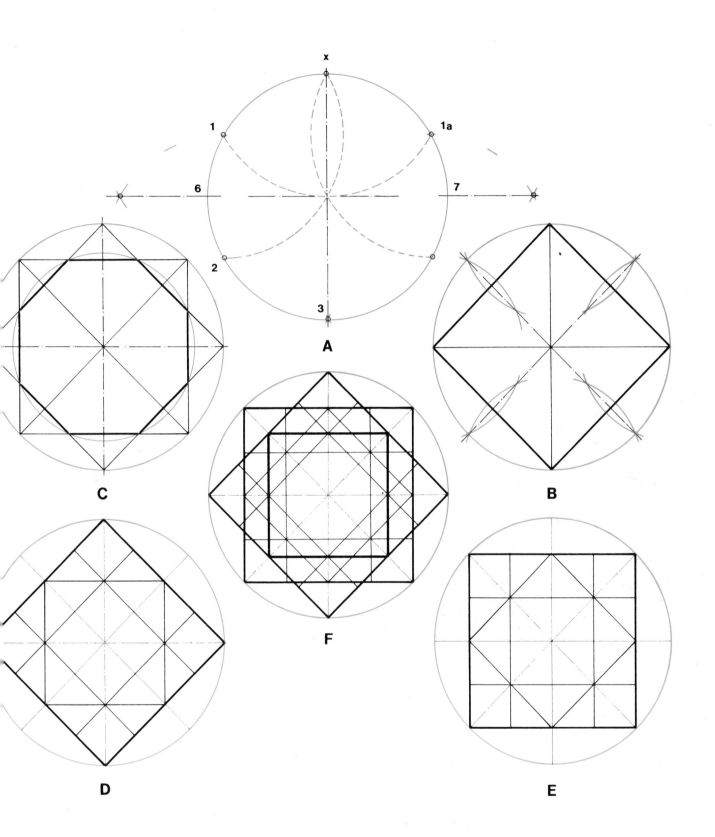

x

1 1a

6 7

2

3

A

C

B

F

D

E

The second polygon in our established triad, the triangle, is demonstrated as the natural division of the circle. By tradition symbolic of human consciousness and the principle of harmony, the triangle is the geometrical expression of two entities and their reconciling relationship (the third factor).

Drawing A begins with a circle (as with the preceding layout of the square); in this case we start by placing our compass point on top at point 0 and strike the first arc to cut the circle at 1, with the radius unchanged from that of the circle. Point 2 is obtained by moving the static point of the compass to point 1 and making a second arc to 2, and so on, for points 3 and 4.

Drawing B links point 0 to point 2, 2 to 4, and 4 to 0.

Drawing C extends the three central axes 1 to 4, 2 to 5 and 0 to 3 through the centre point. This divides the triangle into its three-fold symmetry (the three similar ways in which it can be folded to cover itself exactly) as well as dividing the circle into six equal portions.

Drawing D demonstrates the interaction of the upward-pointing triangle 0 : 2 : 4, and the downward-pointing triangle 1 : 3 : 5, traditionally related to the upward quest of human consciousness and the downflow of archetypal ideas, respectively.

Drawing E shows the harmonic diminishing (or augmenting) triangles from the outer 0 : 2 : 4, to the smaller $\frac{1}{4}$-sized 6 : 7 : 8, to the $\frac{1}{4}$ of this triangle, and so on indefinitely. The length of the edge 8 : 6, taken as one unit, makes the proportional distance between 0 and 7 $\sqrt{3}$ (in other words the number which when muliplied by itself will have as its product 3). This can only be expressed approximately in arithmetical terms and is consequently known as an 'irrational number', but geometrically it can be drawn with precision and hence belongs to the realm of qualitative mathematics — a harmonic ratio.

Drawing F outlines the pattern known as the Pythagorean tetractys within the two triangles residing within any circle. This is made up of ten points and represents the sum of the first four whole numbers, i.e. 1 + 2 + 3 + 4 = 10. More will be said of this figure later (see Chapter 6).

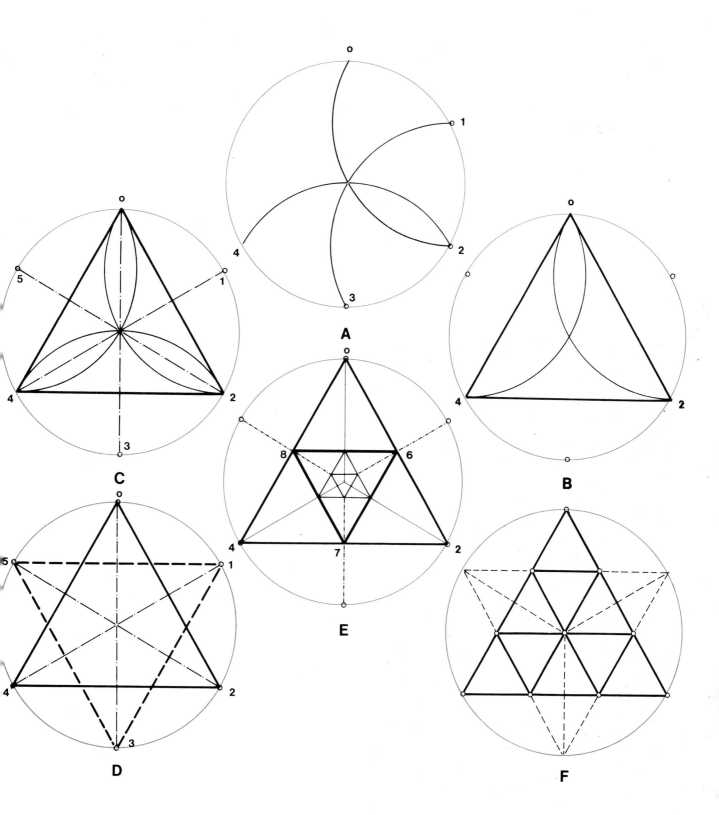

A

B

C

D

E

F

This page describes the qualities of the hexagon — which is graphically the most natural shape with straight line edges produced by equal divisions of the circumference of a circle. The reason is quite simply experienced: by placing the point of the compasses anywhere on the edge of a circle, without changing the radius, one has merely to cut off six arcs using each point of intersection as a centre for the next, i.e. starting at 0 we strike off both 5 and 1; from 1 we strike off both 0 and 2; from 2 we strike off both 1 and 3; centering successively on to 4 and 5 we create the characteristic flower pattern within the circle with its own arcs. Drawing B reduces this divisioning into straight lines and hence the hexagon with its centre diagonals. Drawing C fills in the two triangles (pointing upwards and downwards) with three more central axes. Drawing D demonstrates the effect of these new axes of symmetry on the hexagon; particularly how the right- and left-handed triangles (shaded) become reversed but 'similar figures' in the inner hexagon which is turned 30° round from the position of the larger one. Drawing E demonstrates methods of diminishing hexagons within hexagons to obtain harmonic diminutions (or augmentations), i.e. similar figures which shrink (or grow) in their relative proportions, exemplified in the organic kingdom of plants. Drawing F takes the characteristic rectangle that sits within any regular hexagon (there are three ways of taking this rectangle in any regular hexagon) and demonstrating its unique quality of having proportions shrinking in a ratio of exactly $3:1$ as the short side becomes the long (and vice versa, growing in the proportion of $1:3$). The rectangle called $\sqrt{3}$ has one unit as its shorter side and the number which when multiplied by itself becomes 3 as its longer side. Drawing G represents the horizontal and vertical $\sqrt{3}$ rectangles that would be contained in the respective hexagons of this circle. Each rectangle has one diagonal shown in broken line; these diagonals cross at 90° at the centre and the diagonal of one rectangle cuts two edges of the other. These points of intersection are joined (in heavy line) to the corners of the rectangles from which the diagonals are drawn. The heavy lines are seen to set up a characteristic 'spinning' motif, as well as demonstrating another way in which the double equilateral triangular rhomb fits the rectangle.

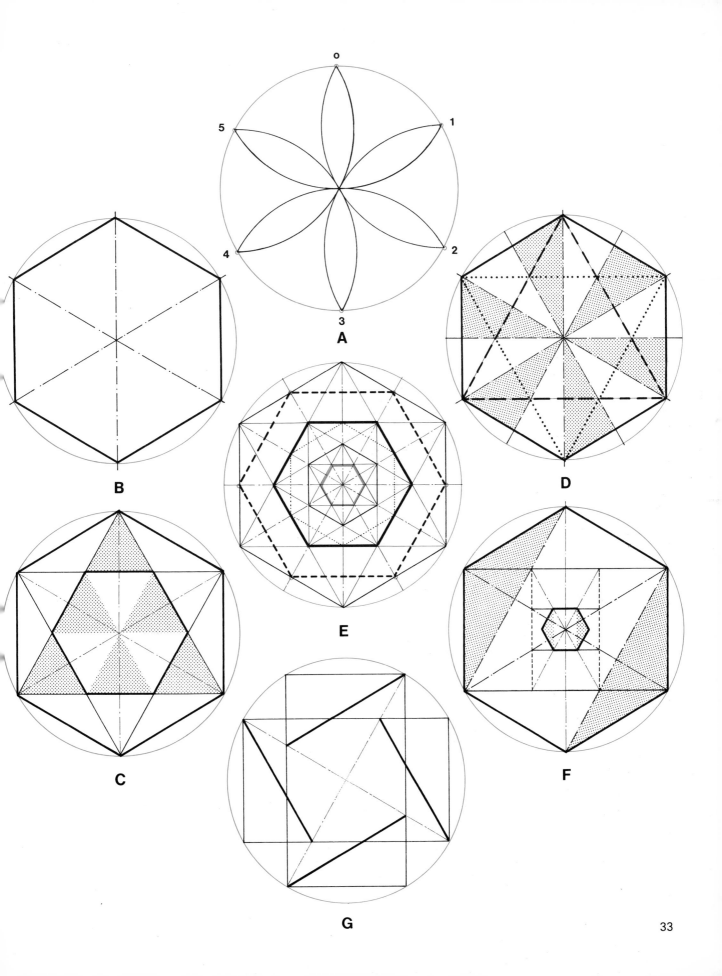

A

B

C

D

E

F

G

33

From the integrated symbolism of the shapes as co-operative and individual cosmological symbols we return to the shapes as the three most elemental divisions of a surface area. The practical and useful level of operation of archetypal expressions in no way diminishes or reduces their effectiveness as symbols, on the contrary it merely reinforces the fact that what we take to be simple and 'in the nature of things' has become profound to the point of us becoming oblivious to it, in much the same way that if we find ourselves in an environment with a great deal of noise for any appreciable length of time we cut out our awareness of that noise. How often has any one of us stopped to think how curious it was for gravity to have been 'discovered'.

If one is about to embark on weaving some fabric in a simple repeating pattern, or on making a repeating patch-work out of similar regular pieces, or if one is intending to make some tiles which should regularly repeat their pattern, one finds that one's endeavours are governed by the simple law that only a square, a triangle, or a hexagon can result if the work is to repeat regularly. Variations will emerge as experiment goes beyond the first three basic shapes. But it is on this very simple law of 'threeness' that the foundations of Islamic geometric patterning are rooted — practically, symbolically, philosophically and aesthetically.

The triangle repeats by sitting next to itself upside down alternately. When enough are together (A) the centres of these triangles when joined make a hexagonal matrix. The square (B) is most commonly used, to a point well beyond saturation in Western urban environments, and is self-repeating when the centres of this kind of matrix are joined. The hexagon (C) will nestle together with six others identical with itself surrounding it to make a regular repeating pattern, and when the centres of these are connected a triangular grid emerges. Hence we say that the hexagon and triangle are self-dualling or complementary.

The bottom drawing (D) illustrates this dualling property of the hexagon and the triangle (shown in colour), as well as treating the points of contact as the three primary shapes which integrate in a repeating pattern. A smaller triangle occurs over each centre of the coloured triangles and like-wise a smaller hexagon over the centre of each coloured hexagon, with a smaller square centred on the cross-over of the coloured dual grids. The whole represents an equilibrium of the three regular tessellations and is itself a key guide for many Islamic patterns.

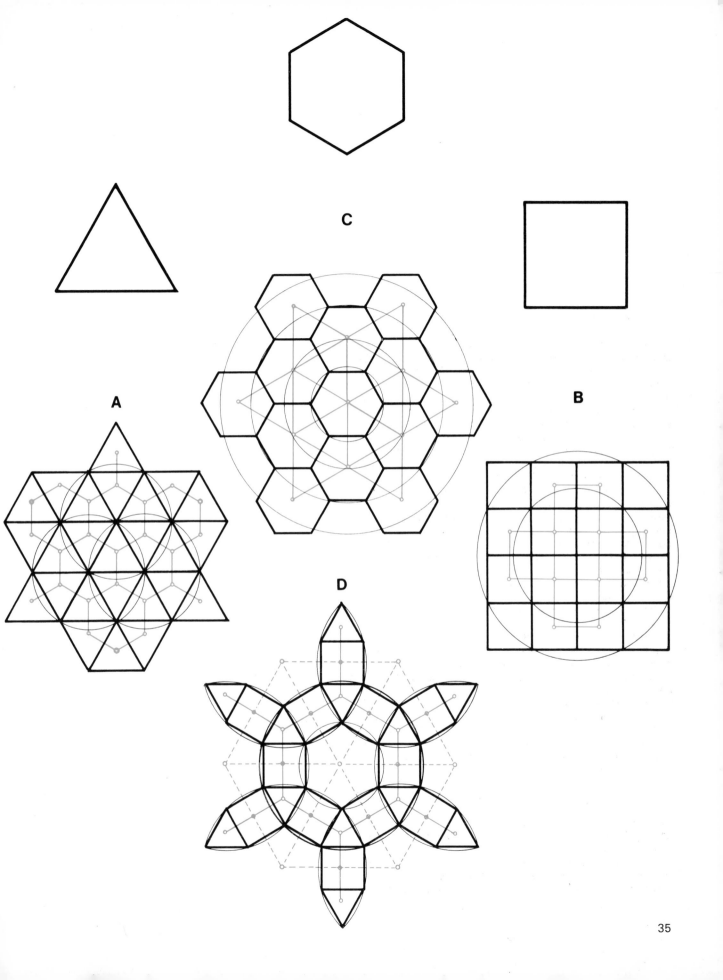

A

B

C

D

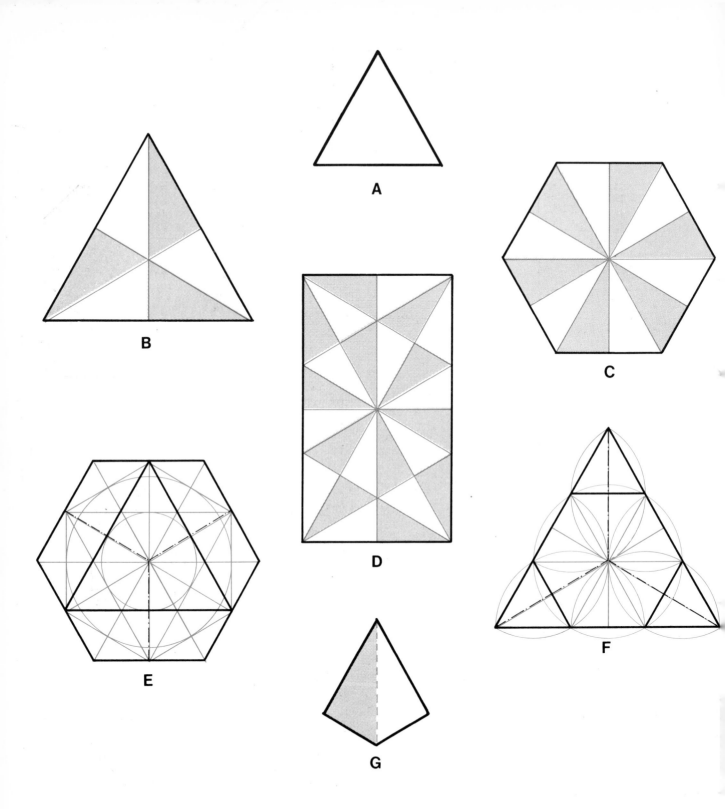

An exploration of triangular, three-fold symmetry.

A *Basic shape*
B *The three axes of symmetry; the right- and left-handed constituent triangles*
C *Hexagon composed of constituent triangles*
D $\sqrt{3}$ *proportional rectangles composed of constituent triangles*
E *Proportional relationships between triangle and hexagon, with axes of symmetry in colour*
F *Method of construction using compasses*
G *Characteristic kite shape composed of right- and left-handed constituent triangles*

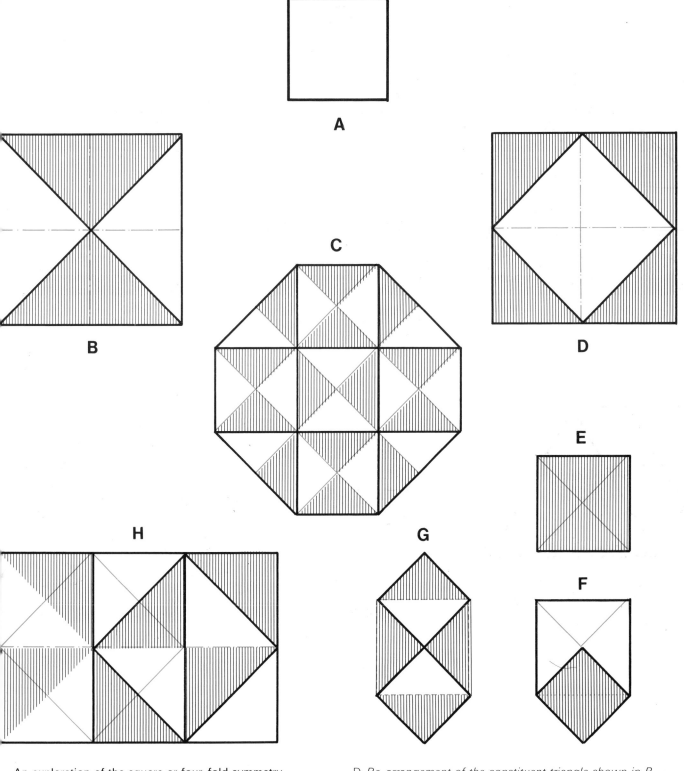

A

B

C

D

E

F

G

H

An exploration of the square or four-fold symmetry.

A *Basic shape*
B *Four-fold symmetry shown in two ways*
C *Pseudo-octagon created from constituent four-fold triangles*

D *Re-arrangement of the constituent triangle shown in B*
E *Original square*
F *Square unfolding from its centre creating √2 proportional extension below*
G *√2 extension unfolding above and below from square*
H *Proportional rectangle showing relationship between √2 and whole number increments*

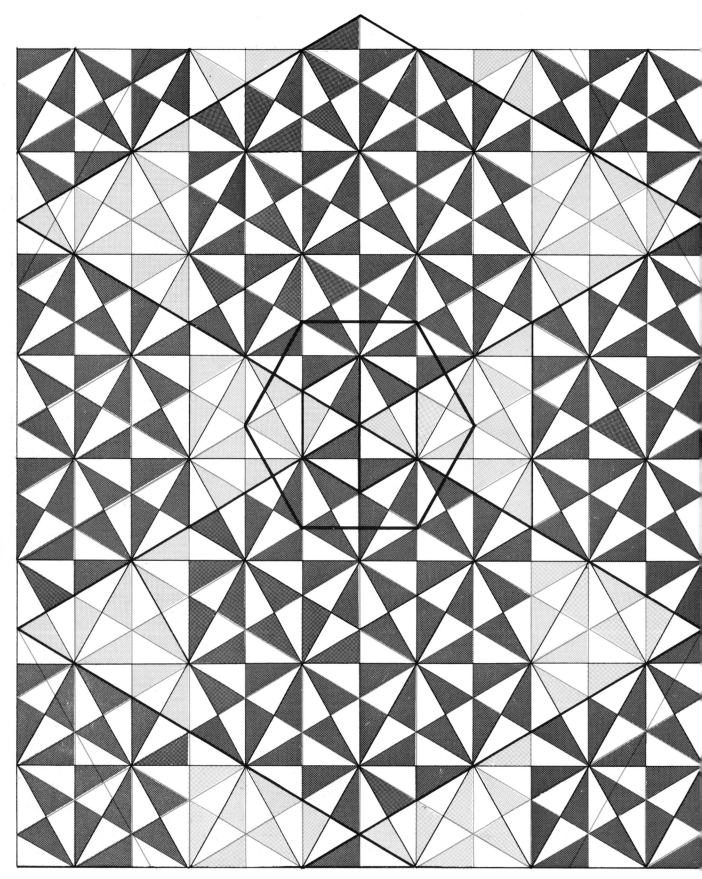

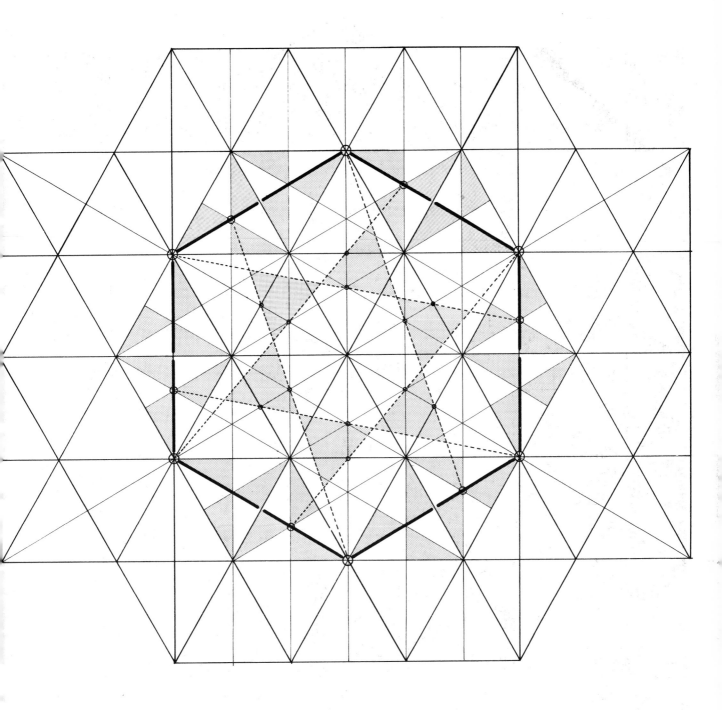

Left
Repeating grid based on triangular three-fold symmetry, outlining proportional relationship between hexagon and triangle.

Horizontal $\sqrt{3}$ rectangle with central hexagonal core shown in heavy line, giving rise to a vertical $\sqrt{3}$ rectangle which relates to the horizontal by a larger proportional hexagon contacting with the centres of the sides of the horizontal $\sqrt{3}$ rectangle.

Certain points on the edges of the core hexagon have been used, together with its nodes, to set up a gyrating six-pointed star, shown in broken line.

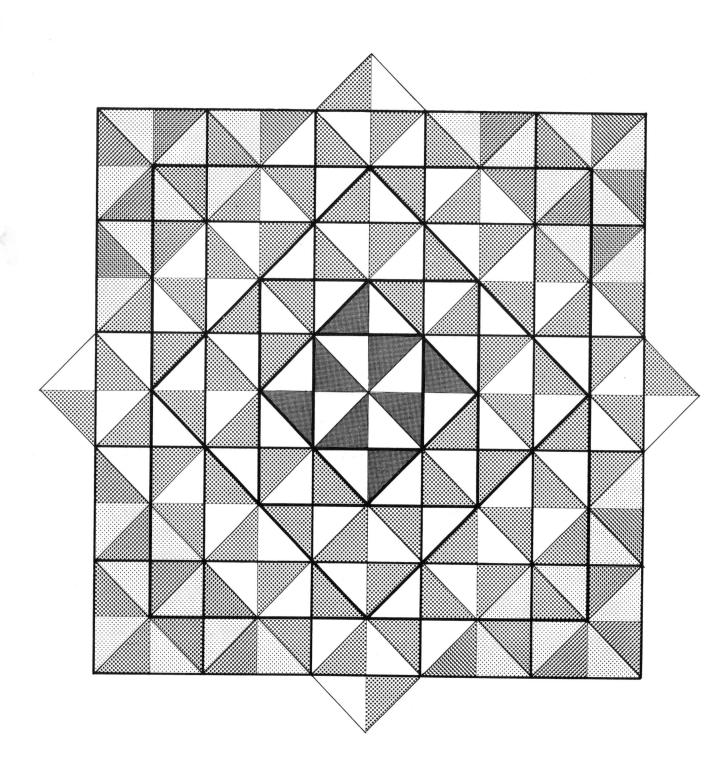

Concentric squares increasing in $\sqrt{2}$ proportion from one to the next, with toned areas demonstrating certain symmetrical functions.

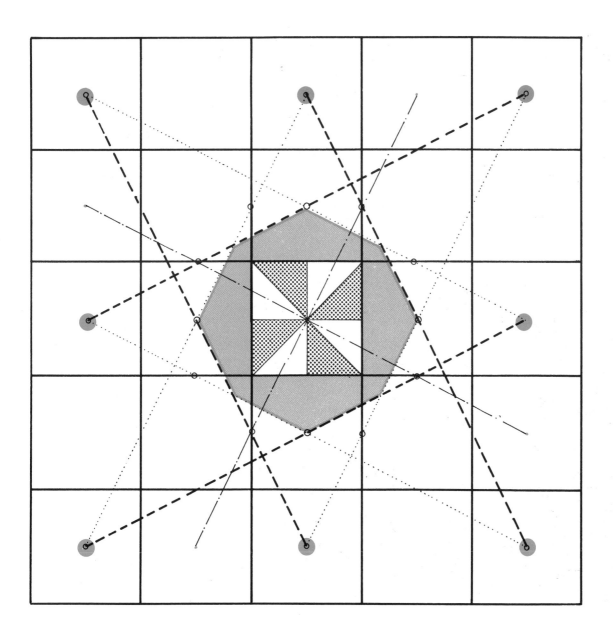

A 5 x 5 square grid with 'turning' square motif generated from the centres of the four corner squares and the centre side squares (shown in broken line). Other axes of symmetry create a pseudo-octagon with inner four-fold square core.

3 Magic Squares

Magic squares are conspicuous instances of the intrinsic harmony of number and so they will serve as an interpreter of the cosmic order that dominates all existence. They appear to betray some hidden intelligence which by a preconceived plan produces the impression of intentional design.

The above sentiments were those Paul Carus in his foreword to W. S. Andrews' life work on Magic Squares first published in 1917. The attitude would not be so very different to the traditional Islamic one. The actual difference, however, being firstly the undoubted Divine origin to mathematics, secondly the qualitative aspect of number (of which magic squares are an example) is given greater significance, and therefore metaphysical effectiveness, than the merely quantitative. Therefore, as the expression of archetypal entities, numbers are far more than the 'mere intellectual play' of Carus as they not only sustain, but pervade the form of the terrestrial elements quite in harmony with the findings of modern physics. Through this latter fact they can be effective in the scheme of things and represent a branch of science in themselves.

The Brotherhood of Purity was a group of anonymous scholars in the fourth/tenth century who produced a compendium of the arts and sciences in fifty-two epistles. This they published for all to read and it contained a virtual condensation of all knowledge of the time. They placed the science of numbers at the 'root' of all the sciences, '. . . the foundation of wisdom, the source of knowledge and pillar of meaning.'[1]

The pre-eminence of number was confirmed by the later great Islamic mathematician al-Khwārasmī, author of 'The Book of Summary in the Process of Calculation for Compulsion and Equation' (from which the word *al-jabr* for 'compulsion' and 'restoration' is believed to have given rise to the European 'algebra'); he quotes the prophet Muhammad as having said 'Praise God the creator who has bestowed upon Man the power to discover the significance of numbers.'

No greater clarity has been given to the meaning of this significance in the sense of cosmology or the 'science of being' than by Nasīr al-Dīn al-Tūsī (597–672 AH/AD 1201–74), a syncratic second only to Avicenna in importance. In the second chapter of his *Taṣawwurāt* (Notions) he elucidates '. . . the descent of the things of the world from the first cause' — this world is of the kind of which it is said in the Quran (ii, 256), 'They comprehend not aught of His Knowledge but of what He pleases.' It was so destined by

the command and wisdom of God the All-High that there should be nine spheres, twelve constellations of the Zodiac, seven 'fathers', i.e. planets, four 'mothers', i.e. elements, and three kingdoms of nature (mineral, vegetable and animal). And as an explanation as to motivation or moving power: 'with regard to the elements and kingdoms of nature the (Universal Soul), in the longing which it experiences for the perfection of the position of the First (Intellect) and imitating the latter, which it usually does, keeps the spheres continually moving.'

It is in the sense of finding the perfection of a 'thing' that we might best understand both the pattern and effectiveness of a magic square. Though the archetypal co-operation of pure number with the seven spheres (represented by the planets) special properties were co-related and the inner laws of the symmetry of number displayed.

Here we are concerned primarily with displaying the traditional square forms and some of their multiple inner qualities. Far more significance than is normally realized outside Islam resides in the magical properties of the number patterns lying within the warp and weft of the great carpet tradition — so often in the memories of the womenfolk learnt in songs of praise and transmitted through the beauty of the 'magic' carpets.

Opposite
The 3 × 3 square of Saturn as archetype, showing in tone the symmetry between odd and even numbers. There are eight possible ways of arranging the outer numbers around the central figure 5.

Overleaf
This page demonstrates (top) traditional dot number groupings, or morphic patterns, in the square of Saturn. The group of eight smaller figures (below) describe graphically number sequences, patterns based on the sums of digits, odd and even number patterns, and particularly the method of arranging the numbers in sequence. This is shown in the two central diagrams in the upper row: on the left, the digits from 1 to 9 are placed in three diagonal lines, read from top left to bottom right — this results in five digits within the square (2, 4, 5, 6 and 8), the others being outside it; on the right, the curved arrows demonstrate how the number 7 is placed between 2 and 6, 3 between 4 and 8, 9 between 4 and 2, and 1 between 8 and 6.

1 Ikhwan al-Safa, *Risalat al-Jamirah*, translated by S. H. Nasr, vol. I, Damascus, 1942, p. 9.

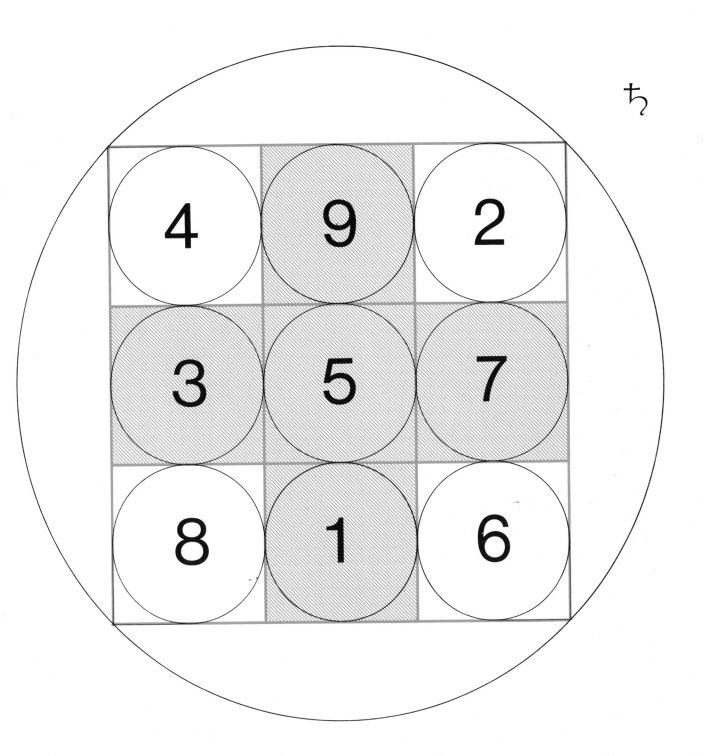

ち

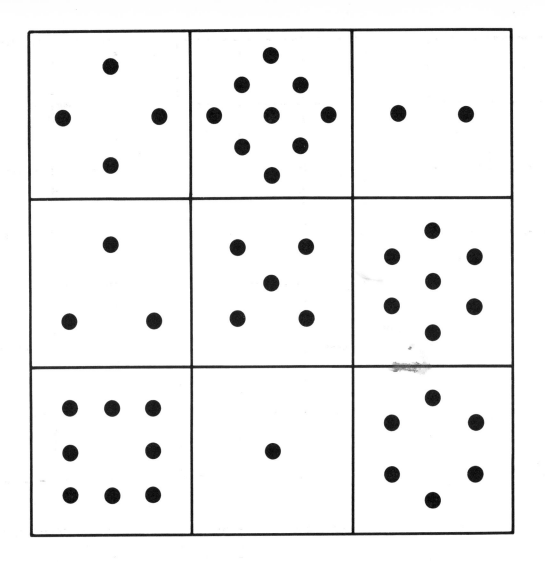

Al-Jabir's alchemical square.

The whole arrangement shows the 3 × 3 grouping of different number patterns. The central pattern was specifically chosen by al-Jabir to demonstrate certain mathematical principles which have a correspondence in the context of natural phenomena. The sum of the digits enclosed by the heavy line is 28, which for al-Jabir symbolized the 28-day lunar cycle, whereas the remaining digits (1 : 3 : 5 : 8) represented ratios between each other and as a sequence which were fundamental to his system of classifying the relationship between certain natural phenomena.[1]

1 See S. H. Nasr, *Science and Civilization in Islam*, Cambridge, Mass., 1968, p. 258.

4	14	15	1
9	7	6	12
5	11	10	8
16	2	3	13

13	21	21	13
21	13	13	21

18		16	
16		18	
16		18	
18		16	

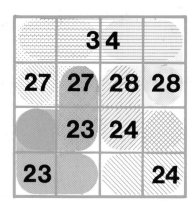

	34		
27	27	28	28
	23	24	
23			24

34		34
34		34

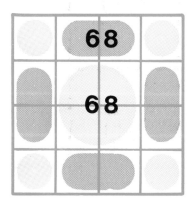

	68	
	68	

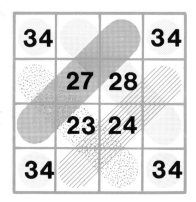

34			34
	27	28	
	23	24	
34			34

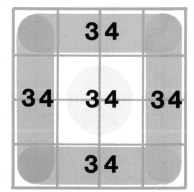

	34	
34	34	34
	34	

♃

The 4 × 4 square representing the archetype of Jupiter. The first drawing (top left) shows the traditional arrangement of numbers. The other drawings in this group show a set of specific arrangements defined as areas (shown in tone), each with its numerical sum; this demonstrates the qualitative value that such number squares held for Islamic philosophers.

11	24	7	20	3
4	12	25	8	16
17	5	13	21	9
10	18	1	14	22
23	6	19	2	15

The 5 × 5 square of the archetype of Mars; toned areas show the symmetry of distribution between odd and even numbers.

Thirty versions of the square of Mars set out in two groups, of ten and twenty respectively. The first group (A–K) indicates sets of four numbers, the sum of each being as follows:

	Contents of squares	Sum
A	17 + 7 + 9 + 19	52
B	25 + 21 + 1 + 5	52
C	12 + 8 + 14 + 18	52
D	11 + 3 + 15 + 23	52
E	16 + 22 + 10 + 4	52
F	6 + 2 + 20 + 24	52

A–F: Symmetric – digit sums 5 + 2 = 7

	Contents of squares	Sum
G	24 + 3 + 15 + 6	48
H	23 + 2 + 20 + 11	56

$$\frac{48 + 56}{2} = 52 -$$ asymmetric

	Contents of squares	Sum
J	4 + 20 + 22 + 6	52
K	2 + 16 + 24 + 10	52

J–K: Symmetric around centre

In each case the sum (52) when added to the numerical value of the centre square (13) gives a total of 65, which is the sum of any single line or diagonal of the square.

The table above indicates an interesting concordance of arithmetical and geometric patterns. The second group (1–20) represents similar symmetrical patterns of three which also demonstrate numerical symmetry:

	Contents of squares	Sum	Sum of digits	
1	11 + 25 + 9	45	9	1 pairs with 4 ;
2	9 + 1 + 23	33	6	2 pairs with 3
3	15 + 1 + 17	33	6	
4	17 + 25 + 3	45	9	
5	11 + 5 + 19	35	8	5 pairs with 8 ;
6	19 + 21 + 3	43	7	
7	7 + 21 + 15	43	7	6 pairs with 7
8	7 + 5 + 23	35	8	
9	24 + 13 + 2	39	3	
10	6 + 13 + 20	39	3	
11	10 + 13 + 16	39	3	
12	4 + 13 + 22	39	3	
13	23 + 13 + 3	39	3	
14	15 + 13 + 11	39	3	3 + 9 = 12 ;
15	7 + 13 + 19	39	3	1 + 2 = 3
16	17 + 13 + 9	39	3	
17	25 + 13 + 1	39	3	
18	5 + 13 + 21	39	3	
19	18 + 13 + 8	39	3	
20	12 + 13 + 14	39	3	

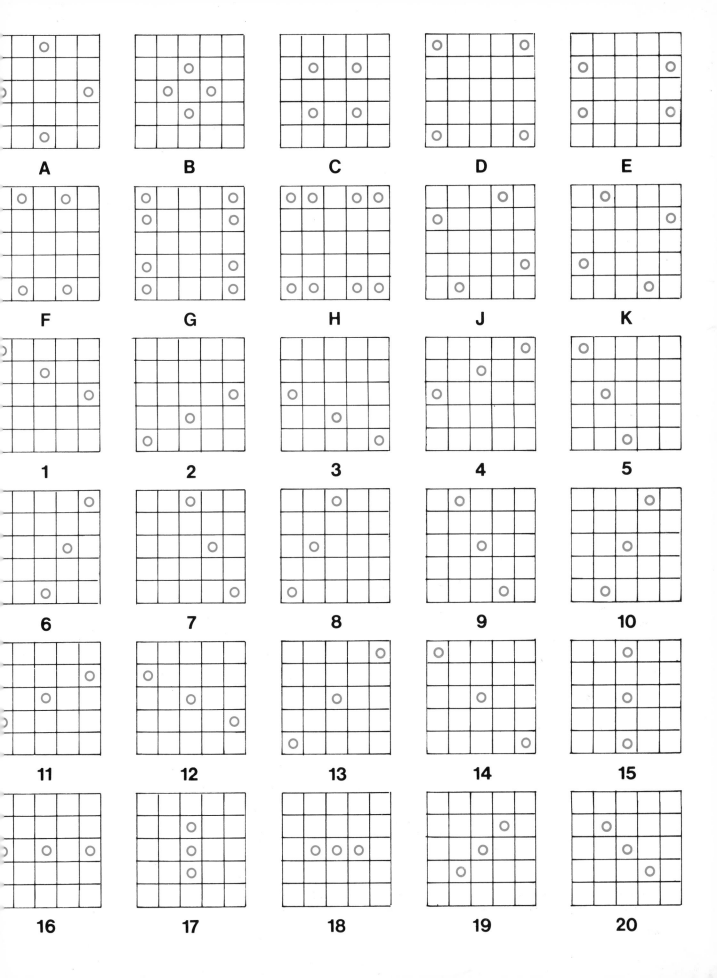

A
B
C
D
E

F
G
H
J
K

1
2
3
4
5

6
7
8
9
10

11
12
13
14
15

16
17
18
19
20

6	32	3	34	35	1
7	11	27	28	8	30
24	14	16	15	23	19
13	20	22	21	17	18
25	29	10	9	26	12
36	5	33	4	2	31

The 6 × 6 square representing the archetype of the Sun. Because of certain calendaric considerations, the asymmetry between odd and even numbers is indicated in tone.

Opposite
Patterns within the archetypal square of the Sun; the first six indicate symmetries of the sums of numbers in groups of four, eight and twelve; the lower six are drawn as enclosures representing further symmetrical 'summing' characteristics.

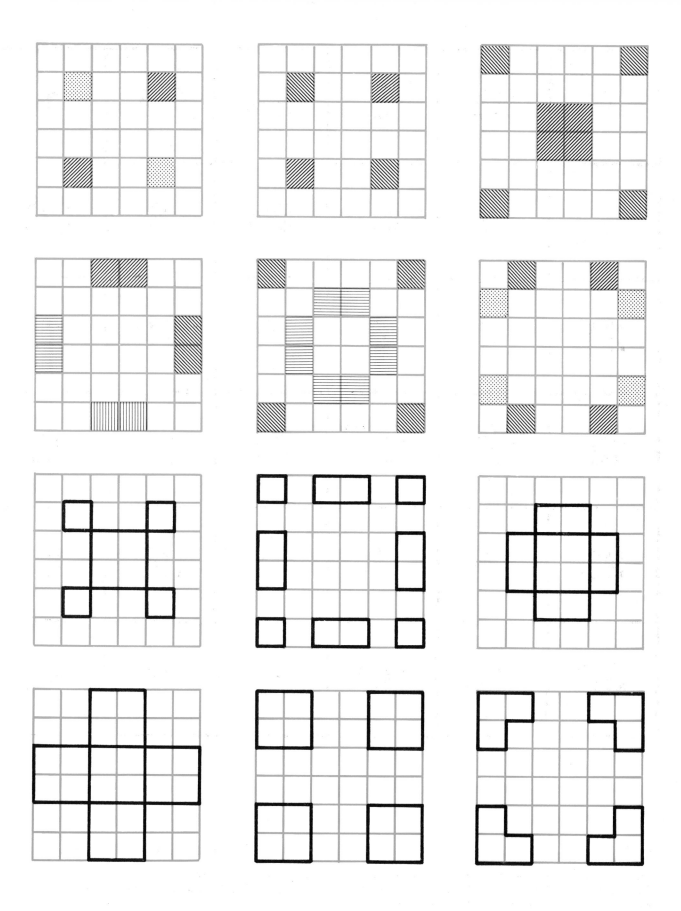

22	47	16	41	10	35	4
5	23	48	17	42	11	29
30	6	24	49	18	36	12
13	31	7	25	43	19	37
38	14	32	1	26	44	20
21	39	8	33	2	27	45
46	15	40	9	34	3	28

The 7 × 7 square of the archetype of Venus. The tone demonstrates the symmetry in the placing of odd and even numbers. This arrangement has as many summing symmetries as the previous example, the square of the Sun.

8	58	59	5	4	62	63	1
49	15	14	52	53	11	10	56
41	23	22	44	45	19	18	48
32	34	35	29	28	38	39	25
40	26	27	37	36	30	31	33
17	47	46	20	21	43	42	24
9	55	54	12	13	51	50	16
64	2	3	61	60	6	7	57

The 8 x 8 square of the archetype of Mercury. The toned areas show the unusual asymmetry between the groupings of odd and even numbers. This square has the same intrinsic integration of arithmetical and geometric patterns.

37	78	29	70	21	62	13	54	5
6	38	79	30	71	22	63	14	46
47	7	39	80	31	72	23	55	15
16	48	8	40	81	32	64	24	56
57	17	49	9	41	73	33	65	25
26	58	18	50	1	42	74	34	66
67	27	59	10	51	2	43	75	35
36	68	19	60	11	52	3	44	76
77	28	69	20	61	12	53	4	45

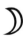

The 9 × 9 square representing the archetype of the Moon. The symmetry between odd and even numbers is shown in tone, and is related in character to that of the squares of Saturn, Mars and Venus. Similarly, the internal properties of this square follow the patterns of the previous examples. This completes the planetary archetypal set.

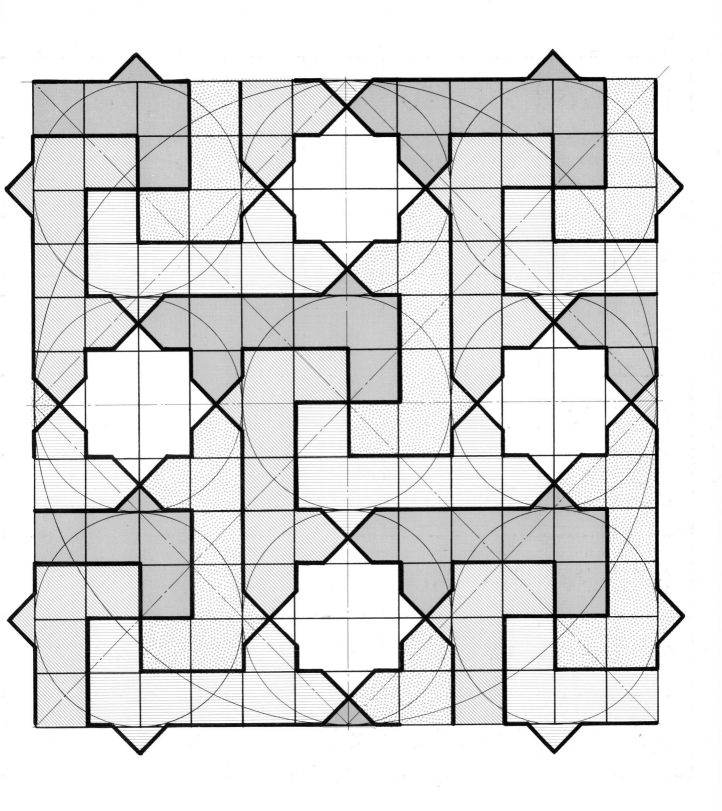

Example of a pattern from the Spanish branch of Islamic art. The square grid-basis is shown in black. The spinning four-fold pattern has been developed in tone with four stabilizing star octagons shown in white. Certain patterns of this sort have as their starting point the arithmetical summing already demonstrated.

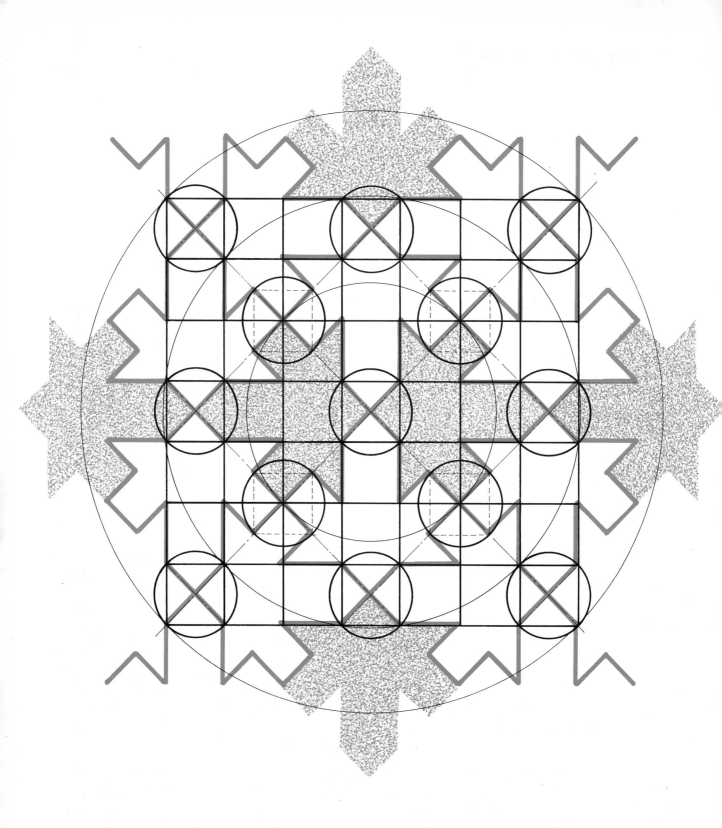

This illustration demonstrates a pattern related (through the right- and left-handed spinning motif) to the previous pattern and originating from the same branch of Islamic art. The underlying square grid-basis is shown in black, together with concentric circles which represent the most accurate control in the constructing of the grid. Once again, the pattern has been inspired by the symmetry — and even the rotational symmetry — of the number patterns of magic squares, thereby linking it and others of its kind to the common archetype.

4 Pattern and Cosmology

This is not only damaging to the nature of revelation, as it prevents access to the ontological dimension, but amounts to blasphemy inasmuch as this word means a 'hurt-doing' or a cutting off from unity. What we will do, however, is to recall the tradition of treating numbers as expressions of archetypes and observe the integral nature of the compact symbols inherent in this diagram. The one centre is surrounded by six intervals, a number of completion relating both to creation and to the traditionally venerated quality of $1 + 2 + 3$ (the divisors) equalling 6. The next peripheral set of intervals are twelve, which were established sequentially by first setting the 90° cross axis on the circle (by the lateral pair of arcs). These two archetypal number qualities are associated with the solar cycle, the four 'turning' points of the year (equinoxes and solstices) and the twelve zodiacal mansions of fixed constellations that the sun passes through in a yearly cycle. Inside the twelve we see a set of seven points — the hexagon and its centre. These are associated with the seven heavens as one of their symbolic forms.

Cosmology

What is cosmology? What is a cosmos? The answer to one is the basis of the answer to the other. A cosmos by definition presupposes an ordered universe. Cosmology is the logic of or study of the laws and intelligence inherent in this ordered universe.

The overriding principle for Islam is the unity of existence and therefore of the universe. This unity has always an inner and an outer aspect — a hidden as well as a manifest aspect. From this it follows that there is an inner as well as an outer way of studying cosmology. The outer embraces sensible observation, the inner is appreciating the expression of cosmological laws within one's own structure. The goal of spiritual disciplines is to unite the inner and outer, the greater and smaller, into an inseparable integrity.

The language of the archetypal laws which unite the inner and the outer cosmos is that of pattern and, in particular, number pattern.

The philosophical perspective of Islam takes the patterns and periodicities of the heavenly revolution to be 'moved' by the same archetypes as the mind of man which appreciates them. It therefore follows that as the Sun and Moon control the biorhythms of our bodies and influence our animistic psychology, so the archetypes control the rhythms of the heavens. By being in harmony with these rhythms, that is by placing oneself at the centre of them — much as the nucleus controls a cell, or the centre of balance which maintains poise — one can master them by being at one with them.

As we have seen, each member of the triad — square, triangle, hexagon — has its own qualities and ramifications, but it must be remembered that they are all, in the regular form we are concerned with, dependent on and sub-qualities of the embracing circle. We return now to the pattern that emerged from the six-fold 'flowering' or expansion of the circle; the stage we called the fourth where the outgoing circles reached the specific relationship to the centre circle which, when the intersections were connected, resulted in a pattern of triangles, squares and a central hexagon (see p. 20). This pattern is a reminder of the archetypal importance of the integration of the three shapes within another, as the expression of unification.

Traditional Islamic cosmology, which has its authoritative roots in the revelation of the Quran, has been developed outwardly with the unfolding of Islamic science and philosophy.[1] The teaching of all three major monotheistic religions confirms that the Creation was accomplished in six days. The subject is too extensive and it is inappropriate here to attempt to enlarge on the meaning of this doctrine. However, it is appropriate to state it is an error of our own times to treat such matters as revelation on an exclusively literal plane.

1 See S. H. Nasr, *An Introduction to Islamic Cosmological Doctrines*, Cambridge, Mass., 1964.

The circle surpasses all other geometric patterns as the symbol of cosmic unity, its inner core or hidden centre becoming the timeless moment of the revolutions of time and the dimensionless point of the encompassing space.

The indication of periods of time and directions in space occurs in pattern form as intervals around the perimeter of this primal circle. For instance, the face of a clock with its twelve hourly divisions exemplifies the measuring of the passage of time with precision, whereas if one should join these same intervals on the clock-face with straight lines one would describe a twelve-sided shape — a dodecagon. Both can be taken as expressions of the archetype twelve, and in cosmology they are united temporally and spatially in one complete annual cycle of our planet; the twelve zodiacal constellations give us both a directional guide and specific periods of time by which to measure the whole year.

The natural divisions of the year, and the rhythms of Sun, Moon and Earth which define it, are a fundamental key to cosmological numbers — although strictly speaking all numbers are cosmological inasmuch as they represent repetitions of unity and are embraced by it.

The year is one cycle, one circle, from mid-winter to mid-winter; from the least daylight sun at the mid-winter solstice to its 'renewal' the day after. The circle is polarized by the summer-winter turning points. This immediately gives rise to the 'fourness' of the year; squared by the two intervals half-way between these major events of longest and shortest nights of the year. The equality of day- and night-length occurs twice, once at the spring equinox and once at the autumn equinox. Thus the 'seasons' are marked by the length of daylight which in turn is determined by the planet's position relative to the sun. Spring, summer, autumn and winter form the square of the year and are symbolically linked with the cardinal points of the compass — East, South, West and North. This clockwise circuit is based on the assumption that one lies on one's back with one's head to the south or stands facing north. I had the good fortune to attend an enlightening lecture on the subject of orientation, given by Professor S. H. Nasr at Tehran University. The esoteric meaning is that the seeker on the path to truth places him- or herself in the correct orientation to the light. By lying on one's back, with one's head to the south, or by standing facing north, one's right hand receives the light at dawn. Next, by turning to face the light (a re-orientation), one's right hand is directed to the south; the right and south connected *yamin* to the Yemen, which esoterically means wisdom, or the return of the exiled soul to its rightful home. Four was also the basis of the cardinal qualities heat, dryness, cold and moistness which embodied the principles of expansion, fixation, contraction and solution,[1] which in turn have their correspondences with the seasons in time and directions in space.

Half-way along the side of any polygon a critical position is reached which represents neither a coming to nor a going from any of the 'corners' of the shape. The point half-way between wet and dry would be moist, and that between hot and cold would be tepid. As each side or segment of the circle has its half-way point, so a new polygon can be defined by doubling the previous intervals half-way between them. Thus, four becomes eight, the octagon; and eight becomes sixteen, the double octave.

Returning to the year, the next most important factor is the triangular relationship between Sun, Earth and Moon. The primal three as archetype represent the minimal conditions for existence, one, the other and the conjunctive; or, put another way, the viewer, viewing, and the viewed; or object, subject and relationship. It has been suggested that the essential spiritual triangle in Islam is Allah, Rahmān and Rahīm, as they occur at the beginning of each *sura* of the Quran.

Three gives rise to six, and six has a vital role in Islamic cosmology as it does in the other two Abrahamic religions, Judaism and Christianity; and that role relates to the number of days in which God created the world. The Abrahamic wisdom insists that we regard the inner and outer meaning of this cosmogony, the symbolic and literal dimensions. The six-pointed star is a symbol of perfection in all three religions.

Six naturally doubles into twelve, which unites the archetypal three with the archetypal four. The profundity of twelve is echoed in the twelve Imams of Shi'a Islam, and in the timeless archetypal sense can be seen expressed in the twelve disciples of Jesus Christ. In geometrical terms the law of twelve is elegantly precise when twelve equal spheres are brought into contact and exactly touch a central enclosed nuclear sphere. Twelve is also the greatest number of evenly distributed points on a single spherical surface which, when connected by lines, result in equilateral triangles. This is known as the icosahedron. In pure geometrical expression this law of distribution of twelve points on a sphere is demonstrable in the following way.

Starting from the centres or point distribution, which are the nodes of the Platonic figure known as the icosahedron (see illustrations, pp. 66–69), if we imagine them expanding to take possession of equal surface area or domain of the sphere they expand until they meet each other at five equally distributed points; if these points were joined the lines would describe a spherical icosidodecahedron (see illustration, p. 71). If these domains or areas kept spreading without infringing the domain of the five neighbouring domains they would each eventually become pentagonal. This is the pentagonal dodecahedron, traditionally related to the universe by Plato in his cosmological treatise, the Timaeus, and embraced into the Islamic philosophical perspective by al-Kindi.[1] S. H. Nasr describes this traditional perspective, quoting from T. Burckhardt's studies of Ibn 'Arabi: 'The basic number of the Zodiac, 12, is a product of 4 and 3. As interpreted traditionally, these numbers symbolize the fourfold polarization of Universal Nature into the active qualities of heat and cold and the passive qualities of moistness and dryness which in their combination form the elements, and the three fundamental tendencies of the Universal Spirit (*al-Rūḥ*), which are (1) the descending movement away from the Principle, (2) horizontal expansion, and (3) ascent back to the Principle. The 12 signs, therefore, contain in their numerical symbolism the totality of the principles which govern the cosmos.'[2] Nasr develops this fundamental relationship between the Zodiac and the two archetypal numbers, 3 and 4: 'Possessing this basic relation with the four fundamental cosmic qualities, the signs are naturally related to all cosmic manifestations which are themselves

1 In his treatise on the Platonic solids; see N. Rescher, *Studies in Arabic Philosophy* (1966), chapter 2.
2 Nasr, op. cit., pp. 152–3; cf. T. Burckhardt, *Clé spirituelle de l'astrologie musulmane d'après Mohyiddin ibn Arabi*, Paris, 1950, pp. 14 ff.

1 Cf. Nasr, op. cit., p. 90.

due to the various combinations of their qualities. Inasmuch as these combinations are limitless, the analogies to be drawn between them and the signs are also without end.'[1] However, he says there is a hierarchy of values to this indefinity of combinations and in relation to terrestrial existence the 'relation of the signs to the cardinal points of the compass is of considerable significance because of the role of "sacred geography" and orientation in sacred rites and the architecture of temples and other structures which are based on the knowledge of the "anatomy of the cosmos"'.[2]

In brief, the 'heaven of the archetypes' stands outside the space of the manifest cosmos; 'Pure Being, which is meta-cosmic, is hidden by the signs while at the same time its polarization is manifested by them. They contain the four qualities of Universal Nature (tabīât al-kull) and the three fundamental tendencies of the Spirit (al-Rūh) and therefore the archetypes, or "ideas", of all the manifestations of Nature which we witness in the world'.[3]

Next in importance in the philosophical perspective of the world is the way in which the Divine Intellect is filtered through the seven spheres of the planetary world. The planets themselves are each to be considered as the physical point which defines a sphere of influence by its orbit, and each of the seven planets represents a concentric sphere between the world (the sub-lunar) and Pure Being beyond the Zodiacal sphere. These spheres . . . 'from the contemplative point of view can be considered as modes of the Intellect in its macrocosmic aspect'.[4]

In the words of al-Biruni they '. . . are the spiritual forces which change the nature of bodies submitted to their influence . . .'[5] The sphere of each planet is to be thought of as forming an intermediate domain belonging at the same time to the corporeal and subtle worlds. 'As intermediaries, the planets "transmit" the fundamental qualities of the Universe from the archetypal world to the earth'.[6]

The number seven, $3 + 4$, is to be considered a product and expression of the same archetypes as those which when multiplied produce the twelve of the Zodiac. Both are symbolically generated by the same forces, one by multiplication and the other by addition, conferring on these mathematical functions symbolic qualities beyond their literal interpretation.

Al-Biruni also gives an exhaustive account of their relationships by correspondence, reflection and analogy in the terrestrial environment: these permeate the human world from agriculture, minerals, spices, plants and animals to the human body, human psychology, architecture and particularly religious and civil institutions.[7] For instance, the '. . . various organs of a plant are distributed to different planets. Thus, the trunk of a tree is appropriated to the Sun; the roots to Saturn, the thorns, twigs, and bark to Mars, the flowers to Venus, the fruit to Jupiter, the leaves to the Moon, and the seeds to Mercury.[8] One must constantly remember that this view has nothing whatsoever to do with finding quaint symbolic analogies with natural phenomena, but rather is concerned with a viewpoint that saw the outer or manifest as a result of the inner intellect which is its divine source. This is clearly put by Nasr: 'As the macrocosmic mani-festation of the Intellect, the planets must of necessity have a bearing upon all terrestrial beings which, like everything else in the cosmos, owe their existence to the Universal Intellect which in Islam is identified with the "light or reality of Muhammad"'.[1]

Seven is also intimately connected with the Moon. The Moon is to be taken as the feminine principle in this per-spective, measuring the heavens in a passive manner, complementing the active, masculine, role of the sun. As the closest planet to the Earth, the Moon acts as final intermediary between all the other heavens and the final terrestial domain in such a way that the lunar mansions synthesize in themselves all the aspects of the Intellect which are manifest in the planetary spheres and the archetypal world of the zodiacal signs.

Seven not only represents the number of planetary spheres but is the quarter division of the lunar cycle of twenty-eight days, and becomes the rhythm of a week, intimately related to the work and rest cycle in all three Abrahamic religions.

Numerically, the mansions of the Moon — the positions in relation to the background of 'fixed stars' — are the twenty-eight nights in which its changing phases can be observed. These are philosophically composed of the numbers $1 + 2 + 3 + 4 + 5 + 6 + 7$, equalling 28, which is the sum of the planets numerically and in qualitative terms of the modifying action that each has on the effusion of the light of Divine Intellect. Equally importantly, the lunar mansions are the macrocosmic counterpart of the twenty-eight letters of the Arabic alphabet from which the language of the Divine Word can be articulated as an expression of the Divine Breath (nafas-al-rahmān) itself.[2] It is in this way that all events are written in the Book, the cosmos being the macrocosmic writing of the Sacred Book as the Quran manifests this Divine Revelation to the human world. 'The significance of the lunar mansions in Islamic astrology is fundamental, particularly as it is related to the science of Divine Names in certain aspects of Sufism'.[3]

By the principle of doubling, seven becomes fourteen, a fortnight or half a month. From an esoteric viewpoint, according to Shi-ism, the Prophet is the source of light, a light which is transmitted through the Imams as the 'Muham-madan Light' (al-nūr al-muhammadīyah); it was transmitted through his daughter Fatimah (as mother of the Imams), through 'Ali her husband, and so to the twelve Imams. Shi-ism thus describes the importance of light by naming this line 'the fourteen pure ones'.

Fourteen by doubling, an allusion in one sense to the double nature of all phenomena, the inner and outer expression, becomes twenty-eight, the full lunar cycle.

Nine is another number with an esoteric significance extending far beyond the scope of this book. Returning to the primal 'threeness' of the descending, expanding and ascending aspects of the light of Divinity upon which all manifestation depends, the equilateral triangle most aptly expresses this subtle symmetry. The triangle itself is the outward manifestation and crystallization of the three-fold

1 Nasr, op. cit., pp. 155–6.
2 Nasr, op. cit., p. 156.
3 Ibid., p. 159.
4 Ibid.: cf. Burckhardt, op. cit., p. 25.
5 Elements of Astrology, translated by R. Ramsay Wright, London, 1934, p. 231.
6 Nasr, op. cit., p. 159.
7 Elements of Astrology, pp. 240–55.
8 Elements of Astrology, p. 236.

1 Nasr, op. cit., p. 160: al-nūr al-muhammadīyah or al-haqiqat al-muham-madīyah.
2 Nasr, op. cit., p. 162.
3 Ibid.

symmetry itself. It is to be constantly recalled that the spatial controlling factor of Islamic geometric pattern is symmetry — which is represented in itself by the most fundamental numerical set that a given pattern can be equally folded into. By the same analogy, symmetry can be viewed as reflections of unity.

Three by doubling, or in geometrical terms by the triangle inverting and being overlayed on itself, becomes six or the hexagram or six-pointed star. Six, as noted above, is archetypally expressed in the days of Creation in both Quran and Bible, the centre or seventh position relating to both 'rest' and the 'throne'. The symbolism of this figure from an Islamic point of view has been extensively dealt with by Abu Bakr Siraj ed-Din in the 'Book of Certainty', published in 1952.

Three multiplied by itself becomes nine, as if each original aspect or corner of the triangle reflected the other two in itself. Reflection or symmetry, as noted above, is one way of appreciating the mystery of multiplicity in relation to unity. In one sense numbers can be said to be reflections of unity affected in space through symmetry; retaining their unity at the centre of symmetry yet 'flowering' into multiplicity along the radii of symmetry.

Nine has a special relation to the 'Heavens' and their generating intellects according to Ibn Sīnā (Avicenna), the great philosopher and physician.[1] This is expressed in an interestingly symmetrical table.

Number of Heavens	Name of Heaven	Number of Generating Intellect
9	Heaven of Heavens (falak al-aflak)	1
8	Heaven of Signs of Zodiac (falak al-Buruj)	2
7	Saturn	3
6	Jupiter	4
5	Mars	5
4	Sun	6
3	Venus	7
2	Mercury	8
1	Moon	9

This generation of the created universe is seen by Ibn Sīnā as capable of being described in terms of powers and functions.

The First Intellect, highest of all beings, has but one power (qudrah), that of knowledge which is received from the command (amr) of the Divine Truth (ḥaqq). Next the Soul which is closest to it, possesses not only the power of knowledge which it receives from the Intellect, but also that of desire or love (shawqīyah), again coming directly from the Divine Command. From Soul in turn emerge the Universal Nature and the Universal Element into being. Universal Nature is to be taken as that force which moves the Element towards the perfection which is possible for it.

As the third principle in the hierarchy of Being, after the Intellect and the Soul, Nature has three powers:
(1) of putting into motion (quwwat al-taḥrik) which comes from the world of Divine Command;
(2) of guidance (quwwat al-hidāyah) from the world of the Intellect;
(3) of inclining toward movement (quwwah al-mail ila'l-taḥrik) from the world of the Soul.

Here we see the principle of nine by symmetrical reflection. S. H. Nasr, in his commentary on the philosophical system of Ibn Sīnā, proceeds to explain: '. . . the first Element ('unṣur) was in principia the point which, acted upon by Nature was extended to a line, plane, and finally a three-dimensional body (jism).'[1] Here we find once again the pre-eminence of geometry in the manifestation of the corporeal world from Universal Nature, Soul and the first Intellect. It is here also that we can appreciate the profoundly esoteric way in which apparently 'decorative' adornment of buildings in the form of geometric patterns reveals in the guise of symmetry the very laws of possibility in the manifest realm. Both the contemplation of and the creative skill in making these patterns lead in their own way to an understanding of the perfections of Universal Nature as it moves the elements, being itself commanded through the affections of Soul by Divine Truth which has its unitary channel in the first Intellect. Thus Islamic pattern, unique as an art form, is also unitary in its aim and function.

We now redraw the basic propositions within a qualitative and cosmological perspective. Each shape is representative of and in its own realm embodies the same archetypal principles as the cosmos and our consciousness that reads them both.

The unfolding of the geometric laws in the realm of mathematics has a quality corresponding to the unfolding of both consciousness and creation itself. With the centrality of the one source and the primacy of the archetypes of three, four, seven and twelve, we will recreate the basic patterns.

From this planar beginning the illusive relationship between the second and third dimensions will be demonstrated, and the three-dimensional forms will be compared with the ancient Pythagorean symbolism (transmitted by Plato and, in the Islamic interpretation, by al-Kindi), leading to a comparison with the sixteenth-century model of the universe by Johann Kepler. The last two illustrations in this chapter return to the second dimension and propose a link between a perennial pattern and the archetypal cosmic numbers.

1 Born near Bukhara in 370 A.H./A.D. 980.

1 Nasr, op. cit., p. 205.

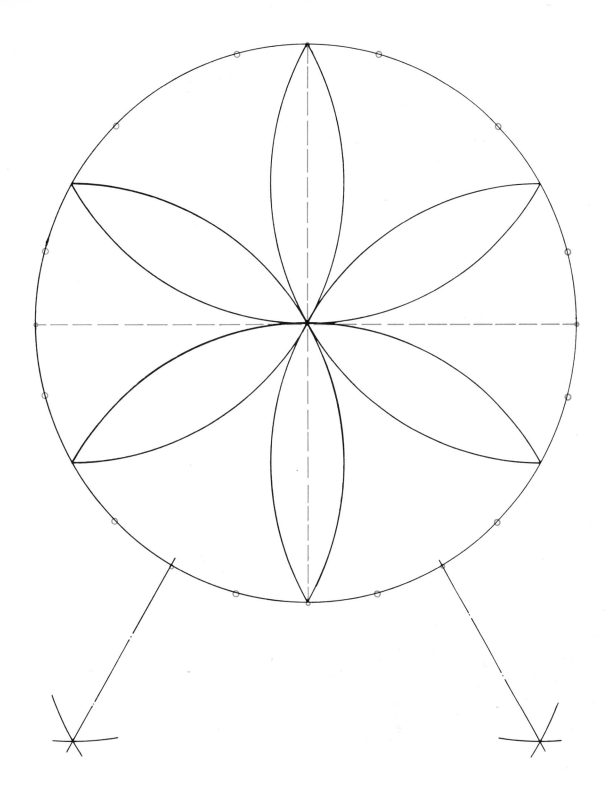

Four, six and twelve set the scene

The primary circle is here shown with its natural six-fold division. If we take the bottom point of the circle and, without changing the radius, cut off with compasses two arcs (below, right and left), we can then move the compass point in turn to the adjacent petals of the six-fold division so as to cut off arcs which intersect the first pair; the two points of intersection enable us to halve the six-fold division, thus giving twelve equal parts. This twelve-fold division is shown in colour as rings on either side of the six petals. If we take the circle as a cosmological image, the twelve-fold division corresponds to zodiacal archetypes and, hence, to an annual cycle; the upright cross (in colour) will then represent the solar equinoxes and solstices. The natural six-fold division can be taken as a symbol of the six days of the Creation expressed in geometric terms.

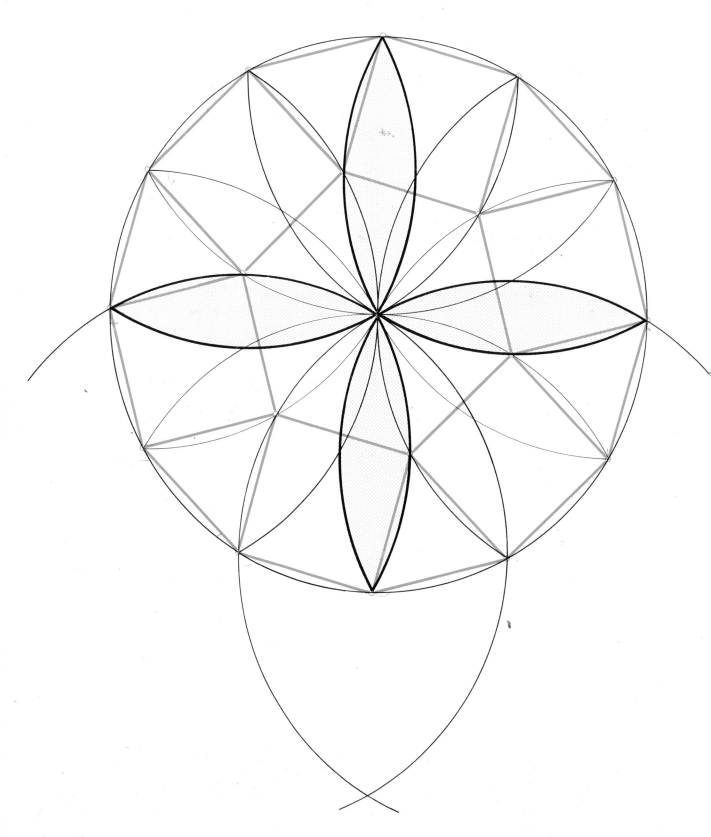

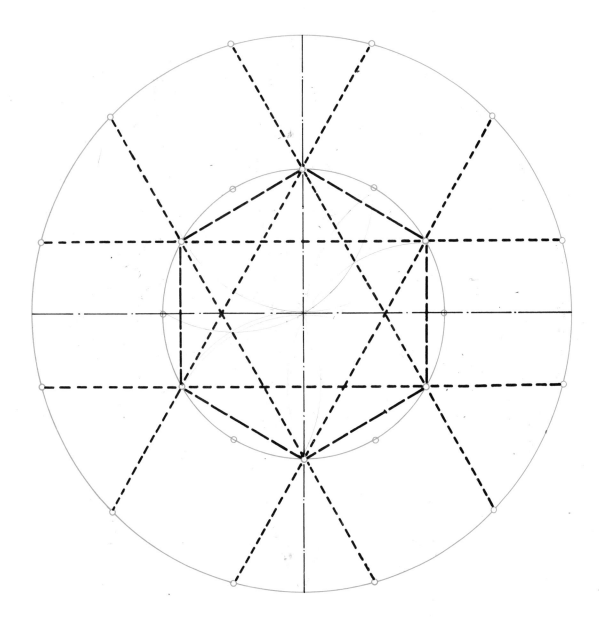

Left
Twelve is here expressed in petal form within the circle, with four shown in tone; the integration of square, triangle and hexagon is shown (in colour) to be controlled by the intersections of the twelve petals.

Three sets of parallel broken lines, which link the opposite squares seen in colour on the previous page, set up a hexagonal star in the centre. The circle enclosing the hexagon sets up a reflection of the whole, and therefore a twelve-fold division (shown as rigid points) is shown around its circumference.

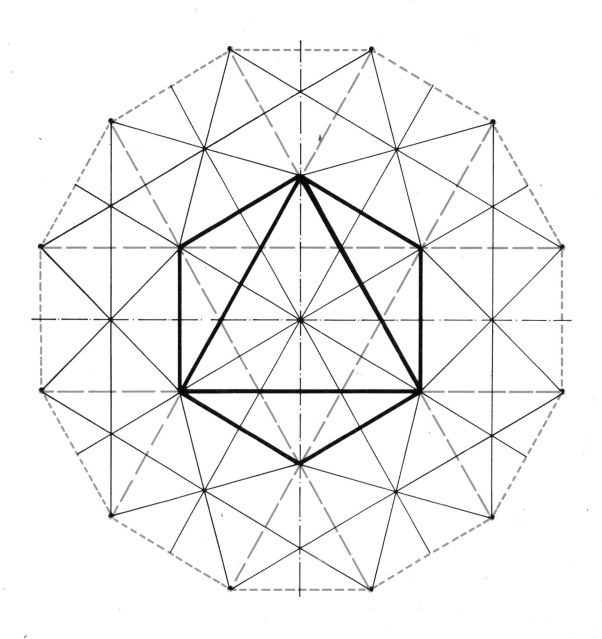

The previous drawing is shown here complete in broken coloured line, with the axes of symmetry of each component shape shown in black. The outline of the hexagon is intensified, and with its inner triangle (apex uppermost). From the flat, two-dimensional diagram the heavy line enables one to see the central shape as a three-dimensional form, the centre heavy triangle being the uppermost face of the Platonic figure known as the octahedron, i.e. a solid form enclosed by eight equilateral triangles (four of them are visible in this drawing, the hidden four are shown in broken coloured line). This projection of three-dimensional space from a two-dimensional pattern illustrates the Islamic philosophical doctrine of emanation where manifestation is asserted through the dimension. 'Our' world is at the gross end of the scale of emanation and exists in three-dimensional co-ordinates. The two-dimensional plane is used as a convention to symbolize the more subtle levels of emanation and indicate the direction of the source of manifestation.

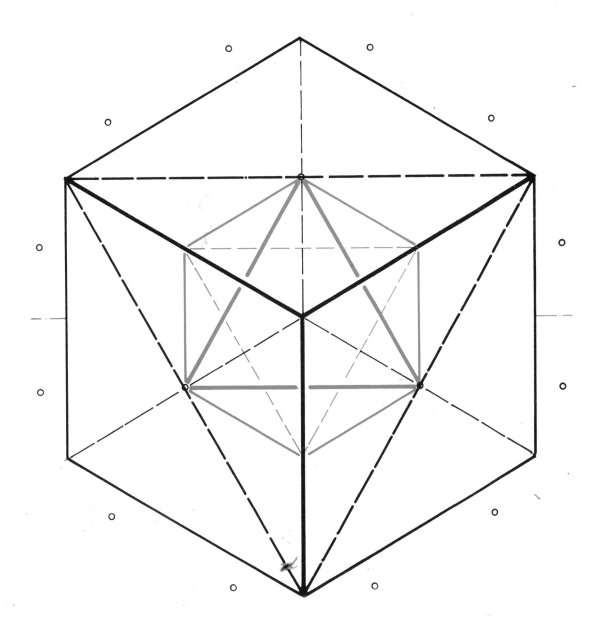

This drawing represents the cube as it would exactly 'dual' the octahedron that grew out of the previous illustration (shown here in colour). For one figure to dual another means that the points of one become the centre faces of the other, therefore the diagonals of the visible faces of the cube are shown in heavy broken line; these also represent the edges of the prime Platonic figure, the tetrahedron. As this is an orthogonal projection of the cube, the hexagonal outline corresponds at its points with the six petals within the circle. Around the cube the rigid points show the twelve-fold division of the circle.

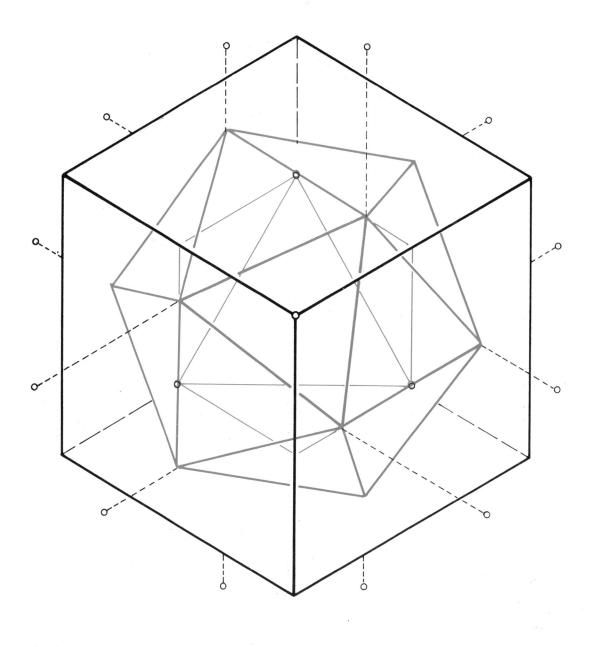

In this illustration the outline of the cube has been retained and certain lengths of the three sets of parallel lines (similar to those but in this case based on a parallel upright) have been drawn in such a way as to exist in three-dimensional space and terminate on contacting the cube's faces. We have therefore placed these parallel lines into x, y, z co-ordinates to each other. Having established the points on the faces of the cube (two per face), we have drawn in solid coloured line the most direct connections between these points. The figure thus outlined represents the Platonic figure known as the icosahedron, with six of its edges lying in the six faces of the centre. The centres of the three visible edges are rigid in black; these are also the points of our nuclear octahedron.

(This drawing is an exercise in visual symbolism and as such lacks no precision, but in strictly mathematical terms, as an orthogonal projection, numerical precision would necessitate certain dimensions being almost imperceptibly larger.)

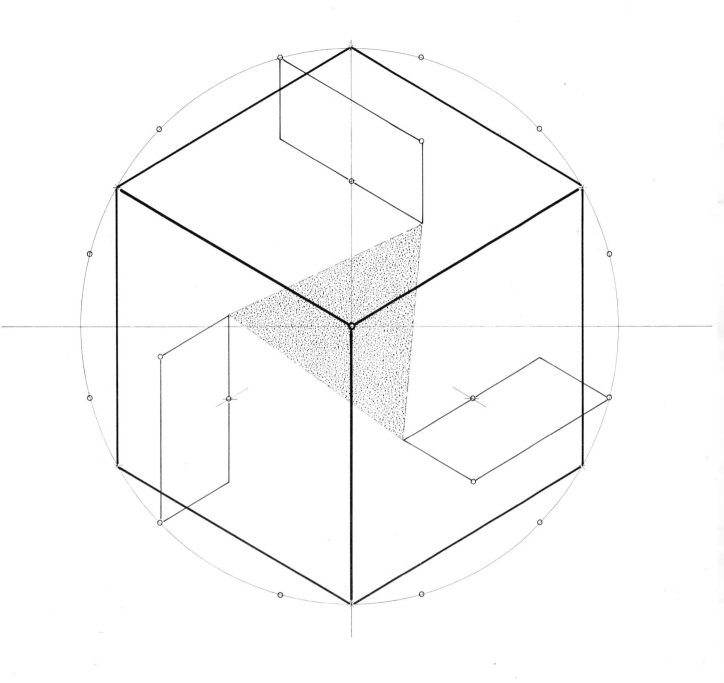

Again the outline of the cube is shown with, in tone, the triangular front face of the icosahedron seen in the previous drawing. From each centre face of the cube similar rectangles are shown projected; in each size the limit of the projection is controlled by the original bounding circle at one point of the rigid twelve-fold division.

These rectangles have as their longest axis the icosahedron edge and their height in proportion makes a double square. Therefore we can now consider the outermost edges of these rectangles in three-dimensional space, demonstrated in the next illustration. The vertical and horizontal cross axis provides an equal division of the twelve-fold division, creating a twenty-four-fold division of the circle.

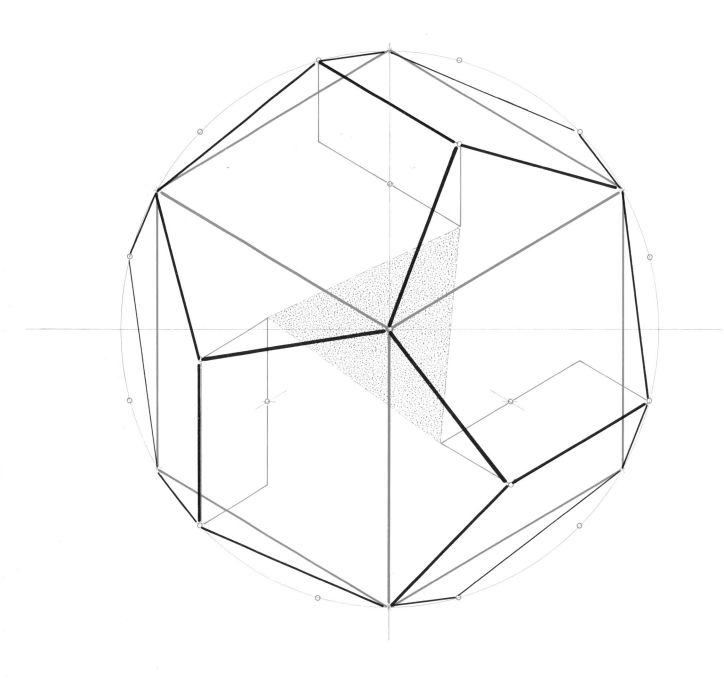

The heavy black line here represents direct relationships
between the points of the extended rectangles and the
corners of the cube, thereby creating the image of the
pentagonal faces of the regular dodecahedron. This com-
pletes the full set of regular convex polyhedra.

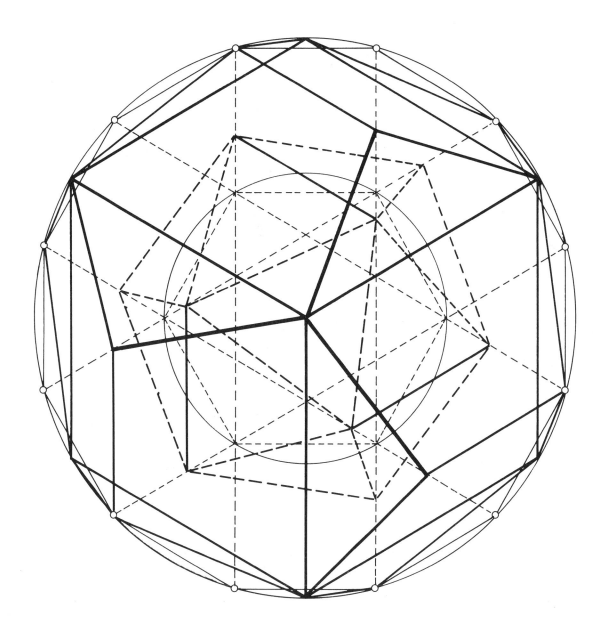

The significant constructional lines, the outer dodecahedron
and the significant edges of the icosahedron are shown
differentiated. Of the two circles in this drawing, the outer-
most with its rigid points can be taken to symbolize the
circumsphere of the dodecahedron, whereas the inner circle
becomes the circumsphere of the octahedron and thereby
the intersphere[1] of the icosahedron.

1 The intersphere of a regular polyhedron is the sphere which lies inside,
and whose outer boundaries are determined by (or touch) the centres of
each edge. See K. Critchlow, *Order in Space*, London and New York, 1969,
p. 95.

'Again, from whence shall we say this name of mathematics and mathematical disciplines was assigned by the ancients, and what apt reason can we render of its position? Indeed, it appears to me, that such an appellation of a science which respects cognitive reasons, was not, like most names, invented by indifferent persons, but (as the truth of the case is, and according to report) by the Pythagoreans alone. And this, when they perceived that whatever is called mathesis is nothing more than reminiscence. . . .'[1]

Comparative cosmologies which link the Platonic solids, their inherent spheres and the orbits of the visible planets of the solar system.

The drawing on the left is a schematic representation of Kepler's discovery that the planetary 'spheres', i.e. the overall volume contained by the orbit of any given planet around the sun, correspond — to a remarkable degree — to a sequence of spheres inherent in the Platonic figures. The largest sphere (bottom) in which a cube is drawn symbolizes the planetary sphere of Saturn, the size of the second sphere is governed in its proportion by inscribing the cube within the larger sphere. This cube in turn contains the smaller sphere in such a way that it exactly touches the centres of the faces of the cube (the cube's insphere). This smaller sphere represents a correspondence to the orbit of Jupiter, which has been extended upwards in broken lines, and the tetrahedron has been drawn with its points lying within the sphere. The insphere of this tetrahedron corresponds to the orbit of Mars which proceeds in the same way through the orbit of the Earth, Venus and Mercury. The only difference lies in the relationship between the orbit of Mercury and the octahedron within the orbit of Venus, as Mercury's sphere corresponds to the octahedron's intersphere (cf. note on preceding page) and not the insphere as with all the others.

In the top centre is a woodcut from Kepler's *Harmonica Mundi*, published in 1621. This shows concentric drawing of the facts outlined above.

Immediately below we show the reconciliation pattern of the five Platonic solids, based on the spherical icosahedron division.[2]

Above right are shown the regular solids in the Keplerian sequence, starting at the top with the octahedron (which Plato also used to symbolize the element air); below this, the icosahedron (with the Platonic symbolism of water); next the pentagonal dodecahedron (symbolizing ether); next the tetrahedron (symbolizing fire); and, finally, the cube, as a symbol for earth.

The father of Islamic science, al-Kindi, also wrote on the regular solids and put forward the same symbolic correspondence, ascribing it to the wisdom of the ancients. He also indicated, well before the time of Kepler, the concept of concentricity — the elements enveloping each other in sequence on a macrocosmic scale.

Following along the bottom of the page are the three fundamental face shapes of the Platonic figures — triangle, square and pentagon. These have been subdivided into their characteristic symmetries in alternate toned areas which are also a key to their spherical interpretation in the drawing immediately above. This diagram demonstrates the paths of symmetry (in broken lines of different thickness; these lines are also all equal in length); these demonstrate the unification of all the various circumspheres into one pattern.

'Man has been called the "Heart of the World" because the heart is in the middle and has knowledge of all the parts while the parts know nothing about the state of the heart.'[3]

In the Islamic perspective the Divine Principle is appreciated as being veiled or hidden behind successive 'envelopes', the first of which is matter; in reality, however, the Divine Principle envelops everything — as it is the whole.

If we enumerate these five Presences (or 'universal degrees', as they are called in Sufism),[4] we have first the human domain — *Nāsūt* — which is also the corporeal world of matter, followed by the 'domain of Royalty' — *Malakūt* — so named because it immediately dominates the human domain. After this comes the domain of power — *Jabarūt* — macrocosmically Heaven and microcosmically human intellect, described by F. Schuon as 'this supernaturally natural Paradise which we carry within us'. The fourth degree is known as the 'domain of the Divine' — *Lāhūt* — pure Being and uncreated Intellect, the Logos. The final or fifth presence or degree (if it is possible to use such a term provisionally) is the one infinite Self — *Huwa* ('He' from *Hāhūt*) — known variously as 'Aseity', 'Ipseity' or 'Quiddity'.

Another set of terms which can be applied to these degrees are: (1) the corporeal or sensorial; (2) the subtle or animistic; (3) the formless or supra-formal angelic or paradisiac; (4) Being, self-determined and extrinsic, qualified; (5) Non Being or Beyond Being, non-qualified, non-determined intrinsic Pure Absolute.

Again, in another perspective, the Quranic premises of the doctrine are as follows.

The prime or first 'Presence' is the absolute unity of God — *Allāhu ahad*; the second is God as Creator, Revealer and Saviour, the divine qualities; the third is the 'Throne' — *'Arsh* — supra-formal manifestation, identified as the world in its entirety; the fourth is the 'Footstool' — *Kursi* — on which the feet of God rest (this is animistic Manifestation, Rigour and Mercy); the fifth, most distant, 'Presence' is the earth — *ard* — and the human realm — *Nāsūt*.

These five Divine Presences should be borne in mind whenever the pentagon or five-fold symmetry is referred to in this book as it is the intrinsic underlying symbolism. See especially Chapter 5.

1 *The Commentaries of Proclus on the First Book of Euclid*, translated by Thomas Taylor, London, 1792.
2 See K. Critchlow, *Order in Space*, London and New York, 1969, p. 94.
3 Nasafi, *Kashf* 310b–311a, 10; as quoted in Fritz Meyer, 'Nature in the Monism of Islam' in *Spirit and Nature*, Eranos Yearbooks I, Bollingen Series XXX, Princeton, N.J., 2nd printing, 1972.

4 The subject of the five Divine Presences is authoritatively dealt with by F. Schuon in *Dimensions of Islam*, London, 1969; in his book he devotes a whole chapter to the subject, and I have taken this as my guide.

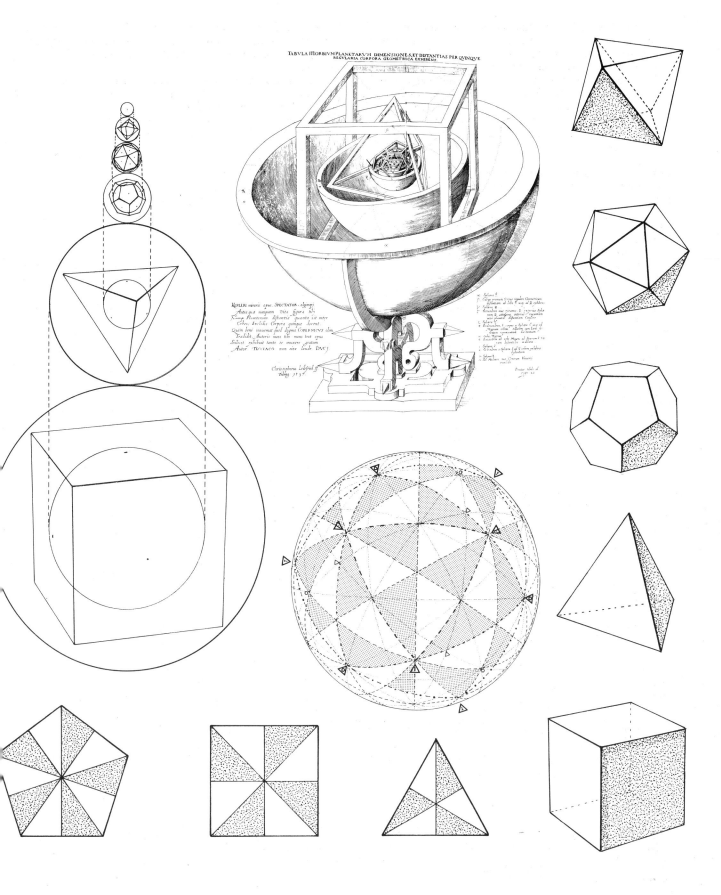

This spinning motif within a square is possibly one of the most frequently recurring patterns throughout Islamic art. It has been used as a flat inlay, timber latticework or panelling, and even as a metal grille. It has the particular quality of combining four symmetrical kite shapes around a central square. This particular form of symmetry is only possible when the diagonals of the central square when extended intersect the bounding square in the following manner. A twelve-sided polygon can be drawn in any given square such that four of its sides which are at right angles to each other lie in the edges of the bounding square. The diagonals of this dodecagon coincide uniquely with those of the central square of our pattern motif.

This coincidence of the twelve and four suggests a zodiacal symbolism controlling or embracing the four axial kite shapes which can be taken to symbolize the four seasons, the four elements and the four qualities of heat and cold, moist and dry; the central sphere symbolizes the quintessence as a reflection of the bounding square.

In this illustration we suggest ways in which bricks would be cut to interlock structurally and create the same archetypal pattern in their own terms. The spaces left between the bricks becoming either ceramic infill or pierced latticework.

5 The Pentagon

'Reality affirms itself by degrees but without ceasing to be "one".'
Frithjof Schuon[1]

The human body — a multiplicity of cells, organs and simultaneous functions — is nevertheless clearly recognizable as an integrity and a whole. The very concept of 'health' is based on such a fundamental wholeness and co-ordinated activity. In the same way, each person is recognizable as an individual, and the word individual signifies a whole which cannot be divided without loss of meaning.

A thoughtful and considered view of the range of phenomena presented to our sensibilities will give rise to the recognition of many such thresholds of completion, or we might rather say semi-completion in the light of their relationship to other 'wholes' as well as the sum totality within which they exist as a part, be it a leaf, a tree, a forest, the world of vegetation, the planet, and so on.

Geometry is a language ideally suited to the expression of this fundamental principle and to the experiencing of parts and a whole. It is in symmetry — the principle of repeating by reflection — that this can be shown most clearly. If a single element of any description or shape is reflected between two mirrored surfaces set at significant angles, that element will take on an entire new set of values in the patterns of the reflection. This has been exploited in many ways in different kinds of kaleidoscope. The other aspect of the study of symmetry is to take the pure products of the significant angles of repetition, e.g. 60°, 30° or 36°, and enquire into the nature of the fundamental planar components. This latter study is the implied technique of the Platonic method as described in the Timaeus dialogue. We find that there are fundamental triangles (triads) of great significance to the Greek and associated Pythagorean schools; these triads, by repetition, govern the laws of order in the second dimension and the third dimension (known as 'solid' geometry; cf. p. 70, in relation to Kepler and al-Kindi). The deeper meaning of reflection as a psychological counterpart to the more obvious way in which a physical object is reflected in, say, a mirror or a still lake, was used extensively by the poets, philosophers and sages of Islam. Symmetry, or the series of ways in which a single motif can be repeated an exact number of times within a circle, is the most fundamental manifest aspect of Islamic geometric art.

1 Frithjof Schuon, *The Transcendental Unity of Religions*, p. 53.

This first page of illustrations is divided for convenience into four vertical and six horizontal divisions; symmetry is demonstrated at its inception in the plane, as three-fold, and proceeds step by step to the five-fold, in different forms.

Starting at the top row, the first image is of a large 'parent' circle within which three other circles of exactly half its radius are inscribed in such a way as to be symmetrical to each other; or put another way, they are distributed within the parent circle in such a way as to have their centres at the furthest possible distance from each other, while still contained within the parent circle. The pattern formed is brought out by the inner three broken lines which link the points of contact of each smaller circle to the larger one and pass through the overlap points of each of the smaller circles with each other. It will be seen that this inner equilateral triangle, in broken line, is intersected exactly half-way along each edge by the three overlap points of the circles. These three inner circles by their symmetry express 'threeness' in three different ways: by their contact with the parent circle, by their own centres and by their overlap points.

The next image is an equilateral triangle in tone, demonstrating that three symmetrically distributed points have a relationship — the connecting lines — which produces an equilateral triangle.

The following image draws attention to the centre point; any regular polygon has as its 'invisible' controlling point a centre. The broken lines drawn from this centre to the outer three points outline the three axes of symmetry of the equilateral triangle. By including the centre point, 4, this polygon (and likewise every other one) can be seen to contain inherently within itself the number next higher than the sum of its points.

The last image in the top line demonstrates the inner reflections of the equilateral triangle within itself. Each smaller centre triangle is in area one fourth of the larger in which it is placed, being generated from the centre-edges of the larger. This pattern gives both an arithmetic and harmonic diminution series, and is fundamental to the principle of relating the larger to the smaller in controlled proportion. Harmonically the proportion is $1 : \sqrt{3}$.

The next row down from the top begins with the same principle as the image above it, but this time with four inner circles demonstrating the same phenomenon of symmetry — here a square (in broken line) is intersected at the half-way points of each side.

The next image is the square in tone as made up from four equally distributed points around the centre point — the fifth element — contained within the square. Finally, the diminishing squares: in this case the area of each smaller square is exactly $\frac{1}{2}$, or arithmetically in the ratio of $1 : 2$, whereas the edge-lengths of each successive smaller square are in the harmonic ratio of $1 : \sqrt{2}$.

In the third row we see the five-fold symmetry displayed in a similar manner to the three and four above it. A new element arises with the pentagonal symmetry; this is the emergence of the star or star polygon. This time, by joining the points of contact between the five smaller (half-radius) circles and the parent circle, the broken line produces a pentagonal star. This star is also contained within a regular pentagon (also shown in broken line). The interesting result is that in this case the circles have two overlap points and both these sets of five overlap points cross exactly on one or other of the half-way points of the sides of the star or those of the outer pentagon. Another 'new' factor is that the cross-over points of the star lie exactly at the centre of the overlap area between two adjacent circles.

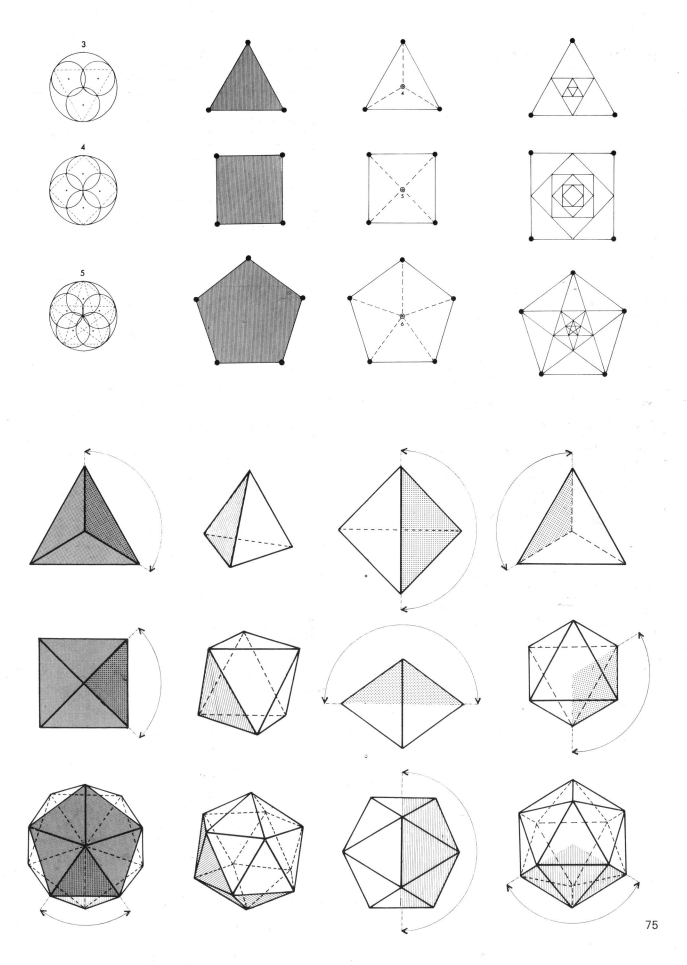

The lateral sequence follows the pattern of those above it. The regular pentagon in tone is followed by the pentagon with its controlling centre point, and after this the harmonic diminution of star pentagons within star pentagons. This last pattern draws attention to the harmonic series or proportion known as the golden mean $(1 : \frac{\sqrt{5}+1}{2}$ or $1 : 1\cdot618)$, about which whole books have been written.[1] Not only does this proportion or its arithmetical counterpart express itself in the orderly unfolding of the world of plants, but it also occurs in the generation ratios of the breeding of animals and insects. It is even found in the proportion of light rays which are reflected from two sheets of glass in contact, i.e. in the light transmitted, light absorbed and part reflected — the number of emergent rays will be in the Fibonacci series. This is a series of whole numbers each of which forms an arithmetical progression, in the approximate proportion $1 : 1\cdot618$. For example: 1, 1, 2, 3, 5, 8, 13, 21, 34, 55, 89, 144 etc.; where 3/5 is an approximation, so 13/21 is a better approximation, and 89/144 still closer to the ratio $1 : 1\cdot618$, and so on.[2]

In the next line we begin with 'three-ness' once again, but this time expressing symmetry in three dimensions — the tetrahedron or prime 'Platonic' solid. The lateral sequence of images shows next a perspective view of the tetrahedron with its characteristic four points, four faces, and six edges — this prime solid is the most elementary expression of three dimensions. Following this is a view looking directly at one edge — the result is seen as an exact square with one diagonal in full line — the edge nearest the eye — and the other (in broken line) representing the edge below. This is known as the two-fold symmetry of the tetrahedron. Next we see a triangular face with the apex of the figure below and the hidden three edges in broken line; this once again demonstrates the three-fold axis of symmetry. The tetrahedron is therefore said to have a 2, 3, 3 symmetry; in other words, if we view it with the point toward our eye it is the same in three directions; if we view it edge towards our eye it is the same in two directions, and if we view it face-on it is again similar in three directions. These directions are its planes or axes of reflection or symmetry. So the prime solid, the tetrahedron, exemplifies two and three as its archetypes of symmetry.

The next row begins with the octrahedron or second regular solid (also called 'Platonic'). It is seen first with its point toward the viewer's eye and appears as four-fold, or square; the next image is a perspective of the octahedron showing its characteristic eight triangular faces, twelve edges and six points or nodes. Next is the edge-on view which demonstrates the two-fold axis of symmetry, and this is followed by the face-on view which demonstrates the three-fold axis of symmetry. This latter view also shows the six-pointed star 'hidden' within the figure and the hexagonal profile. This figure exemplifies the archetypes of 2, 3, and 4 in three-dimensional form.

The bottom line begins with the five-fold axis of the solid known as the icosahedron, or third 'Platonic' figure. This is followed laterally by the image of the solid in perspective; followed by the edge-on view of the figure showing its two-fold axis, and after this the face-on view shows the three-fold axis with a hexagon profile similar to that of the previous octahedron. This set of three regular figures made up from equilateral triangles completes the possible symmetries in three-dimensional space although there are two other regular figures: the cube and the dodecahedron, these having the same symmetry as the octahedron and the icosahedron respectively.

This final representative of three-dimensional regularity of symmetry — the icosahedron — represents the archetypes of 2, 3 and 5. In the symbolic values of both al-Kindi and Plato this latter figure is associated with water. The Quranic phrase, 'we made from water every living thing . . .' (xxi, 30), links the pentagonal symmetry with its biological logarithmic growth spiral associations through the traditional symbolism of the icosahedron.

In drawing A, at the top of the page opposite, the method of inscribing a pentagon within a double arc or 'vesica' (cf. p. 168) is demonstrated: the two overlapping circles symbolize the two 'worlds'. The height (*ab*) and the breadth (*cd*) are used to establish the edge-length of the pentagon.

First we take the distance *c–d* and mark upwards from *o* to *e*, the highest point in the illustration. From the point *e* a line is drawn to one of the arc centres, *d*. Returning to the first upright length *oe* we divide it in half and by placing our compass on the topmost point, *e*, we then draw an arc to cut the diagonal *de* (at *f*); we then place the compass point on *d* and by opening the compasses a little more and, taking as radius the distance *d–f*, draw an arc down to cut the centre axis at *g*. This gives the length of the side of the inscribed pentagon and (by making a series of arcs) all the other sides of the pentagon.

Drawing B is the star pentagon demonstrating at its most elemental the five-fold division of a circle and the internal five-pointed star — within which is a pentagon in tone.

Drawing C represents the way in which two of the 'arms' of this five-pointed star can be swung out from point *x* and *y* respectively to an upright position to describe a 'golden mean' rectangle.

Drawing D represents the five axes of symmetry as they pass through both the pentagon and the star pentagon.

Drawing E demonstrates the particular 'hexagon' that arises from assembling five upright and five inverted triangles from the five-pointed star. Three central axes have been added; the central horizontal axis has reflected above and below an upright and an inverted pentagon.

Drawing F is a demonstration of the genesis of some of the most important shapes that enable the five-fold symmetry to harmonize with the necessary repeats of a two-dimensional surface. These shapes are exemplified in the climax of Safavid art in the Persian city of Isfahan, as well as being found in patterns throughout the length and breadth of Islam. The overlap characteristics set up by the special juxtaposition of the major pentagons are shown in tone. These areas of 'common ground' become pieces in the mosaic and timber constructions in Islamic art, particularly in Isfahan.

1 For example, H. E. Huntley, *The Divine Proportion*, New York, 1972.
2 Huntley, op. cit., p. 154.

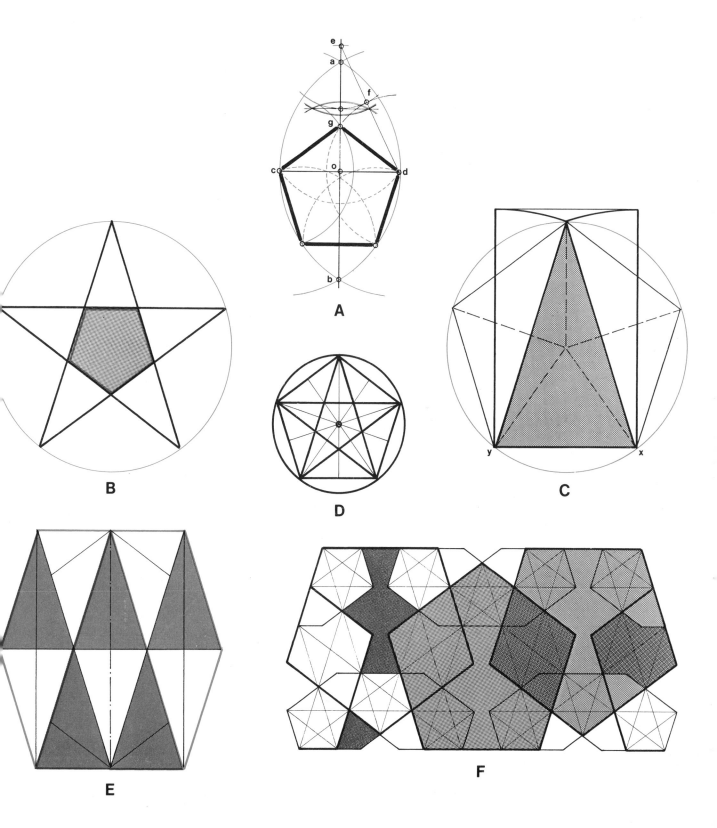

A

B

D

C

E

F

This page continues to explore special relationships inherent in the pentacle or five-pointed star and its containing polygon, the pentagon.

Drawing A demonstrates the proportional relationship between an arm of the star and the edge-length of the containing pentagon. If the latter is taken as 1, the arm of the star is in golden mean proportion, in the ratio $1 : \frac{\sqrt{5}+1}{2}$ or $1 : 1\cdot618$.

Drawing B takes the golden mean rectangle (as constructed in drawing C on the previous page) and demonstrates the internal characteristics when a regular square is 'taken off' the interior rectangle. The diagonal of each successive square is drawn in heavy line. It can be seen that when a square is taken off the golden mean rectangle the resultant rectangle is itself in golden mean proportions – a square taken off this will leave another in diminishing ratio – a series which can in theory be continued indefinitely, the only restrictions being physical constructibility and practical usefulness. In the illustration we have taken five squares away from resultant golden mean rectangles and demonstrated that the diagonals of these squares set up a rectangular 'spiral'.

Drawing C takes the triangle between two arms of a five-pointed star and places another such triangle on the base of this triangle such that the shorter base of the larger triangle becomes the longer 'arm' of the lesser triangle. This systematic reduction is shown in five stages. This is followed by a continuous curve in colour which passes through the apex of each sequential triangle. This logarithmic spiral is the golden mean spiral and is intimately associated with the laws of biological unfolding previously mentioned.[1]

Drawing D shows the characteristic diminishing star pentagons within a circle setting up series of proportional ratios and potential spirals.

Drawing E shows a rectangle, abcd, made up of two perfect squares with the diagonal ca drawn in heavier line. Taking ca as radius, and rotating on point c, an arc ae is drawn; the distance c–e is $\sqrt{5}$ if the side of the original square (ad or cb) is 1. This enables us to see that ce is the side of a $\sqrt{5}$ rectangle, cefb. We now add a further square to the $\sqrt{5}$ rectangle, which thus graphically expresses the formula $\sqrt{5}+1$. By dividing the total rectangular area now formed at the midway points, g and h, the new rectangle ghcb itself becomes a golden mean rectangle, thus completing the formula $\frac{\sqrt{5}+1}{2}$.

1 Huntley, op. cit., p. 154.

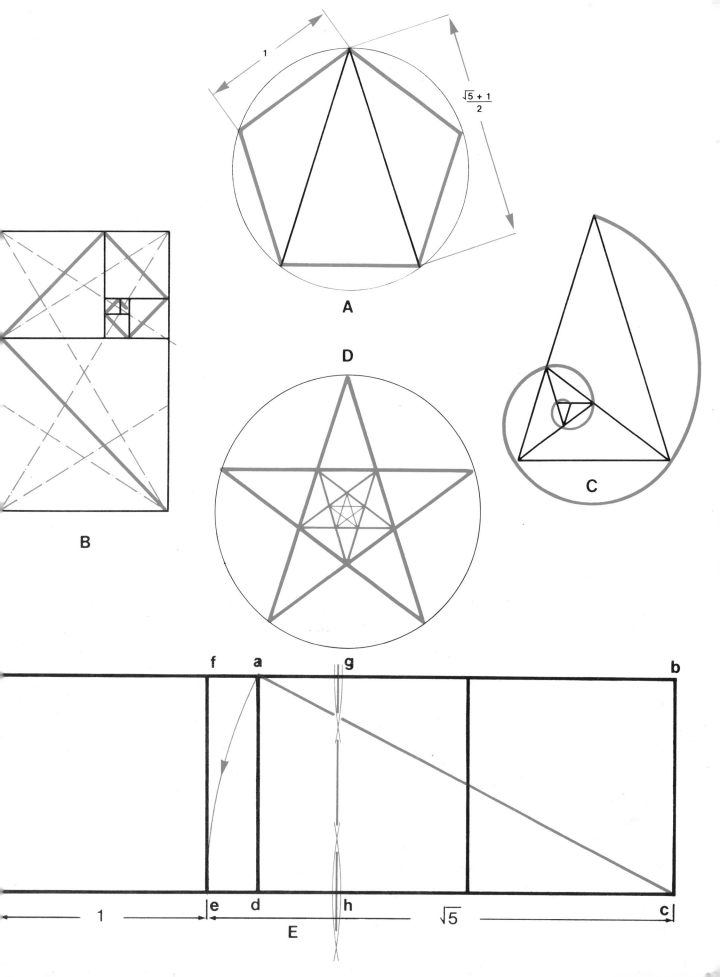

A

D

C

B

$$\frac{\sqrt{5}+1}{2}$$

1

f a g b

e d h $\sqrt{5}$ c

1

E

This drawing relates the star decagon to its peripheral pentagons through the inherent two five-pointed stars intrinsic to any decagon or star decagon.

The five-pointed stars have been drawn in solid and broken lines and the arms have been extended beyond the boundaries of their apices on the points of the central star decagon to form the basis of smaller five-pointed stars within pentagons. The sizes of these peripheral pentagons are governed by their points of contact in a circle. This point of contact is also a property of extending the ten arms of the decagon star until they meet to produce a 'sharper' ten-pointed star; moving outward, the distance from one point, the inner, to the next becomes the length of the side of the peripheral pentagons. It can be seen that the arm that joins the outer ten-pointed star associated with each of the outer pentagonal stars inside the peripheral pentagons makes up a regular decagon. This straight-edged version of ten regular divisions has alternate sides of solid and broken coloured line.

This pattern of tens and fives is fundamental to a host of traditional patterns in five-fold symmetry — one might call it the master plan underlying the various expressions.

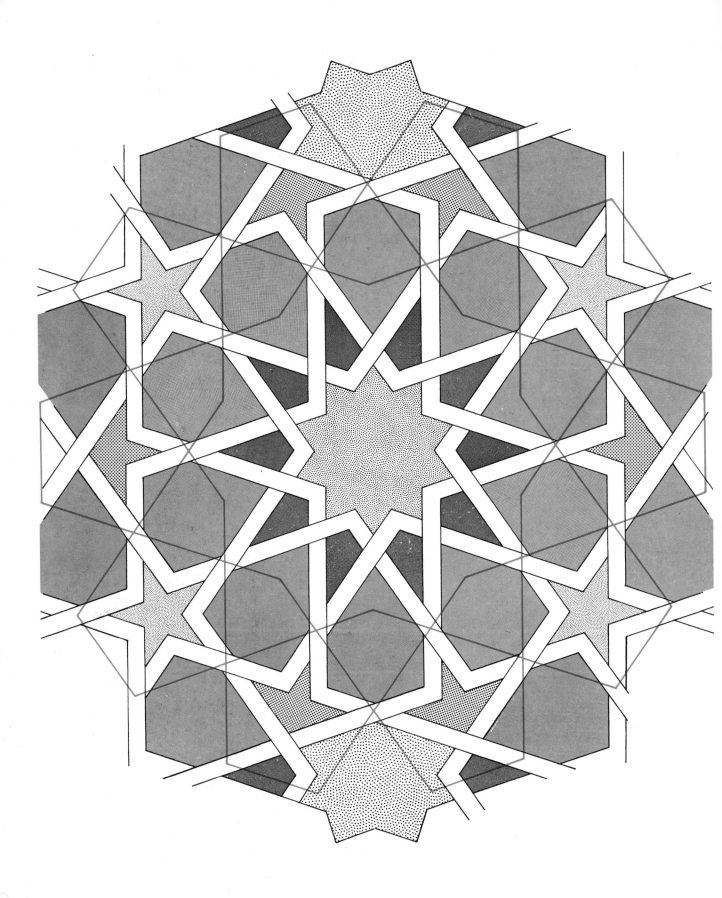

Opposite

We now demonstrate how the previous master diagram or geometry underlies one such fundamental pattern. In this drawing the woven closed-path characteristics of traditional Islamic patterning are developed.

Because of the nature of the two-dimensional surface and its characteristic three-fold, four-fold and six-fold natural divisions the pentagonal patterns have to be subject to an adjustment. This is usually achieved through adapting the regular square division into a golden mean rectangle to establish the basic repeat.

In this illustration only four of the coloured star pentagons remain whole in a rectangular relationship. The other resultant shapes are derivatives 'invented' or distilled by the Islamic master who devised the pattern to ensure greater freedom of repeats. Six shapes are represented here. In the centre is the decagon star, with the rhombic pointed emanations between each hexagonal petal with its two parallel sides. These in turn 'dovetail' with star pentagons and 'arrow' shapes pointing away from the flower centre. Next appears the irregular twelve-sided shape which enables the others to repeat. This latter shape appears above and below in the illustration.

Overleaf

If a polarity can be identified between the geometric crystalline and the spiraloid, biomorphic, elements of Islamic art, then the unifying element is calligraphy — the pre-eminence of which is due to its archaic origins and its role as the vehicle of expression of the text of the Quran. There are at least twelve distinct kinds of calligraphy — the one with which the present study is concerned especially is the version called 'masonry' style owing to its intimate connection with the method of cutting and laying of bricks in a wall. In this sense it is most physically permanent in its manifestation, reflecting the appropriateness of the rectangle.

The name of God, the opening prayer of each *sura* of the Quran and name of the prophet Muhammad are the most frequently found motifs, whereas in Persia particularly (the host country to Shi'a Islam) the name of 'Ali is almost as frequently featured in this style of calligraphy.

This illustration demonstrates the integration of geometrical symmetry based on ten peripheral pentagons surrounding a decagon. This pattern and the explanation of the masonry style were elucidated for me by Dr B. Shirazi, director of the preservation and restoration of ancient monuments in Isfahan, during a visit I made to this city at the time of writing. Many beautiful versions based on this theme are to be found in Isfahan.

It should be noticed that the sacred name, Muhammad, is rotated around a five-pointed star, indicating connections between prayer, sound repetition and significant numbers, and symmetry 'ordering' space.

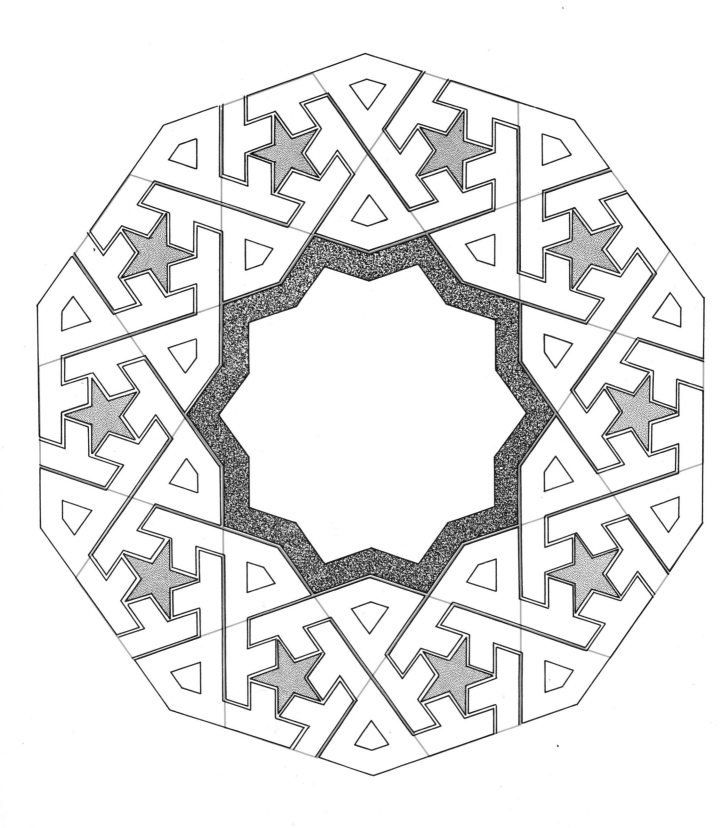

This page demonstrates another arrangement of ten peripheral pentagons arranged symmetrically around a decagon (ten-sided) star. The precision of this convergence is determined by the relationship between the overlapping area and the nature of the gap left between two adjacent pentagons which makes up each 'point' of the ten-pointed star at the

centre. Each pentagon is directed along its two-fold axis to the centre of the central decagon star.

The gap between the lateral pentagons within a central pentagon is directly related to the 'bottle'-shaped ten-sided configuration which was shown on p. 77 (F) and is characteristic of a whole 'school' of Western Islamic patterns — exemplified in the Persian city of Isfahan.

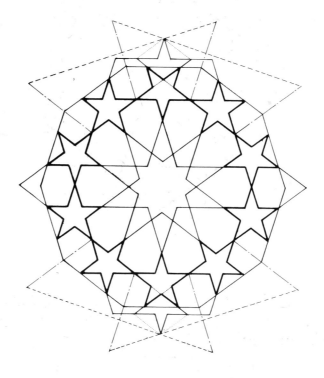

In this illustration we have developed the diagram above in such a way as to demonstrate the intimate connection between the underlying star decagon and its associated pentagons. In this case the ten peripheral pentagons are drawn as star pentacles, and the adaptation techniques are shown (at the top and bottom of the diagram) in finer line. The underlying controlling geometry is shown in colour opposite. Both the arcs and the straight lines of the decagon construction can be seen at the top, with the dotted lines indicating the parallel phenomenon of the 'sides' of the decagon, each of which gives rise to the possibility of inscribing a golden mean rectangle in five different directions.

Opposite is a panel which accords with the principles of the primary pattern while fitting into a harmonic rectangular relationship in different ways. Here we demonstrate the positioning and proportions of the arcs which need to be drawn to control the precision of the final pattern — whether it be made of wood, tile, mosaic or other medium. The centre pentagon demonstrates the golden mean proportional controls determining the sizes of the arcs generated from its intrinsic proportional nature, i.e. the arm of the inner star is

related in a golden mean proportion to the side of the pentagon. Careful study will reveal the method of using tangents and centres generated from the points of the pentagon.

Such harmonic patterns were features of door- and wall-panelling and both enabled small pieces of wood to be used economically and allowed the whole 'jig-saw' puzzle to 'breathe' with climatic changes of temperature and humidity. This ethic of carpentry accords — in principle at least — with the Chinese and Japanese tradition of wood jointing in architecture, so that in one respect earthquake tremors can 'flow' through a hammerbeam system just as the humidity 'flows' through an Islamic door. In another respect the principle accords with the philosophical attitude propounded by Buddhists, that as creation needs no string, glue or screws to hold it together, so an architect is even less justified in doing so when building a house. The Islamic carpenter-designer also exhibits such an ability and understanding by using only geometry and wooden plugs to hold his creations together.

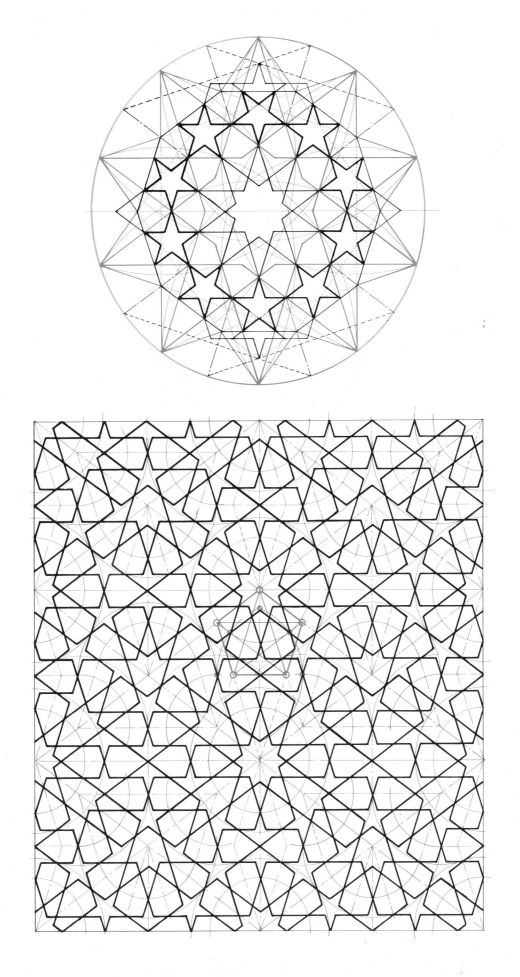

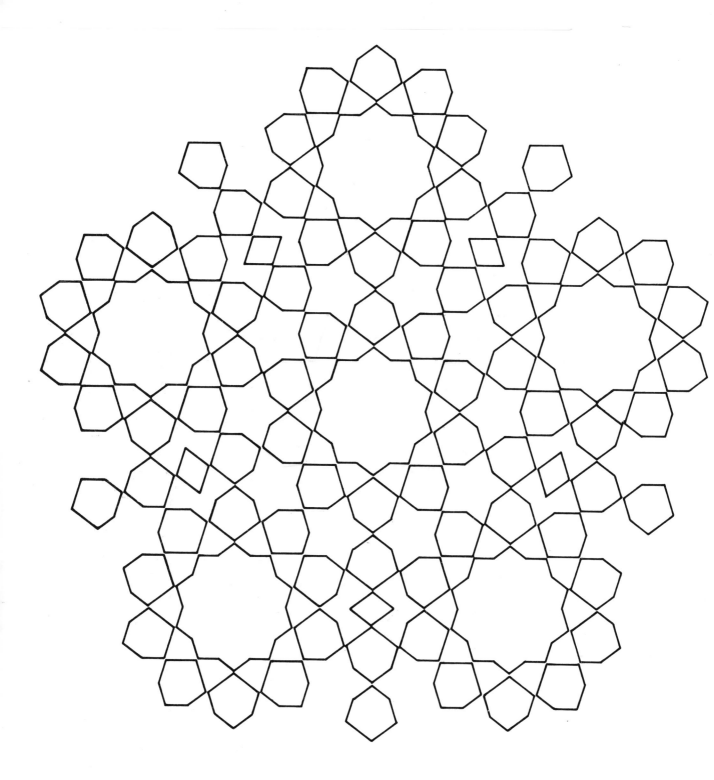

This pattern is presented as if it were of mosaic, to show that it could be made by using just three basic shapes, i.e. the star decagon, the asymmetric hexagon 'petal' and the small 'diamond' shape infill.

A mosaic technique is found when the artist-craftsman presses precisely cut ceramic pieces into a wet plaster ground, leaving the ground to create part of the pattern.

Alteration of the figure-ground gives rise to a great variety of possible versions, in colour, surface emphasis and effect. An analogy could be drawn between this kind of relative freedom and a musical improvisation on a theme, changing key, intensity and even rhythm according to the dictates of the particular moment.

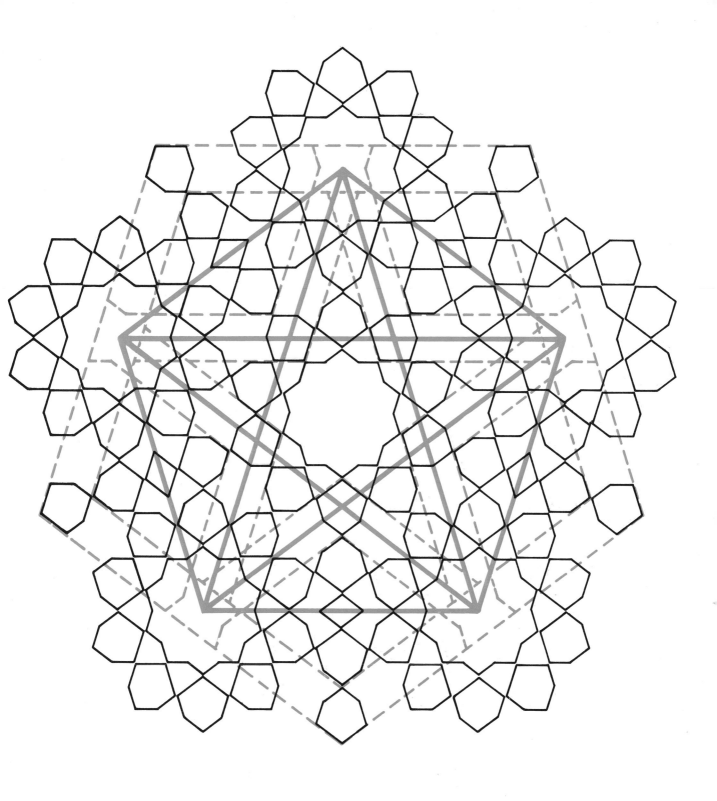

This illustration is designed to show the underlying proportions and controlling order hidden within the apparently simple repetitive mosaic pattern.

The large pentagon with its internal star can be drawn again with greater thickness in broken coloured line, with the adjacent overlapping similar pentagons implied by the rhombic pattern. This gives the possibility of dominant and subsidiary themes as well as a basic layout pattern to control the accuracy of the surface division and ensure the exact fitting together of the pieces of the pattern.

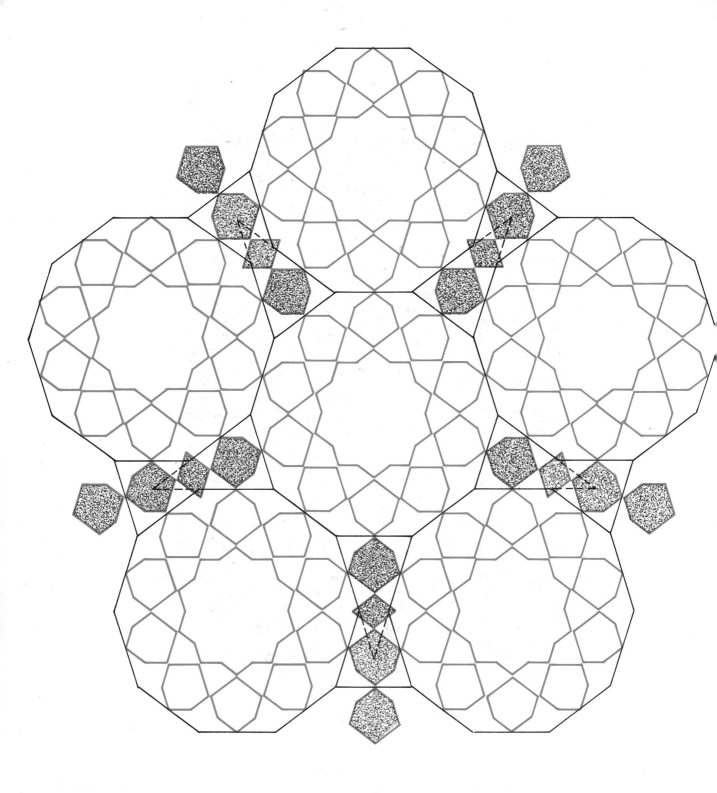

In this drawing the colour coding is reversed to demonstrate the most elemental mathematical tessellation of the pattern in black.

As five-fold symmetry is not a regular divisor of a two-dimensional surface (in terms of convex polygons), some geometric adjustment has to be made to achieve a repeating pattern. In this case the strategy devised by the Islamic master was to introduce an irregular hexagon with regular sides.

The drawing shows, in tone, how pairs of irregular hexagonal petal pieces of the final mosaic relate intimately to the guiding 'hidden' concave hexagon (in colour).

The final mosaic pattern is shown in colour underlying the mathematical tessellation.

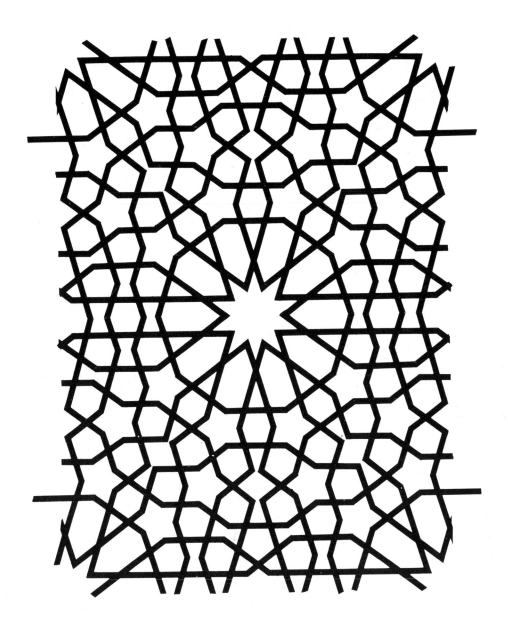

Another version of the same family of patterns is shown here where new pieces arise from a more complex system.

The whole area of the drawing is a golden mean rectangle in which the central motif is repeated at each corner, i.e. the ten-pointed star in the centre is continuously repeated with the centres occurring on the four corners of the diagram.

The pattern is designed in such a way that a regular decagon surrounds the central star and itself gives rise to the 'sides' of a set of eight complete five-pointed stars surrounding it, with four above the meridian and four below.

These star pentagons in turn generate asymmetric hexagonal 'petals' exactly similar to the shape seen in the last pattern. By juxtaposition, these create the characteristic 'bottle' shape which is the 'bridge' by which the repeat is made possible since each set of pentagonal stars shares an asymmetric hexagon with the set belonging to the neighbouring decagon.

The pattern has been created in a strictly proportional thickness of line which would feature as a 'woven' element in a completed design.

Here we explore more closely the supra- and sub- themes which are the feature of many Islamic patterns, and a potential feature of all Islamic art, symbolizing, in one aspect, the concept of microcosm and macrocosm reflecting each other — as above, so below; as with the greater, so with the smaller.

This particular version shows how a particular multiple of smaller shapes of this family of patterns can be arranged so as to produce star decagons on the apices of a larger set of similar shapes. In this instance a large pentagon and a pair of characteristic rhombs are shown (with part of the reflecting pentagon seen in the upper part of the drawing).

The thickness of the macro-pattern's edges is related directly to the size of the diagonal of the characteristic rhomb in the micro-pattern.

The total number of shapes in the pattern is five: the star decagon, a regular pentagon; a twin pentagon; the characteristic rhomb; and what we have called the 'bottle' shape (which in fact has ten equal sides and could be considered a concave decagon; cf. p. 77, drawing F).

If one takes any of the shapes in the macro-scale, they contain a particular number of shapes of the micro-scale: for instance, in this version we find the characteristic rhomb has two 'bottles' (concave decagons), two whole pentagons, six major parts of pentagons, and two minor parts of the pentagon, three fractions of the star decagon and one larger portion of the same shape, and finally eight characteristic rhombs. In fact the whole can be defined by the eight rhombs and two bottle shapes.

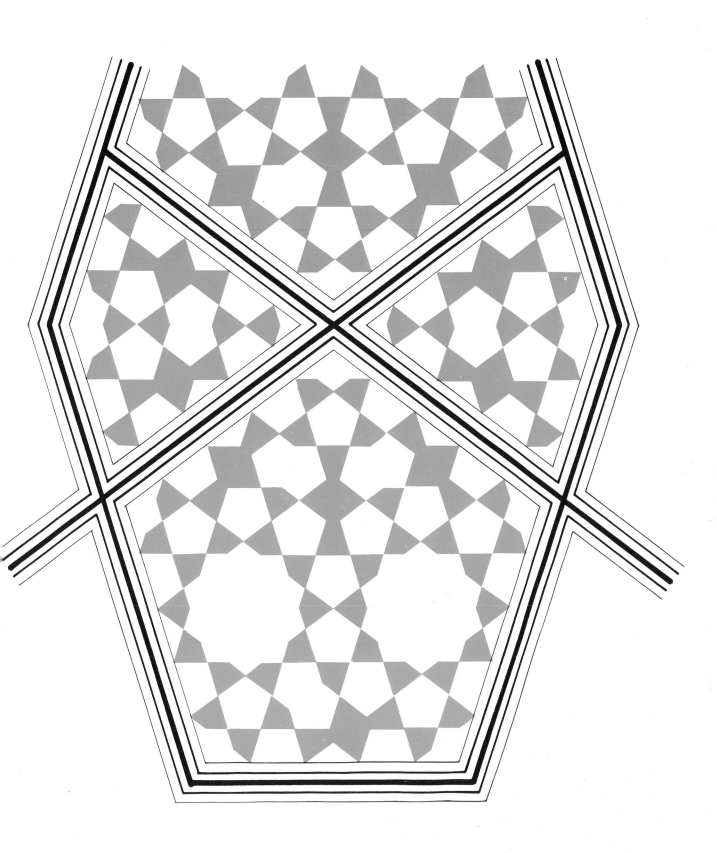

In this illustration we turn to a different way of expressing the pentagon, one which places the star pentagon inside a square grid in such a way that the pentacle sets up flowing rhythms through the static background of squares.

This page shows half the pattern so that the square background and flowing pattern, which focusses an asymmetric octagon over alternate junctions of the squares, are seen as separate complementary functions.

From the point of view of the final pattern the squares can be seen to be grouped in sets of four, with small exten-

sions at the outer centre points of each group. These work as sets enclosed by the woven asymmetric octagons.

This pattern is from the northern area of Islam — the Turkish region. One should, however, avoid ascribing patterns to particular regions since the place of origin of each pattern or the identity of the master who conceived it would be extremely difficult to prove. The frequency of use of certain patterns is evident in the tiles, bricks and marble of individual mosques and shrines of different regions with very particular meaning in the context of their precise locations.

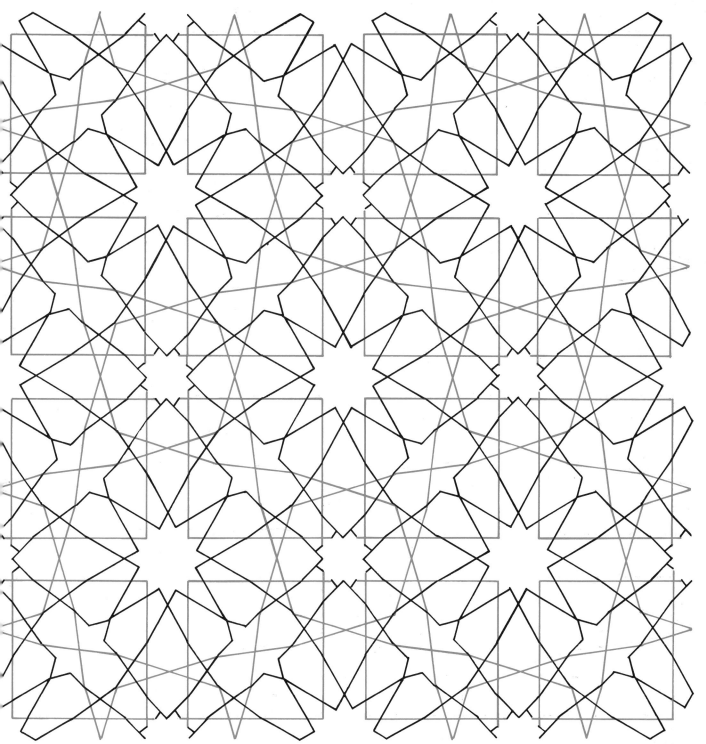

We now complete the pattern so that the combined effect of the two themes can be fully appreciated.

The fact that the asymmetric octagon is made up from a set of five-pointed stars is the first feature apparent to explain the rhythmic flow through the static square grid.

By a continuation of certain of the extensions of the five-pointed star, a twelve-pointed star is created at the junction of four of the square patterns outlined in the previous illustration. We can also see how a very small twelve-pointed star has been created at the half-way junction of the square grid where the original overlaps were pointed out on p. 94.

This pattern is a good example of the primary and secondary decisions that have to be made by the master-designer. First, mathematical certainties are selected and an arrangement is decided upon — the regular five-pointed star, the arrangement of eight and the square grid. Second, a creative decision had to be made to arrive at other forms necessary to the overall concept — the twelve-pointed stars as symbolic verification of the inner cosmic referent. This necessitated finding the correct change of angle at the apices of the five-pointed stars and return angles at each twelve-pointed star focus to obtain the most balanced results.

This much revered pattern (on the facing page) can be found from Turkey to India and from India via Saudi Arabia to Egypt, Morocco and Spain, as well as in the mosques of Persia [B. 182].

The characteristic shapes that arose from the overlapping of the regular pentagons (displayed at the beginning of this chapter) now take on a new value — that of overlapping or interweaving paths.

Each part of the central ten-'petalled' motif extends to its own 'point' and can be read as a dual closed path across the centre creating its own part of the whole.

The characteristic kite shape which figured so predominantly in previous patterns — particularly those associated with the ceramic mosaics of Isfahan dating from the Safavid era and since — now becomes itself a closed path. As it interweaves or overlaps the central star it also creates pentagonal and dual pentagonal interspaces.

It is important to recall the profound integration that such a pattern represents; at the basic level of material economics it represents the most profitable use of small pieces of raw material — particularly so with wood which in many Islamic regions does not grow in the long straight form characteristic of the pine forests of hyperborean regions. Not only this size factor but the radial distribution of the grain of the wood, together with the ingenious non-glued jointing, make the panels so constituted ideal to 'breathe' with changes of temperature and humidity. I personally discovered such a door in the Friday Mosque in Isfahan which appeared many centuries old and was as 'whole' as when it was first made, although it must have survived the many changes in seasonal movement and natural wear which had revealed the pattern of the grain, the precision of geometry and the visual beauty of the whole.

Underlying the same pattern is a procedure which is generated from an inner central pentagon (see drawing overleaf).

This initial 'flower' pentagon can be considered to develop by reflection star pentagons from each pair of its points; three have been illustrated here as the other reflection in the pattern occurs across the horizontal centre line.

The larger simple regular pentagon drawn around the centre is at a tangent to the circle enclosing the primary five-fold 'flower'. The enclosing circles, in broken line, of the other star pentagons determine the proportional ratios of the rest of the pattern.

Next (overleaf, p. 99), in black we develop the subtle way in which the originator of this pattern determined the thickness ratio of the 'path' or line of the pattern.

The upper finer lines (both broken and solid) explore the five-fold symmetry of the intermediate dual-pentagon interspaces with the small central upper star pentagon situated between and relating to the neighbouring interspaces. The two star pentagons (in full and broken line respectively on either side of the top) determine the path thickness in the following way: the bottom arms of the five-pointed star in broken line determine the 'upper' edge of the secondary pentagon in the centre of the page; the inner edge is at a tangent to the central circle, which both circumscribes the primary pentagon 'flower' of the previous illustration and is contacted by the points of the lateral star pentagons of the upper two interspaces (in full line). Certain centre lines and axes of symmetry have been added in the black drawing.

Finally, it is important in the context of this group of drawings, to reiterate a previous commentary on the symbolism of five (see p. 70). The number five, particularly as represented by the star pentagon standing on two 'legs', has a traditional symbolic association with a human being. From the Islamic viewpoint, it can most appropriately be interpreted as a perfected person who is aware of the five Divine Presences and has realized these Presences in himself, i.e. a 'whole person' in the fullest meaning of the term, or a saint; it thus represents the full humanness of an individual. In this way Islamic geometric art has chosen an undeviating directness of simultaneous form and content.

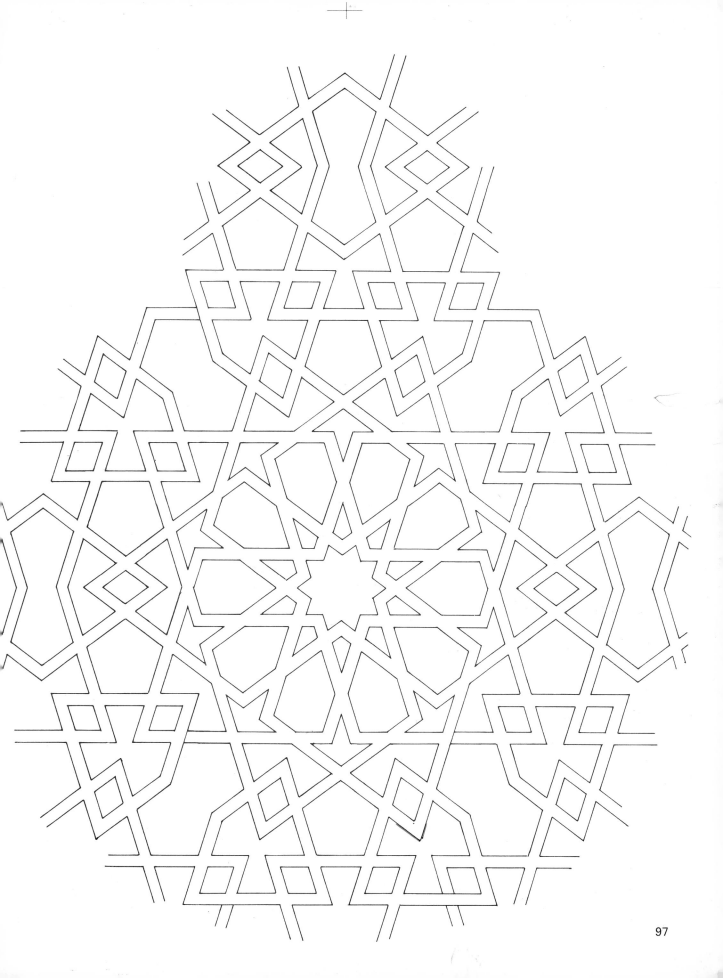

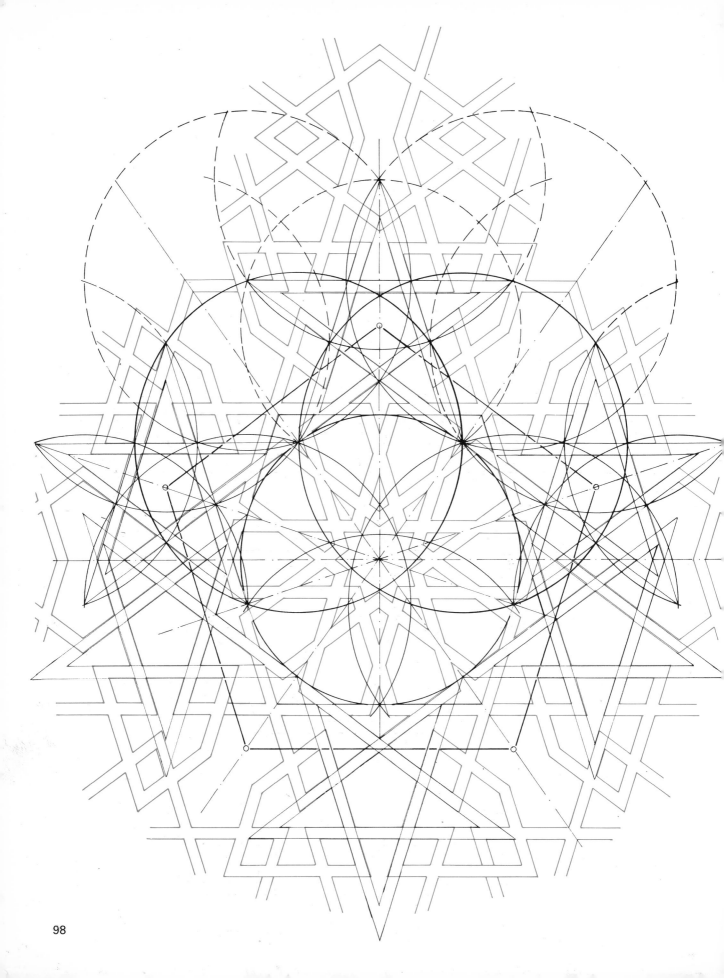

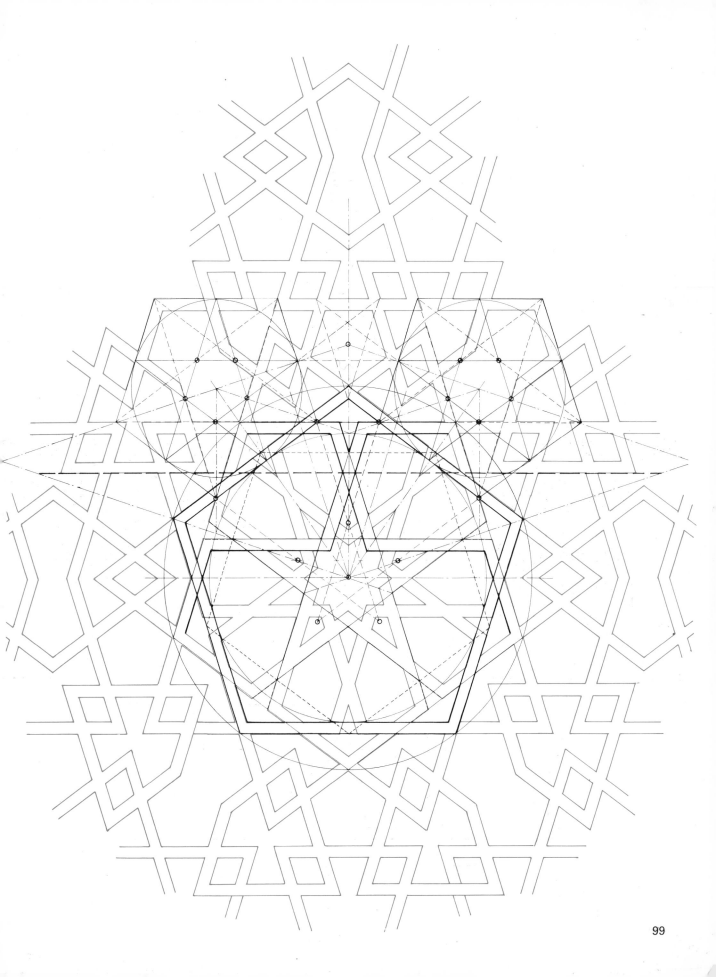

99

The two following drawings are based on a survey of the tomb of Imamzada 'Abdullah at Farsajin. They illustrate how appropriate the determining geometry of such monuments is to their spiritual function, whether as a centre of pilgrimage, a resting place for the body of a spiritual teacher or as a place for ritual circumambulation. In much the same way that the planar surface patterns exhibit cosmic norms and archetypal geometries, the tombs enshrine these same geometries and symbols in three-dimensional form – the cycles of time and space frozen in matter indicating a timelessness and unbounded space which transcends the wear and tear of 'worldly' existence.

> 'Ten laws with stages nine and heavens eight,
> with seven planes, six reasons thus relate:
> Five senses, tenets four, triad of soul,
> In pair of worlds have thee as One in State'.[1]

Here the bottom left-hand drawing shows the plan in solid line, a square anteroom with an octagonal central space with eight recessed spaces. The proportional relationship between the square anteroom and the octagonal 'drum' is demonstrated in finer broken line. We have demonstrated elsewhere the $\sqrt{2}$ proportional values intrinsic to the octagon and star octagon – particularly the diminishing harmonic ratios obtained by inscribing star octagons repeated within star octagons.

The drawing above demonstrates the method used to analyse this building. Taking the obvious determining geometry of the star octagons of the plan, we have applied the basic octagon to the elevation of the building. This has been applied in two instances very close to each other in scale. In the first instance the octagon with its bounding circle is placed so that the bounding circle touches ground level. This produced a series of close 'misses' at the periphery but displayed a convincing centre at the base of the dome space. In the second instance the edge of the enclosed octagon (the octagon of the plan) was placed at ground level (two lower points ringed) and this immediately determined the uppermost height of the dome of the interior space: the centre fell on the lower edge of the division between the octagonal prism of the lower space and the hemispherical upper space. Also the central diagonals exactly correspond to the lower corners of the windows at the springing of the dome, shown here crossed over by parallel broken lines to demonstrate further relationships to the recesses of the octagonal prism below. This new position of the plan octagon projected onto the elevation is reinforced in colour, as is the internal diagonal square of this octagon. One further correspondence, which acts as a confirmation of this lower setting of the octagon, is the way in which the extension of the lines of the conical tower down to the ground (in broken line) exactly cut the half-way line of the containing circle of the octagon virtually half-way along the line from the termination of the cone's eaves to the ground; it will also be noticed that this line 'touched'

the cornice of the lower octagonal part of the building on its way. The centre lines (in fine broken line) from the ground point of the cone's projection line to the octagon's centre becomes the lower part of the five-pointed star in the drawing at lower right.

In the lower left drawing we have developed the angle of the conical tower; this angle is that of a five-pointed star. The crossing-over points of the greater five-pointed star, drawn from the ground and determined by the height of the tower, themselves indicate further important positions in the inner proportions of the whole: e.g. the outer springing of the interior dome, the same centre as the octagon of the previous drawing and transition cornice between lower prismic space and hemisphere of the dome.

Another intrinsic geometric symbol has been proposed in the form of three intersecting circles, in fine black line reinforced by colour, these represent the traditional triad of Heaven (above); Earth (below); and Mankind the intermediary. This intermediate circle also determines the intrinsic body and curvature of the dome.

Further harmonizing values between the elevation and the ten-fold division, growing out of the five-pointed star, are shown in the circle which touches the ground centrally below and is centred on the cornice of the octagonal prism and cuts the conical roof just above the eaves. This circle is divided into ten equal intervals, ringed, which emphasize the golden-mean harmonic relationships which are inherent in such a division. It can be seen that the first two intervals to the right and left of the base point determine the inner extremities of the eight recesses of the octagonal prismic space below. The next two points (ringed) on either side, when connected to the centre point, intersect the two lower circles (of the triad of symbolic circles) at their cross-over points. The next two intervals on each side of the ten-fold circle, when also connected to the centre point, make an interesting intersection with the window openings in the dome. The eighth and ninth ringed intervals of this circle exactly intersect the cone of the roof of the building – while the tenth and uppermost interval sits centrally in the void of the upper and hidden interior between dome and cone. Other points of interest are shown in fine line and the overall five-pointed star has been indicated in broken line with its (coloured) containing pentagon.

The upper right drawing represents a schematic diagram in both colour and black lines of various kinds which summarize the proportional system indicated by our analysis. It is important to emphasize that such analysis is purely empirical and, because of the remarkable lack of almost any architectural production drawings from traditional Islamic sources, the conclusions can only be regarded as suggestions, and are not definitive. We believe that the indications are toward symbolic philosophic geometric schemes which expressed cosmic laws for their users and were common ground both for the whole edifice and for the detailed patterns which were reduced to an inlay scale as small as the area contained within the dimensions of a finger nail. This serves as an indication of the manifest doctrine of macrocosm and microcosmic reflection.

1 The *Ruba'iyat* of Omar Khayyam, I, 52.

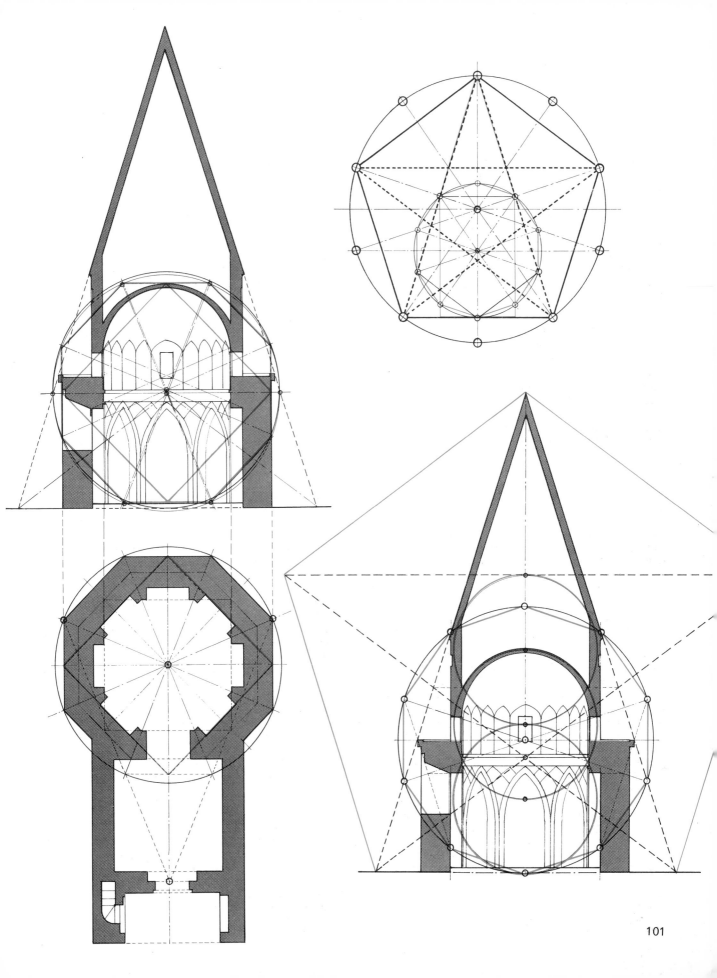

In the architecture of Islam it is geometry which provides the link — whether between a city and a citadel within it, or between the citadel and the buildings within it, or between the doorways, windows, walls, grilles and screens within a building. The geometry may vary from the symmetricality of the plan of ancient Baghdad, to that dictated by fortress requirements (such as firing angles), to the distribution laws similar to parched clay that seems to typify much of the infill patterns of domestic housing in so many Islamic cities. The four-square geometry of mosque, palace or home courtyard represents a foundation constant among sedentary peoples much as the more radial and conical forms predominate among the nomadic; the carpet provides the rectangular constant between the two with its own 'foundation' role as prayer mat. The hemisphere crowns both traditions, as the form of both the *yurt* and sprung-tent form on the one hand, and as the most integral spanning strategy for brick and mud-brick buildings on the other — the crowning glories being the great mosque domes in marble, coloured tiles and relief stonework. The square founds, the hemisphere crowns and the triangle makes possible the connection.

In the introduction to this book we quoted the Brotherhood of Purity who insisted that sensible (practical) geometry was the path to skill in all the practical arts whereas intelligible geometry led to skill in the intellectual arts — 'the root to all knowledge'. The connection between the two was a matter left to the imagination of the reader — the role of sensible geometry is to lead to intellectual geometry, intellectual geometry in turn leading to the root of all knowledge — the experience of unity.

What is a door? It constitutes a passing from one situation to another, a transition; this can be viewed lightly in a purely mechanical sense, or taken in the seriousness that a change of consciousness demands. The entrance to a sacred place at any time in human history was a matter of great import. It necessitated an effort of mind and heart; to leave behind the petty concerns of daily life — the debts and indebtedness, the desires for material gain, the frustrations, the jealousies, suspicions meanness and deceit. This was a form of cleansing of inner attitude: from a self-centred to a cosmic-centred attitude, from a self-justified arrogance to one of humility and submission to the will of God.

The doorway, as the symbol of threshold, is the most appropriate place for the content of sensible geometry to affect a man's perceptual awareness and remind him of the greater values that one might expect to experience on entering either another situation or state of consciousness.

The Moorish doorway shown opposite remains as a reminder as much to the present-day visitor as it did when it was built in Islamic times in Spain. The entrance at body level is simple, unaffected and of sound proportions; no doubt the original timber panelling within the door-frame was robust and geometrically subtle and beautiful. The entrance is clear, while the crown of the entrance is radiant and elaborate. The 'functional' level of mechanical opening is as efficient as the 'functional' level of symbolic geometry above. As the opening lets through the body the symbolic geometry has the potential of 'opening' to the mind or intellect — a reflective reminder of the fact of reconciliation.

The *dā'irā 'ala* — the horseshoe arch, as it wrongly but graphically described — visually takes the upper part of the rectangle of an opening and transforms it into the symbolic language of the 'world of ideas' or Heaven, i.e. circular form.

Around this circular form radiates a nimbus of nine partitions, so constructed as to appear to be constantly moving 'upward'. This radiant ripple of form is in turn surrounded by the crysteline upper part of a hexagon which in turn is surrounded by rectangle acting as both container and ultimate reminder of the materiality (squareness) of the fabric which bears the symbols.

In between the hexagon and rectangular surround lie two twelve-fold patterns themselves within squares and both composed of a pair of flowing and interwoven hexagonal 'paths'. There are alternately six 'squared' loops and six rounded loops in continuous line.

The proportions of the three primary circles (which we proposed were intrinsic to the design of the tomb on the preceding page) are here determined by the larger of the 'horseshoe' arcs and determining by their cross-over points the thickness of the door surround below.

Within the upper circle (its intrinsic triangle is shown in heavy broken line in colour) we have drawn a seven-fold division which not only links the proportion of the smaller triangle to the smaller horseshoe arc along two of its lower edges but also sets the seven-fold division of the circle to determine the centres of the nine small circles of the nimbus (these are nine of a possible full contingent of fourteen). It is almost unnecessary to point out the connection between this seven-fold division and the 'seven heavens' of the Quran. Standing on the two lower points of the inner equilateral triangle (in broken coloured line) are the lower arms of a five-pointed star, the apex of which concludes as the small ogee of the uppermost circle of the nine-fold nimbus, having determined the width (ringed) of the inner circle of the top circle of the nimbus. This five-fold division is reflected in the enclosed panels radiating within the rectangle immediately above the door. A greater circle has been drawn in heavier coloured line to show the containing circle of the hexagonal boundary to the nimbus pattern which is based on the proportions of the three intersecting circles. Finally we would like to add the suggestion that geometry 'begun' in the sensible patterns above generates lines and arcs which are fulfilled in the intelligible or empty space of the door opening, thereby in its own subtle way involving the subtle geometry of the person who is passing through the space below.

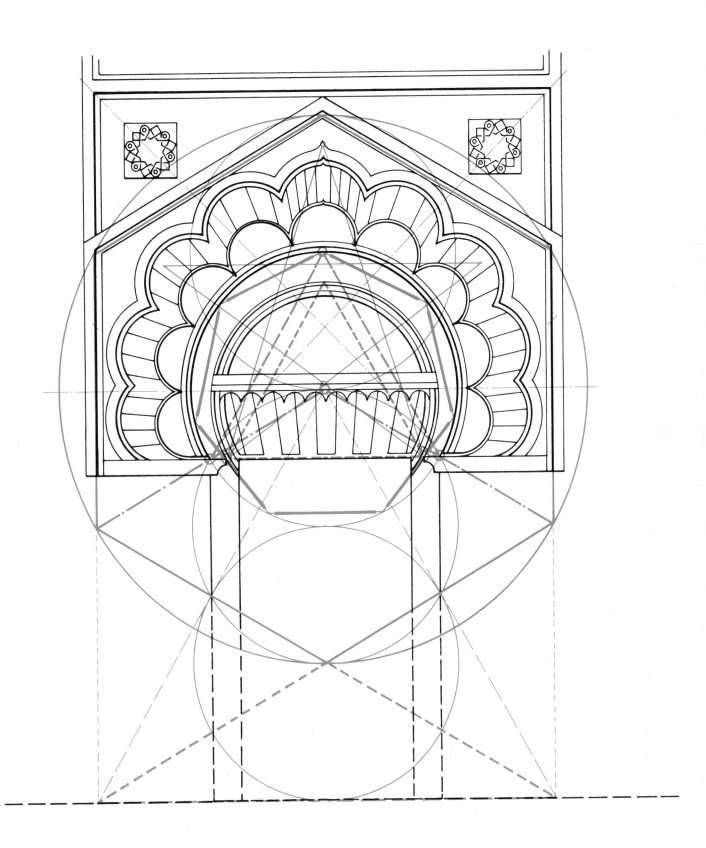

6 The Tetractys

The tetractys has been defined,[1] at its most simple and literal level, as the Greek term signifying an aggregate of four; and, specifically applied to the Pythagorean perfect number, ten (being the sum of $1 + 2 + 3 + 4$).

This deceptively simple description of the philosophical model apparently used by the school of Pythagoras, whose tradition was recorded for posterity by Plato in the Timaeus, belies the depth of its possible interpretation while at the same time reflecting the extreme simplicity of the model. The most decisive evidence for the influence and transmission of Pythagorean philosophy – in its correct meaning of 'love of wisdom or knowledge' – is particularly seen in the works of the Brotherhood of Purity (Ikhwan al-Safa) and of the philosopher Suhrawardi. The latter describes his view of the transmission of universal wisdom through the ancient sages, of whom there were two lines – one Persian, the other Greek. The Greek line proceeds from Asclepius, the god of healing, through Pythagoras, Empedocles, Plato (and the Neoplatonists), Dhu'l-Nun al-Misri, Abū Sahl al-Tustari and thence to Suhrawardi himself; the Persian line descends through the priest-kings. This synthesis of the knowledge of two traditions by Suhrawardi was called Ishraq by Muslim historians. The important connection between this philosophical aspect of the Pythagorean line and the subject of this book is found in the commentary of 'Abd al-Razzāq al-Kāshānī on the Fuṣūṣ al-Hikam (Bezels of Wisdom) of Ibn 'Arabi; Kāshānī calls these 'followers of Seth' who, according to Islamic sources, were the founders of the craft guilds, and from whom originated craft initiation which was closely connected with Hermeticism.[2] Suhrawardi also confirms the esoteric side of these transmissions of knowledge when he says: 'Since the Sages of the past, because of the ignorance of the masses, expressed their sayings in secret symbols, the refutations which have been made against them have concerned the exterior of these sayings, not their real intentions'.[3] Suhrawardi criticizes Aristotle with severity for not understanding the world of archetypes, or 'Platonic ideas' of his master and thereby through his works cutting things off and separating them from any reality of a higher order of being.

The Brotherhood of Purity, however, speak of their indebtedness to and respect for the Samian Master: 'Pythagoras was the first who spoke of the nature of numbers. He taught that the nature of numbers is in relation with that of Nature.

Whoever knows the nature of numbers, their species and genus and their properties, can know the quantity of species of beings and their genius.' And furthermore they explained their understanding of this archetypal power of number: 'Know, brother, that the creator, most exalted, created as the first thing from his light of unity the simple substance [al-jawhar al-basit] called the Active Intellect ['aql] – as 2 is generated from one by repetition. Then the Universal Soul was generated from the light of the Intellect as 3 is generated by adding unity to 2. Then the hyle was generated by the motion of the Soul as 4 is generated by adding unity to 3.' Thus proceeds the intelligent and numerical unfolding of the phenomena of creatures. Above all 'the science of number was considered by the Ikhwan as the way leading to the grasp of Unity, as a science which stands above Nature and is the principle of beings and the rest of the other sciences, the first elixir and the most exalted alchemy.'[1]

Since so much of what passes as science in our times is fathered by Aristotle and since, as Suhrawardi has rightly complained, Aristotle failed to recognize the 'realm of ideas' or determining archetypes in the sense that his master, Plato, taught them, it is not surprising that so many modern readers have found the Pythagorean approach to number incomprehensible, if not ridiculous. The fault, however, does not lie with the source, as the famous first-century Pythagorean, Nicomachus, himself made very clear concerning the primacy of number and arithmetic: 'which of these four methods (referring to the Quadrivium) must we learn first? Evidently the one which naturally exists before them all is superior and takes the place of origin or root, and, as it were, of mother to the others. And this is authentic, not solely because we said that it existed before all others in the mind of the creating God like some universal and exemplary plan relying upon which as a design and archetypal example the creator of the Universe sets in order his maternal creations and makes them attain to their proper ends; but also because it is naturally prior in birth, inasmuch as it abolishes other sciences with itself, but is not abolished together with them.'[2]

For the Ikhwan, number was 'the "spiritual image resulting in the human soul from the repetition of unity"', since they believed that the final aim of geometry is to permit the faculties of the soul of reflect and meditate independently of the external world so that finally "it wishes to separate

1 By J. J. Rolbiecki, in D. D. Runes (ed.), *Dictionary of Philosophy*, London, 1972.
2 Cf. S. H. Nasr, *Three Muslim Sages*, Cambridge, Mass., 1964, pp. 62–3.
3 See Henry Corbin, *Les Motifs zoroastriens dans la philosophie de Suhrawardi*, vol. II, Tehran, 1948, pp. 10–11.

1 S. H. Nasr, *An Introduction to Islamic Cosmological Doctrines*, p. 46.
2 Nicomachus' *Introduction to Arithmetic*, translated by M. L. D'Ooge, Chicago, Ill., 1952, p. 813. Nicomachus' work, translated into Arabic by Thabit ibn Qurrah, became one of the main documentary sources in the Muslim world for the Pythagorean doctrine of numbers.

itself from this world in order to join, thanks to its celestial ascension, the world of the spirits and eternal life"'.[1]

Nobody has suffered more the 'ridicule of the Sages', as Suhrawardi called it, at the hands of modern Western scholarship, than has Pythagoras; however, there is evidence that his teaching survived throughout the period of medieval Christian cathedral building, in the contemporary craft guilds. A notable example of the portrayal of the Liberal Arts of antiquity occurs on the west portal (in the archivolt of the Virgin's tympanum over the right-hand door) of Chartres cathedral; in this group Pythagoras features prominently. Tradition has it that Pythagoras taught his philosophy on the pattern known as the tetractys — a triangle of ten dots or points arranged in symmetrical relationship. This set of points reads as an equilateral triangle with four points per side — an aggregate of four digits adding up to and representing the perfect number, ten.

The supreme oath of the Pythagorean philosophical community was 'By him who gave the fourness to our soul',[2] and the aim of the community was a purification based on the same law and measure that governed the cosmos, and which in the terrestrial sphere take the form of rhythmic relations in the form of music, song, dance and ritual. Rhythm partakes of and is governed by measure and can be stated in mathematical proportions; hence there was in the community a great enthusiasm for and devotion to the study of mathematics as a source of Divine Wisdom. Four was the number symbolic of justice as it represented or contained the perfect harmonious proportion.[3]

The predominant accent on the number four in the governing of the created universe was a feature of the Brotherhood of Purity's attitude to number reinforcing the Pythagorean influence: 'God himself has made it such that the majority of the things of Nature are grouped in fours, such as the four physical natures which are hot, cold, dry and moist; the four elements which are fire, air, water and earth; the four humours which are blood, phlegm, yellow bile, and black bile; the four seasons . . ., the four cardinal directions . . ., the four winds . . ., the four directions envisaged by their relation to the constellations (awtad); the four products which are the metals, plants, animals and men.'[1]

If we recall the basic archetypes of the Zodiac and Planets as expressed in the Macrocosm we observed the role of the numbers 3 and 4: three as the descending, expanding and ascending of the spiritual light as source, and four as the cardinal qualities of heat, moistness, dryness and cold. These two archetypal numbers are united in the geometrical figure and prime solid — the tetrahedron. This figure has four triangular faces and four nodes; and is traditionally associated with Plato as the first member of the four regular solid figures known as the Platonic solids. In fact it is well to remember that Plato was in fact recording an oral tradition — the dialogues — and, even though the figures can be deduced from his obscure descriptions in the Timaeus, he was obviously guarded as to how much he revealed of the mathematical knowledge of the Pythagorean tradition.

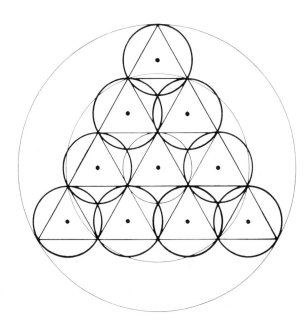

1 From the Rasa'il (I, 58–9), as quoted by S. H. Nasr, op. cit., p. 49.
2 See Thomas H. Heath, The Thirteen Books of Euclid's Elements, Cambridge, 1926, vol. II, pp. 112 f.
3 One such version is believed to be related to the harmonic lambda in the Timaeus.

1 Rasa'il (I, 27), as quoted by S. H. Nasr, op. cit., p. 50.

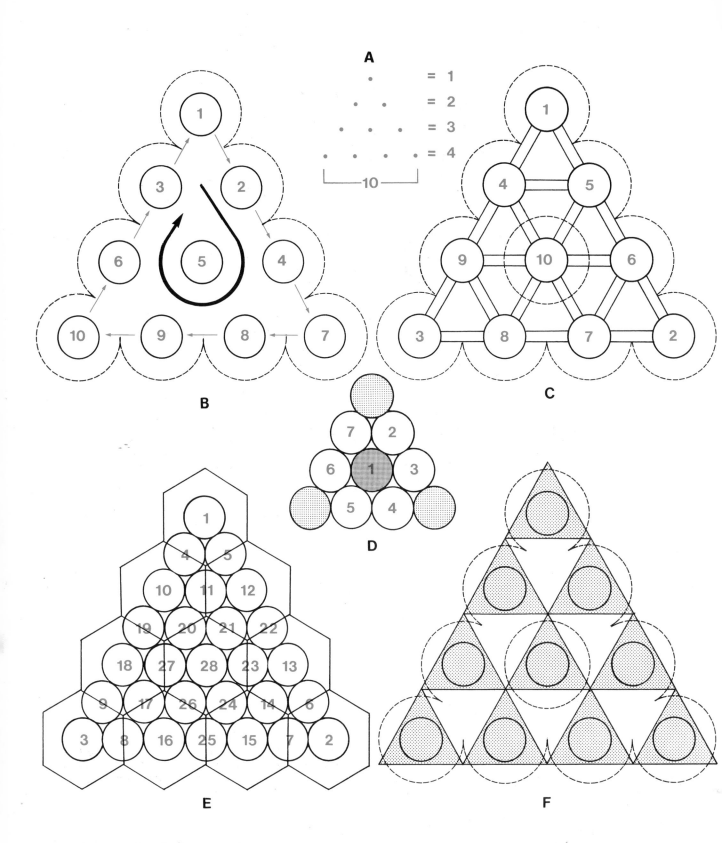

A

B

C

D

E

F

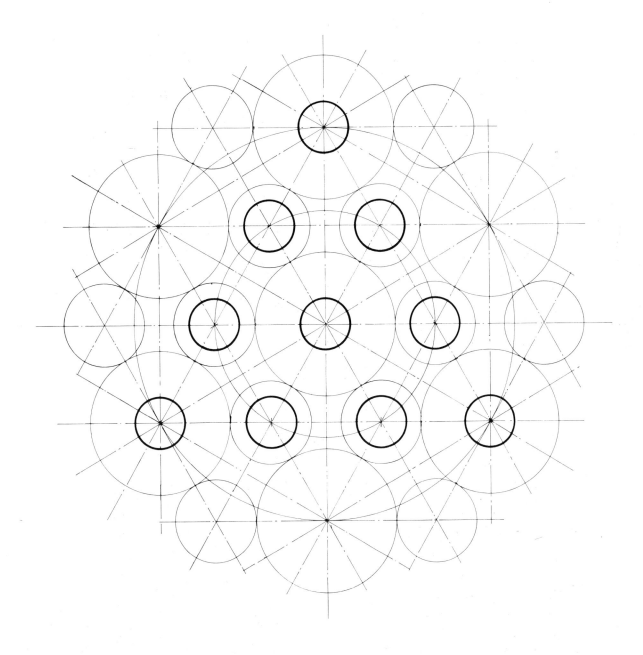

Aspects of the tetractys

A *The morphic number basis of the arrangement*
B *Ascending numbering, with another possible sequence indicated by an arrow*
C *The pattern numbered spirally; the paths between the circles are drawn proportionally*
D *The seven nuclear circles*
E *Version composed of ten hexagons, within which paths plus circles are numbered spirally from 1 to 28, suggesting a correspondence to the emanation model of Ibn 'Arabi*
F *The pattern in triangular form: ten alternate triangles are shown in tone*

Above
A version of the tetractys related to the structural lines associated with one of the semi-regular grids.

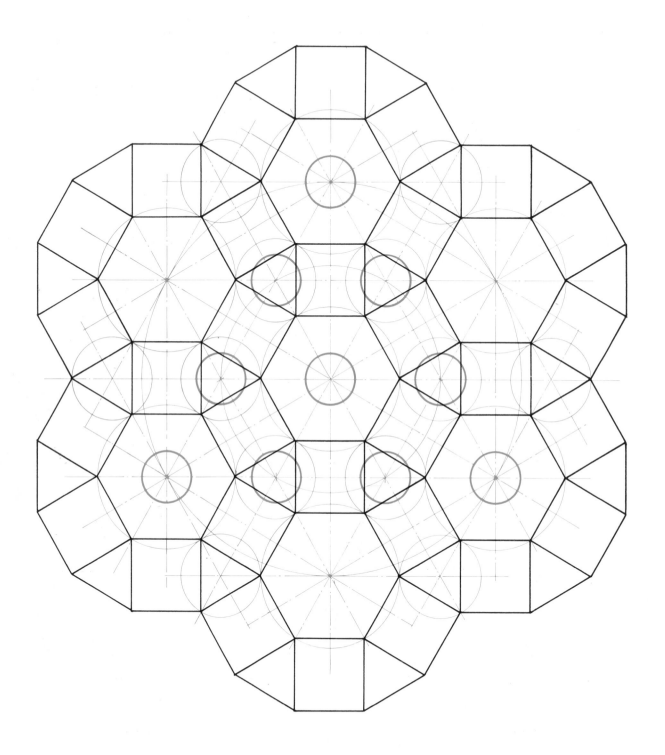

The semi-regular grid, integrating hexagon, square and triangle, can be shown to have an essential relationship to the tetractys pattern in the manner illustrated, where the centres of the four hexagons and six triangles make up the ten points.

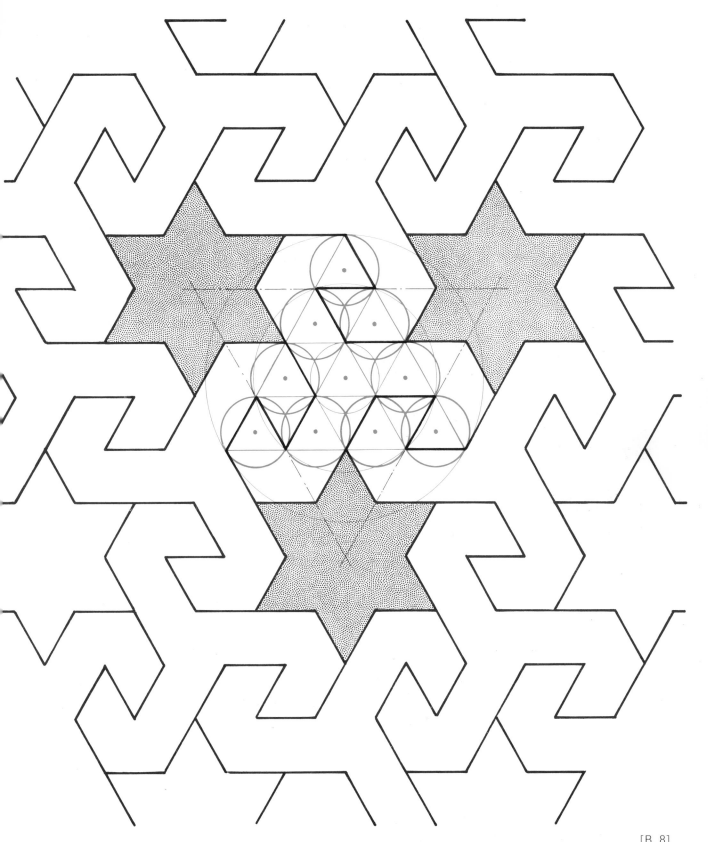

[B. 8]
This interlocking pattern consists of stars and a three-armed
motif; the underlying controlling pattern of the tetractys is
suggested in colour.

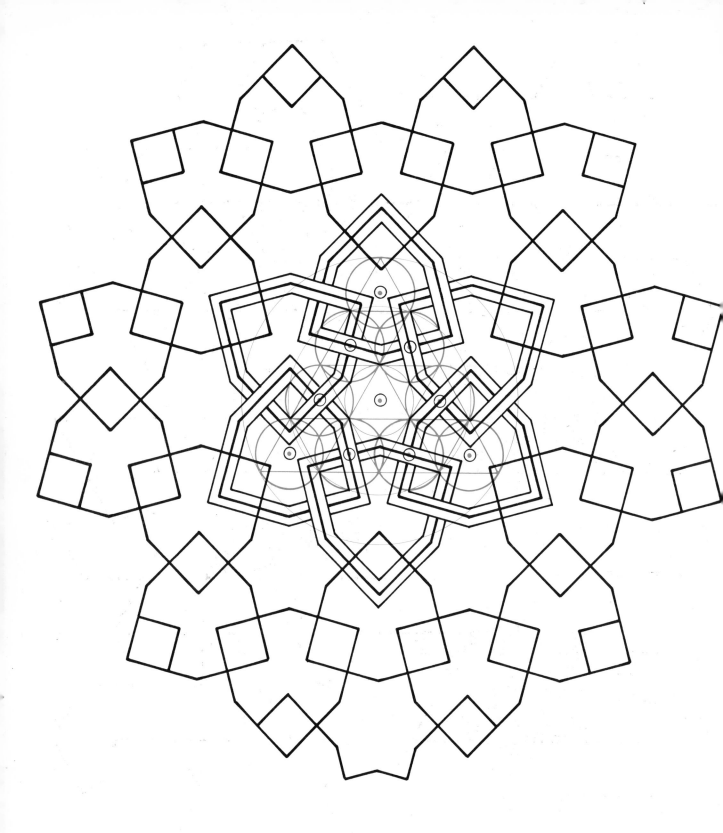

[B. 14]

This pattern of interwoven closed paths unites three, four and six in its own particular way. The hidden controlling proportions of the tetractys are suggested in colour.

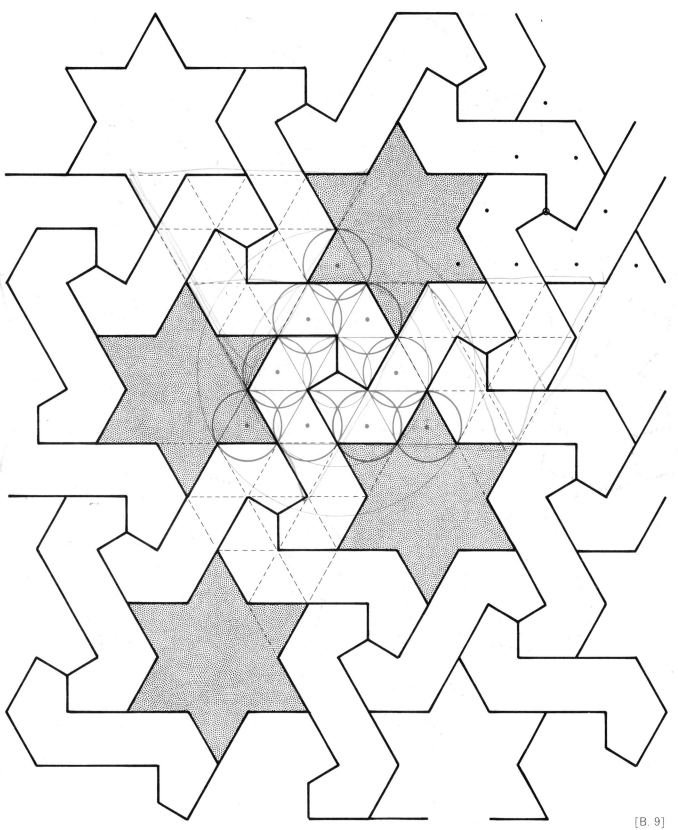

[B. 9]

Another variation on the turning symmetry of six-pointed stars, with sets of three two-armed motifs. The tetractys pattern in colour, together with the broken line in black, suggests an interlocking controlling factor.

111

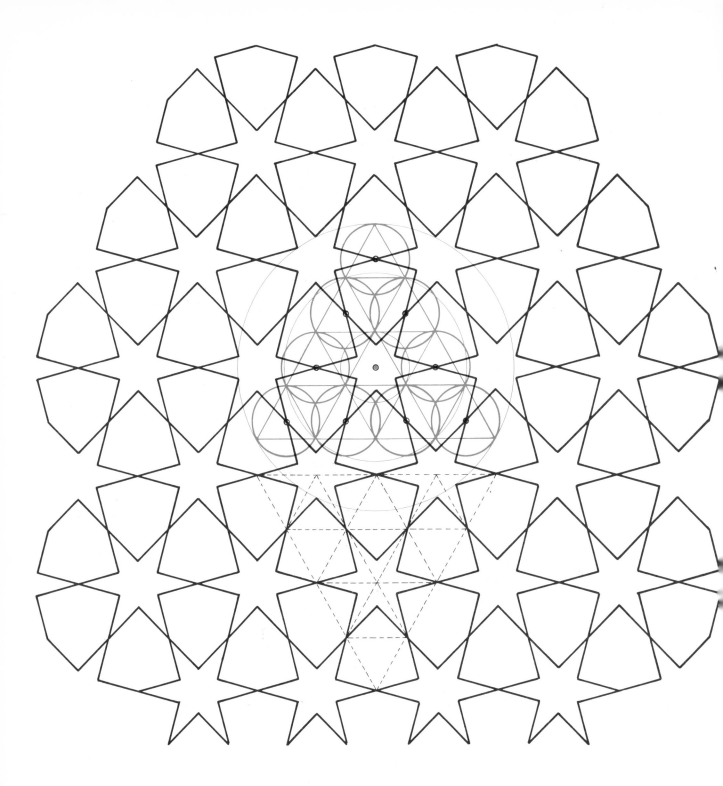

[B. 12]
This visually unusual and singular pattern, which unites
six-'petalled' motifs so different from the previous pattern,
can also be shown to be related to the fundamental module
of the tetractys (shown both in colour and broken line).

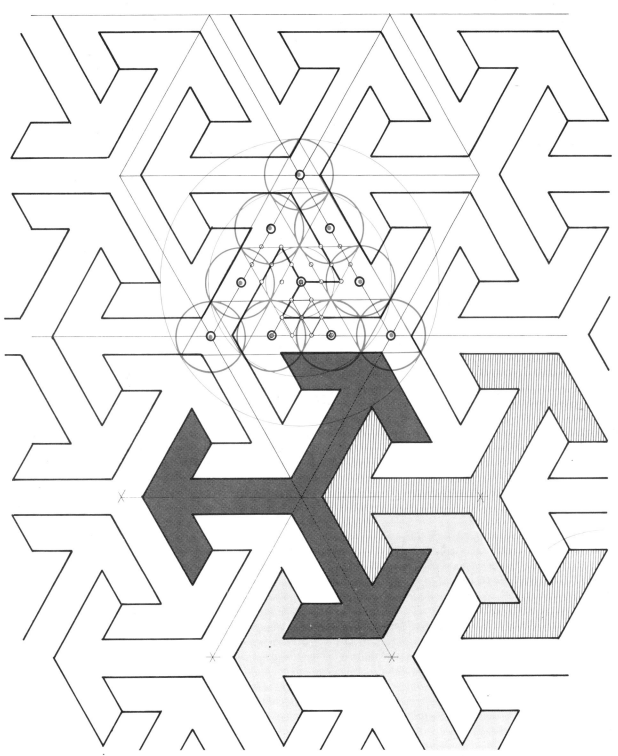

[B. 7]
This pattern shows another universally recurring Islamic motif; it can be found in the widest range of distribution and executed in the widest range of materials. Each motif is three-armed, and three motifs are linked at a central juncture (shown in tone). Above the toned motifs, the tetractys is represented as point circles in two scales; the centre of the tetractys is the meeting point of the three-armed motifs, as well as being the central meeting point of the three smallest-scale tetractys arrangements. This diagram suggests the way in which the smaller tetractys acts as a proportioning device within the overall pattern.

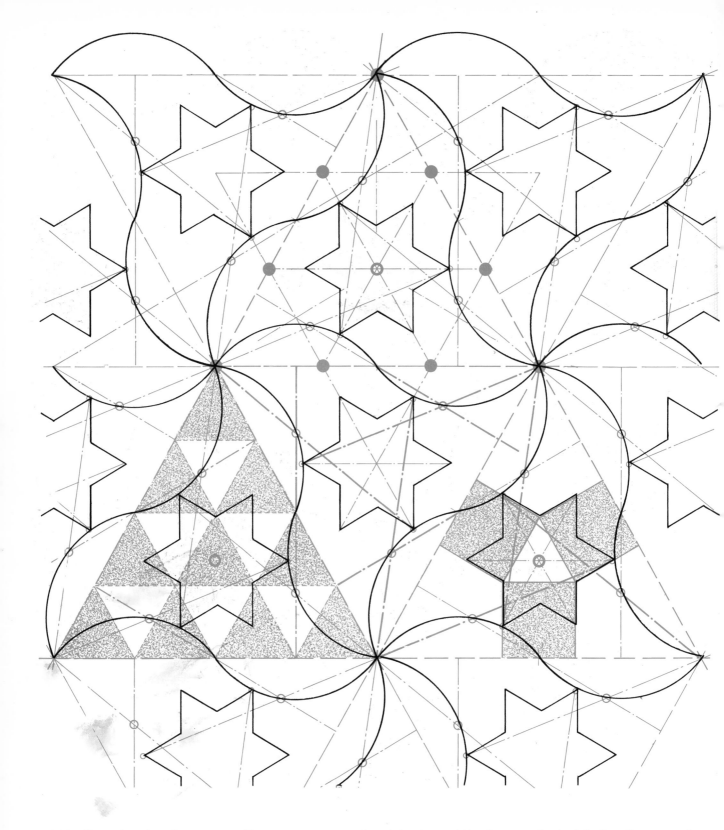

This illustration introduces a curvilinear arrangement of particular subtlety; it is found on the tiled walls of the Alhambra in Granada. The arrangement is based on the six-fold grouping of the three-armed motif, each with a hexagonal star core. The coloured patterns in point, line and plane demonstrate both the connection with the controlling tetractys and the linear method of finding the arc centres (shown ringed). Two versions of the tetractys are shown and a third pattern (bottom right) demonstrates the underlying trio of squares which correspond to the arms of the six-pointed stars and sit within the bounding triangle.

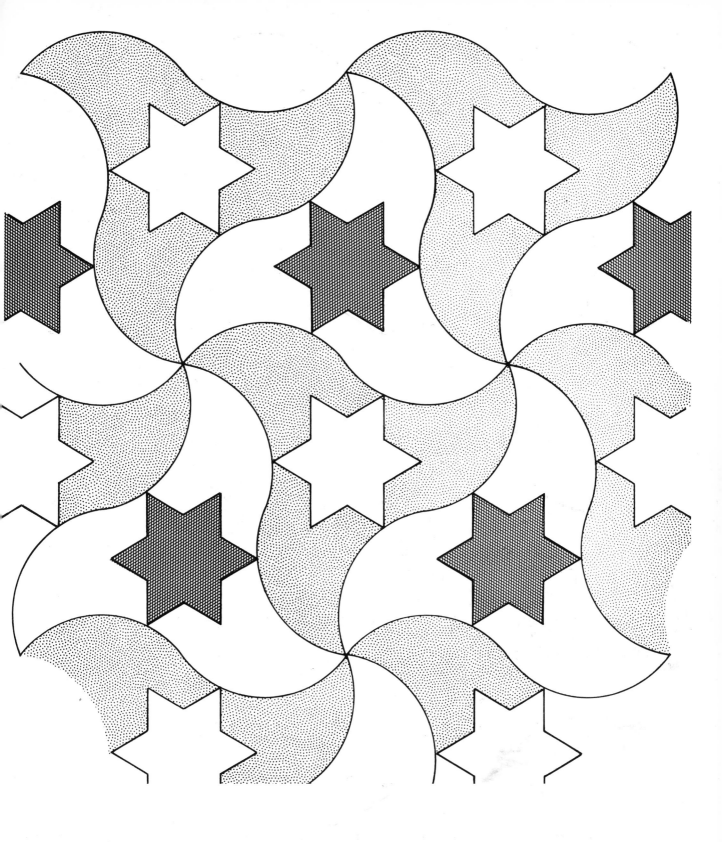

A tonal version of the Andalusian pattern, showing another aspect of the differentiation to which the pattern can be subjected.

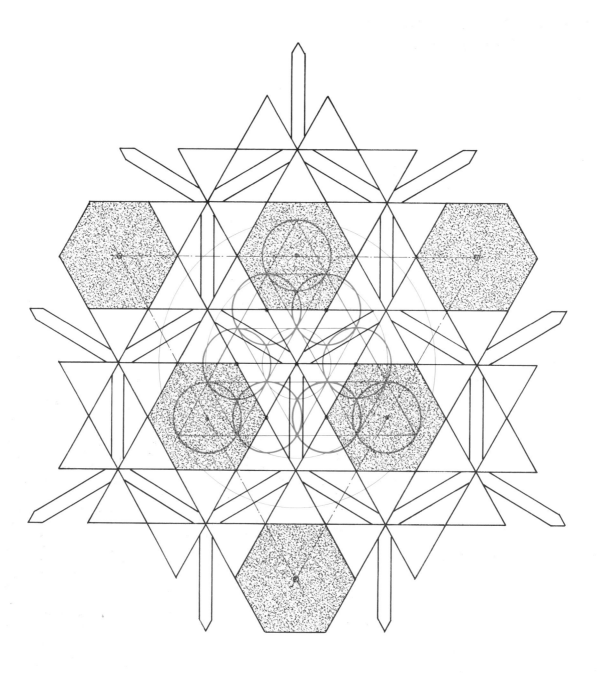

The pattern shown in black represents a pre-Islamic mosaic from a pavement in the Domus Augustana, built AD 81–96 by Domitian, on the Palatine in Rome; it is related to the tetractys format (shown in colour), suggesting that the craftsman may have used as his guide a philosophical basis similar to that of the Islamic master craftsmen of later centuries.

7 The Mathematics of two-dimensional Space-filling

From a philosophical standpoint the tessellations can be considered as elemental combinations of archetypal number patterns. Each polygon has its own archetype and 'personality'. Hence each of the possible combinations of these space-filling elements represents the laws of 'fitting' relationships between these archetypes, each becoming an archetypal lesson in the manner of their disposition and fitting together. The three regular, eight semi-regular and fourteen demi-regular equipartitions (see below) determined by the laws of arithmetic and geometry represent a hierarchy and become the inner core and hidden structure beneath the outward, manifest form of Islamic patterns. These patterns have an indefinite[1] potential, while remaining within a finite set subject to universal laws.

The space-filling surface patterns have been variously termed mosaics, tiles, grids, lattices and tessellations. They can be viewed as vertices, or point relationships, lines, or reticulations of the surface; or as shapes, or the fitting together of regular polygons to fill a surface area exactly.

If we wish to cover a surface with regular shapes or polygons, leaving no spaces between the meeting-points of their vertices, we take n as the number of sides each regular polygon will have, then the interior angles are each vertex of each polygon will be $\frac{n-2}{n}180°$. At each vertex there will be

$$\frac{360}{\frac{n-2}{n}180} = \frac{2n}{n-2} = 2 + \frac{4}{n-2}$$

such polygons. In order that this be a whole number for n greater than 2, n must have values equal to 3, 4 or 6, the regular shapes for figures with this number of sides being the equilateral triangle (1), the square (3) and the hexagon (2). These three are the only regular polygons that cover a plane surface, and are known as the regular equipartitions of the plane surface.

Earlier deductions have shown that there cannot be less than three polygons nor more than six around a vertex. The range of three to six polygons surrounding a vertex provides the equation

$$\left(\frac{n_1-2}{n_1} + \frac{n_2-2}{n_2} + \frac{n_3-2}{n_3}\right)180° = 360°,$$

which gives us

$$\frac{1}{n_1} + \frac{1}{n_2} + \frac{1}{n_3} = \frac{1}{2}.$$

Following the same procedure, we can also say

$$\frac{1}{n_1} + \frac{1}{n_2} + \frac{1}{n_3} + \frac{1}{n_4} = 1$$

and

$$\frac{1}{n_1} + \frac{1}{n_2} + \frac{1}{n_3} + \frac{1}{n_4} + \frac{1}{n_5} = \frac{3}{2},$$

and finally

$$\frac{1}{n_1} + \frac{1}{n_2} + \frac{1}{n_3} + \frac{1}{n_4} + \frac{1}{n_5} + \frac{1}{n_6} = 2.\,[1]$$

From this it follows that there are seventeen possible solutions in whole numbers, shown in table 1. Of these, the three marked with an asterisk (K, P and S) can be discounted as they were the first and only totally regular solutions, i.e. three hexagons, four squares and six triangles per vertex. In addition A, B, C, D, E and J can be eliminated as they can occur at only one point and will not provide a continuous pattern covering a whole surface. Thus there remain only eight conditions of meeting, which, it will be seen, give rise to twenty-two new patterns or grids. These can be divided by symmetry into those whose vertices are similar on each occasion and those whose vertices vary. There are eight semi-regular equipartitions of the plane surface and fourteen demi-regular equipartitions.

The eight combinations that give rise to the eight semi- and fourteen demi-regular equipartitions are given in table 2. Seven of these eight combinations are employed in our definition of the eight semi-regular partition numbers. The third and sixth are both arrangements of Q (marked Q^1 and Q^2 in the drawing); L qualifies only for the demi-regular patterns.

The fourteen demi-regular patterns[2] can be classified as shown in table 3. Only the fifth of these patterns incorporates three vertex situations; four others (numbers 3, 8, 11 and 12 in the table) together use three types of vertex, doubling on the combination of one of these. The remaining nine demi-regular patterns show the characteristics of using two vertex situations, and two of these (numbers 6 and 13) double on the combination of M and N respectively.

1 Indefinite refers to the realm of manifestation and hence to the bounds thereof; however, because of the existence of multiple reflections of a single image in the flowing stream of manifestation, those reflections are so various as to be uncountable, hence the term 'indefinite'. The term is used especially in contradistinction to 'infinite' which, strictly speaking, refers to a state prior to manifestation and is, so to speak, both its cause and its end. An unaccountable number of 'things' in manifestation in no way allows for the use of a term which takes the issue out of the realm of manifestation, i.e. such 'things' cannot be infinite, only indefinite.

1 I am indebted to Professor Maurice Kraitchik for the basis of the mathematical formulae; see his *Mathematical Recreations*, London, 1966.
2 These are fully developed in Keith Critchlow, *Order in Space*, pp. 62–7.

Table 1

Code letter	Faces						Code letter	Faces					
	n_1	n_2	n_3	n_4	n_5	n_6		n_1	n_2	n_3	n_4	n_5	n_6
A	3	7	42				*K	6	6	6			
B	3	8	24				L	3	3	4	12		
C	3	9	18				M	3	3	6	6		
D	3	10	15				N	3	4	4	6		
E	3	12	12				*P	4	4	4	4		
F	4	5	20				Q2	3	3	3	4	4	
G	4	6	12				R	3	3	3	3	6	
H	4	8	8				*S	3	3	3	3	3	3
J	5	5	10										

Table 2

New number	Code letter	Faces				
		n_1	n_2	n_3	n_4	n_5
1	M	3	6	3	6	
2	N	3	4	6	4	
3	Q1	3	3	4	3	4
4	G	4	6	12		
5	R	3	3	3	3	6
6	E	3	12	12		
7	H	4	8	8		
8	L	3	3	4	12	

Table 3

No.	Code letters*	Faces					Faces					Faces					
		n_1	n_2	n_3	n_4	n_5	n_1	n_2	n_3	n_4	n_5	n_1	n_2	n_3	n_4	n_5	n_6
1	E+L	3	12	12			3	4	3	12							
2	L+(1)	3	3	4	12							3	3	3	3	3	3
3	L+Q1	3	4	3	12		3	3	4	12		3	4	3	3	4	
4	N+G	6	4	3	4		12	6	4								
5	L+Q1+(1)	3	3	4	12		3	4	3	3	4	3	3	3	3	3	3
6	M+M1	3	6	3	6		6	6	3	3							
7	N+Q1	4	3	4	6		3	4	3	3	4						
8	N+Q2+Q1	4	3	6	4		3	3	3	4	4	3	3	4	3	4	
9	Q1+(1)						4	3	4	3	3	3	3	3	3	3	3
10	Q1+(1)						3	3	4	3	4	3	3	3	3	3	3
11	Q2+Q1+(1)	3	3	3	4	4	3	3	4	3	4	3	3	3	3	3	3
12	Q2+Q1+(1)	3	3	3	4	4	3	3	4	3	4	3	3	3	3	3	3
13	N1+N	4	4	3	6		4	3	4	6							
14	N+Q2	4	3	4	6		3	3	3	4	4						

* (1) = regular equipartition.

The regular and semi-regular division of a two-dimensional surface.

The top three drawings represent the three totally regular repeating shapes which will exactly fill a two-dimensional surface: 1, the equilateral triangle; 2, the regular hexagon; and 3, the square. Numerical formulae are given above and within the diagram; those within represent the numbers of edges of each shape that meets at a corner point.

The remaining eight drawings (identified by key letters, see table 2 above) represent the eight possible combinations of the above three shapes, so that all node junctions are similar and have the same kind and number of shapes surrounding each node. These have been called, mathematically, the semi-regular tessellations. No. 1 (M) is composed of triangles and hexagons and is unique inasmuch as it is composed of continuous lines crossing in three directions. No. 2 (N) is the exact balance between the three regular shapes and can be read as overlapping twelve-sided 'circles'. No. 3 (Q1) is a combination of triangles and squares with its unique visually 'rotating' movement. No. 4 (G) is a combination of hexagons and squares which leave twelve-sided 'holes'. No. 5 (R) is a combination of hexagons and triangles, another pattern with visual 'movement' which can be drawn right- and left-handed. No. 6 (Q2) is a layered pattern of squares and triangles. No. 7 (E) is a triangular network with twelve-sided 'holes'. No. 8 (H) is the much used square and octagon combination.

The adjacent formulae can be used to calculate exact surface areas of the parts and the whole of a given surface.

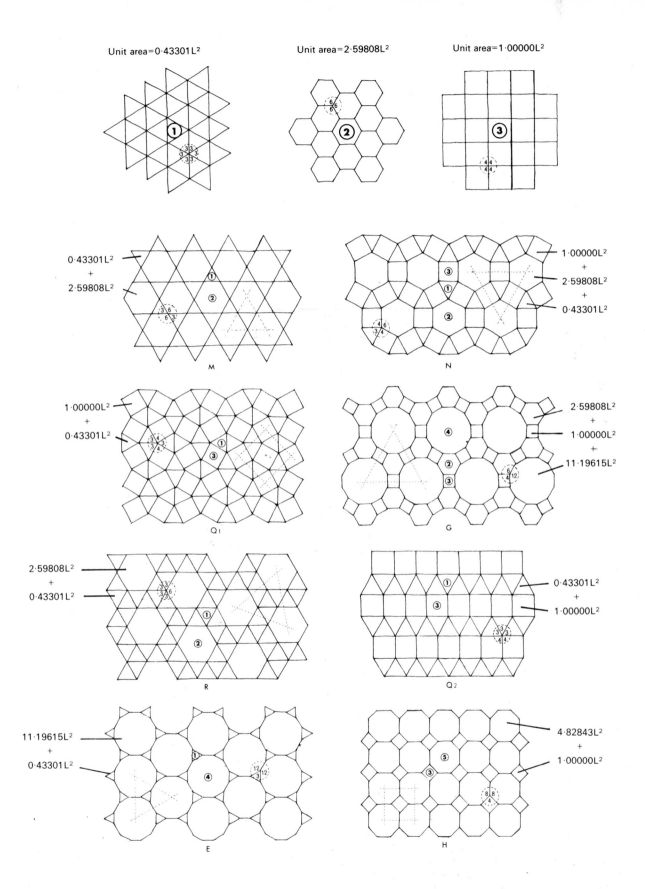

Unit area=0·43301L² Unit area=2·59808L² Unit area=1·00000L²

0·43301L²
+
2·59808L²

M

1·00000L²
+
2·59808L²
+
0·43301L²

N

1·00000L²
+
0·43301L²

Q₁

2·59808L²
+
1·00000L²
+
11·19615L²

G

2·59808L²
+
0·43301L²

R

0·43301L²
+
1·00000L²

Q₂

11·19615L²
+
0·43301L²

E

4·82843L²
+
1·00000L²

H

AREAS OF EACH SHAPE ARE INDICATED IN NUMERALS BASED ON UNIT EDGE LENGTH (L)

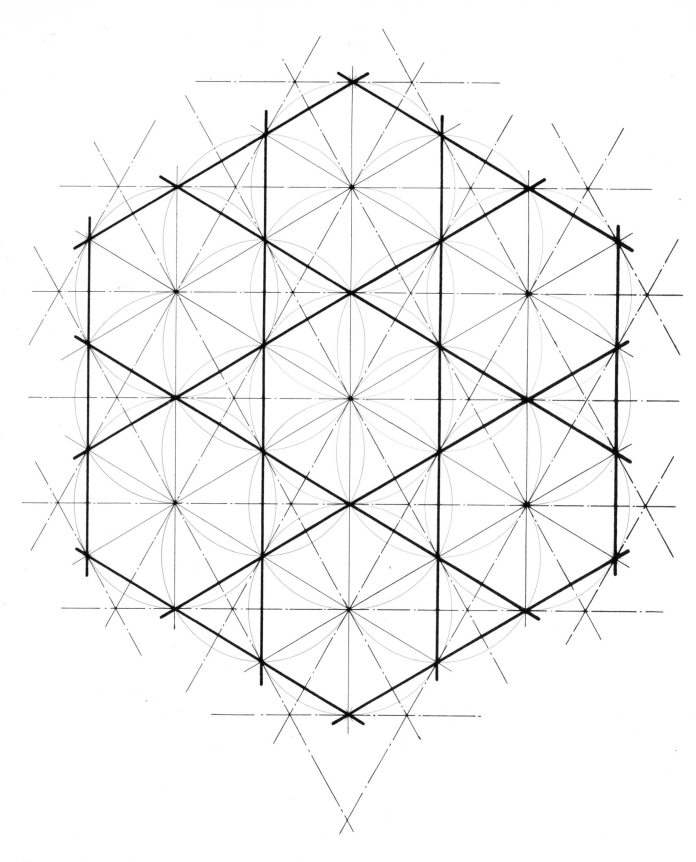

The axes of symmetry on semi-regular pattern no. 1 (M),
with the compass construction shown in colour.

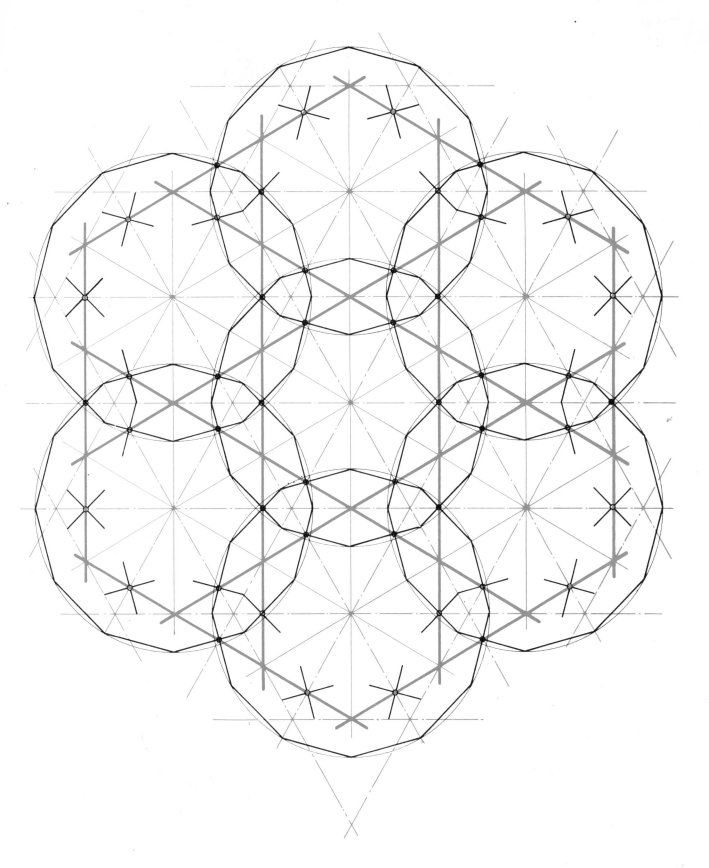

The 90° cross-over points at the centre of each of the edges
of the grid give rise to this specimen Islamic pattern.

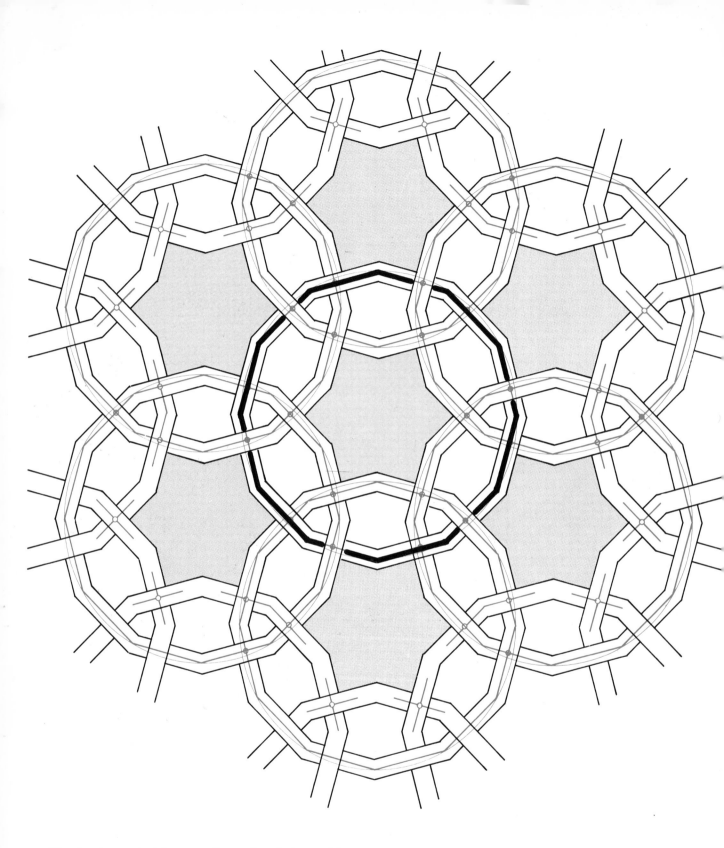

The development of the preceding pattern in 'woven' form.
The linear quality is proportionally expanded to appear as
broad closed paths. The heavy central line isolates one such
path and the toned areas isolate the characteristic star-
hexagon shape as a component.

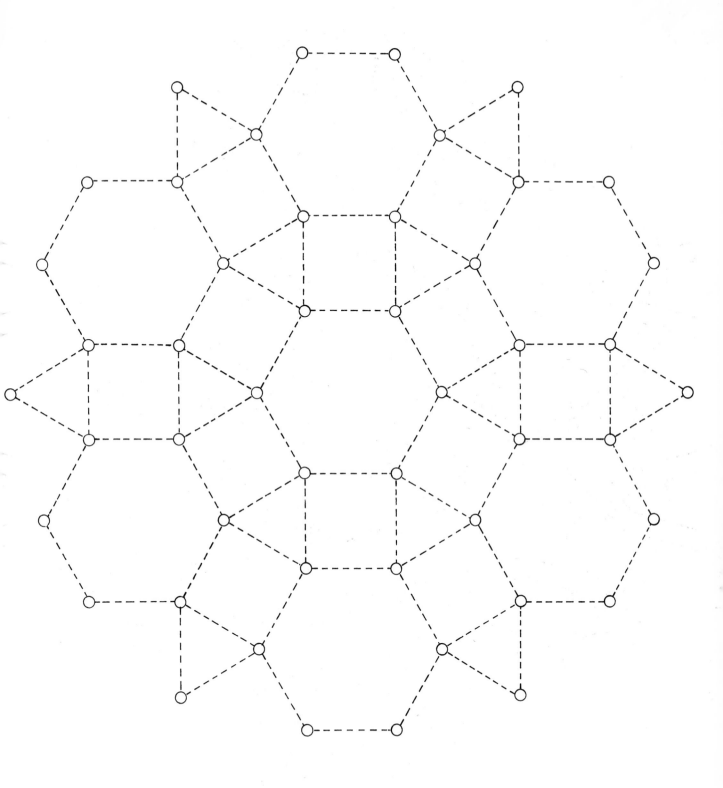

This illustration shows semi-regular pattern no. 2 (N), which also recalls the combination of hexagons, triangles and squares which occurred on p. 35 (D). Here we have accentuated the nodes with circles.

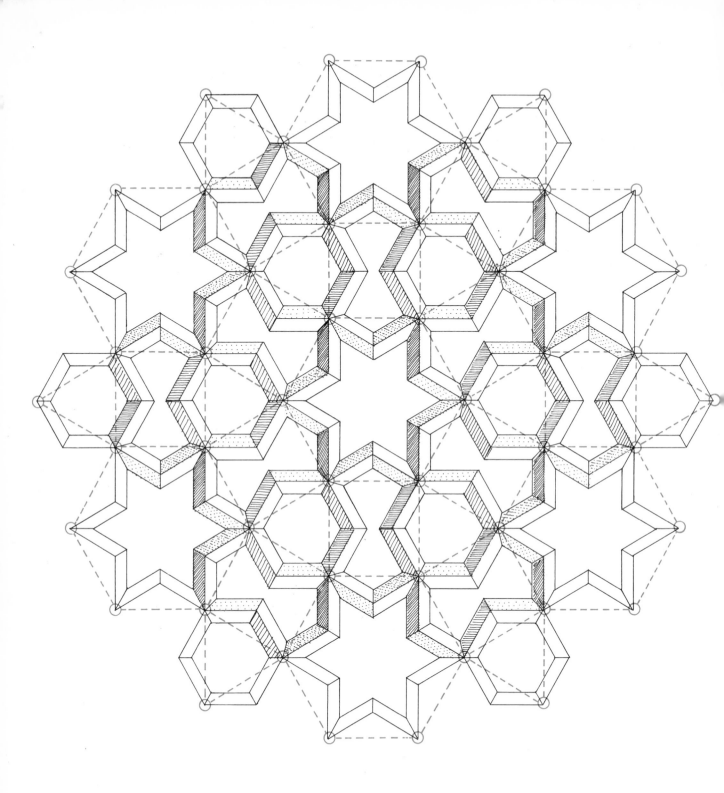

Here we see the same underlying grid (in colour) as the
controlling factor. In black is described a stone lattice
pattern found in the Friday Mosque at Isfahan; the three-
dimensional quality of this lattice is indicated in tone.

124

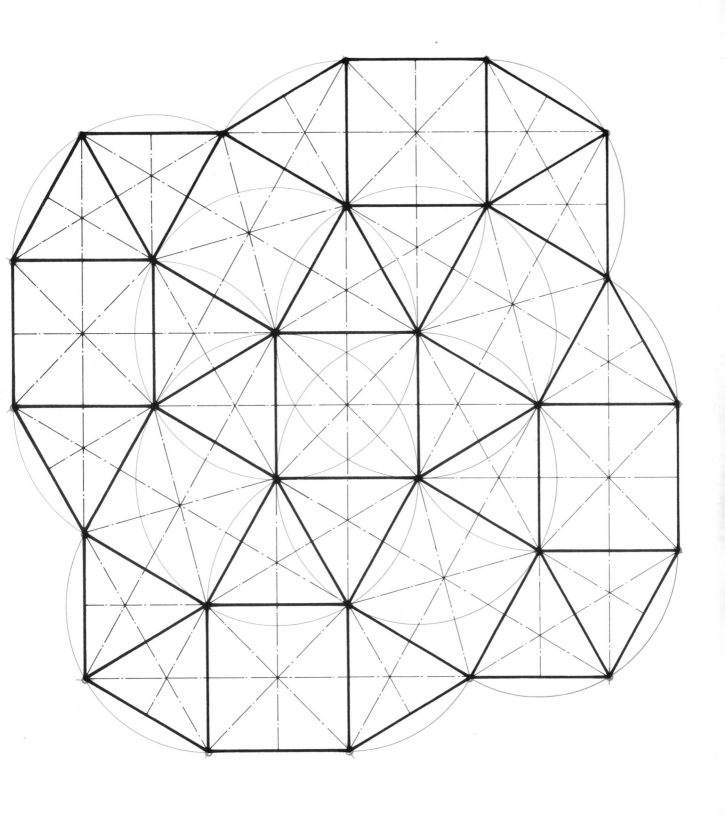

Semi-regular grid no. 3 (Q¹), showing construction arcs in colour and the axes of symmetry in black.

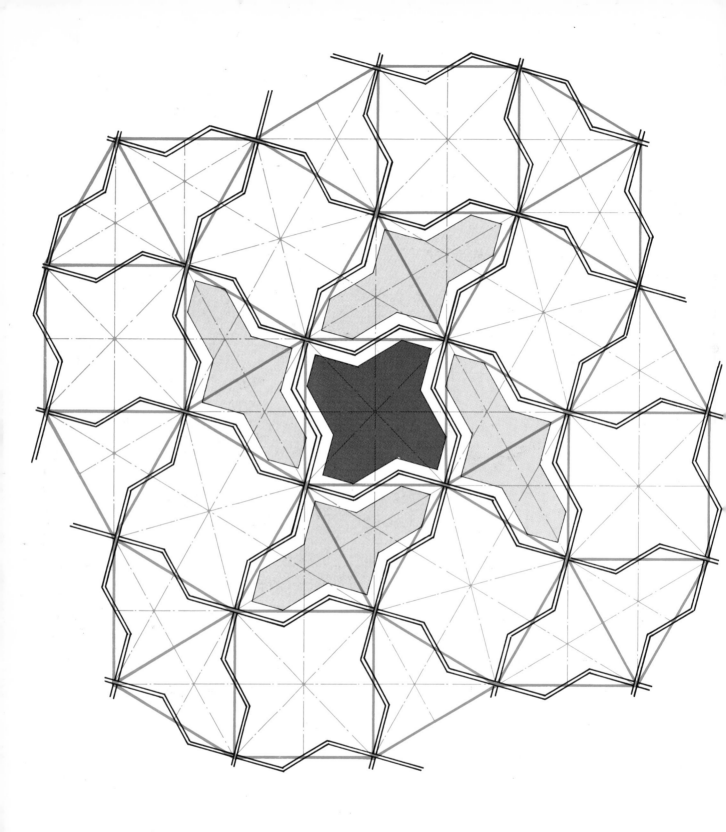

The underlying controlling grid (in colour) can be seen to have been used as a basis for a rotational double bend along each edge. This gives rise to two characteristic shapes, one of which 'spins' to right and left and sits inside the grid squares; the other is in its own terms static and occupies a pair of triangles in each case. This pattern can be found as a window grille in the Alhambra, Granada.

126

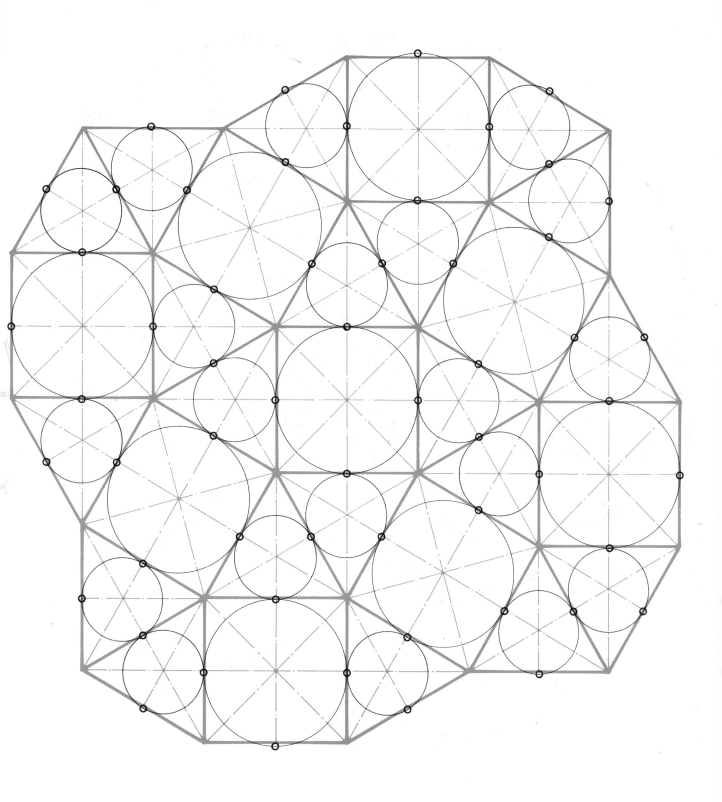

In this illustration we have inscribed circles within each shape and ringed the contact points which are the half-way points of the edges of the underlying grid.

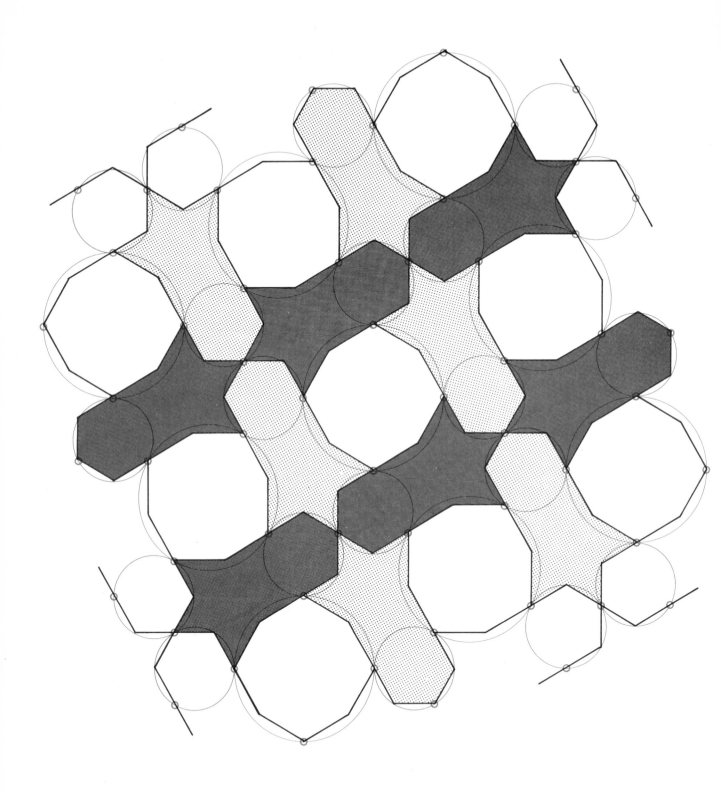

This pattern arises from a particular utilization of the ringed
contact points of the circles in colour. The pattern can be
read as four elements 'turning' around a central asymmetric
octagon or a two-way directional pattern (indicated in tone).

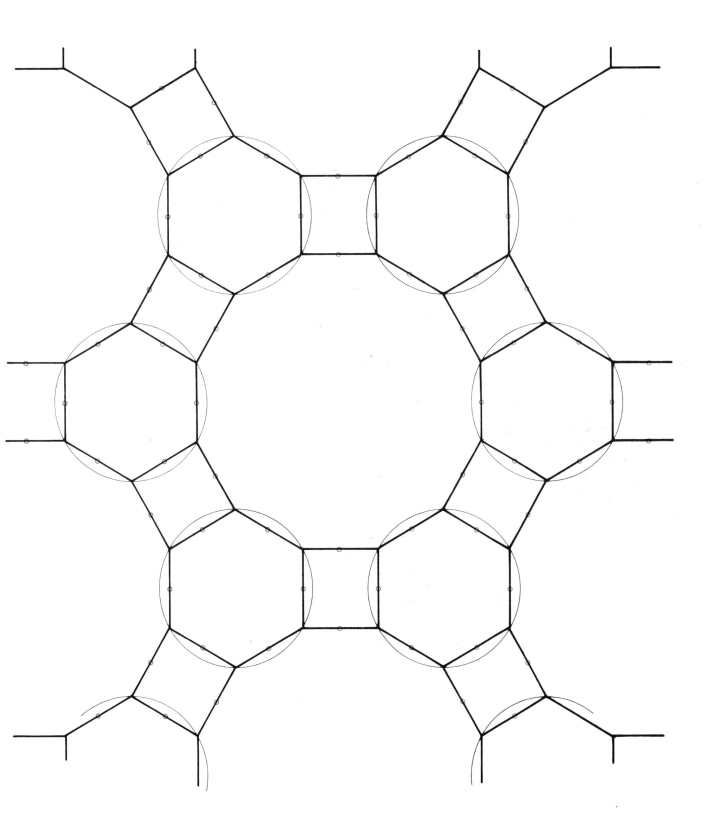

This illustration shows semi-regular pattern no. 4 (G), which is made up of hexagons and squares, leaving a twelve-sided 'hole'. The overall pattern can be visualized as a large hexagon whose points are surrounded by the smaller hexagons in the drawing. After this a secondary hexagon can be visualized, whose points lie midway along the edge of the large hexagon; these in turn are represented by the six central squares in the diagram. The midway points of every line in this diagram are shown ringed in colour as they are the key to the interpretation of the four patterns which follow.

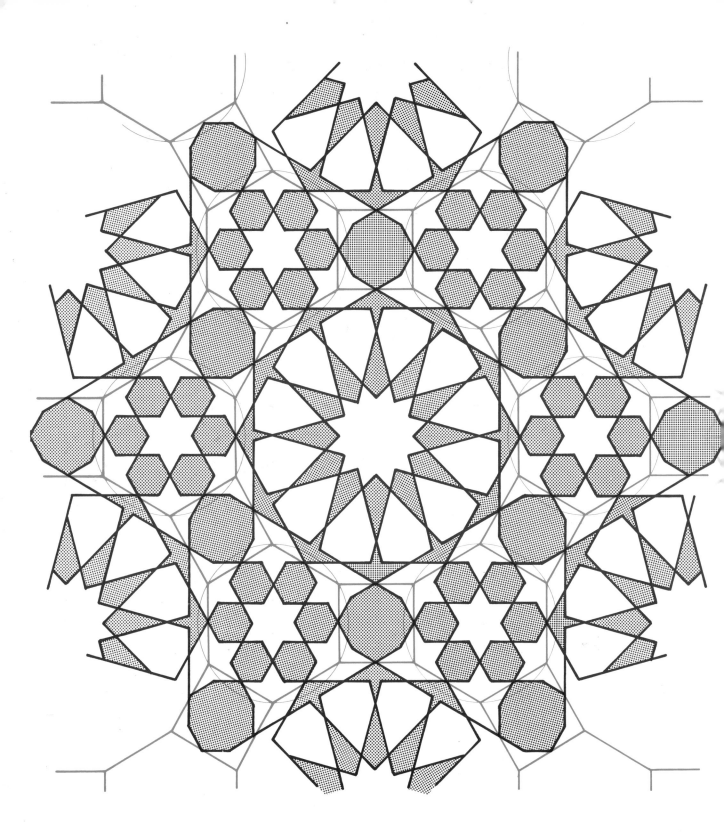

[B. 141]
This pattern is composed of three clearly defined symmetrical shapes. First, the central twelve-pointed star; which in turn generates the twelve 'petals' of the central flower; this set is completed by the surrounding 'arrow-heads'. Six of these arrow-heads point through the midway critical position, each becoming an asymmetric octagon contained by the squares within the coloured grid.

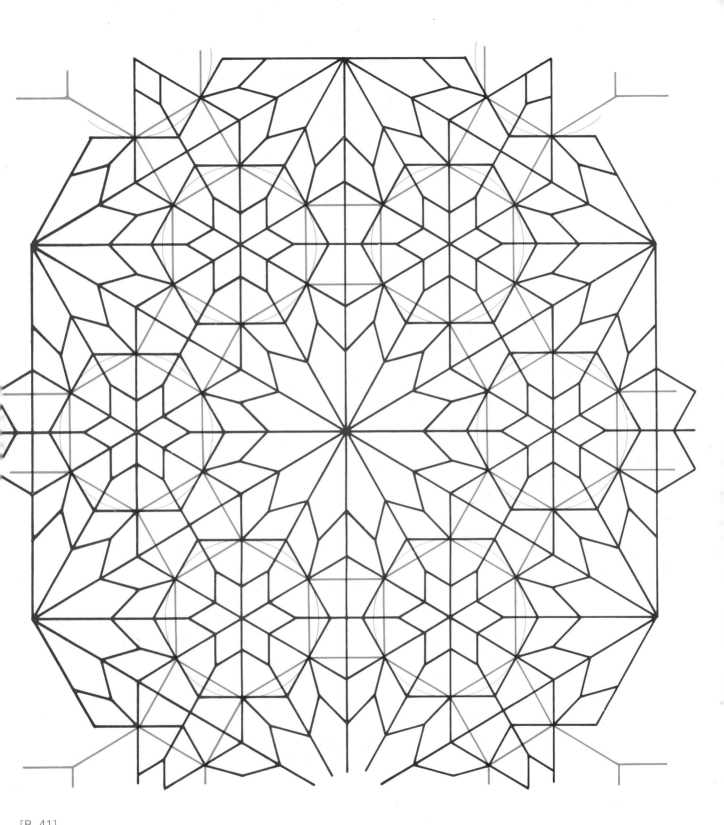

[B. 41]
This pattern, based on the same grid, is in complete contrast both visually and in terms of material function. Whereas the previous pattern dealt primarily with the illusions in the two-dimensional surface, i.e. a very controlled and minimal spatial depth, this example is designed to become the three-dimensional grid of an open latticework, admitting both air and light or (when glazed) light alone. This difference is further emphasized by the fact that an odd number of lines meet at a certain point and therefore cannot 'weave' through. Another property of this pattern is that all the component shapes are four-sided. Such lattices are found throughout almost the entire extent of Islam.

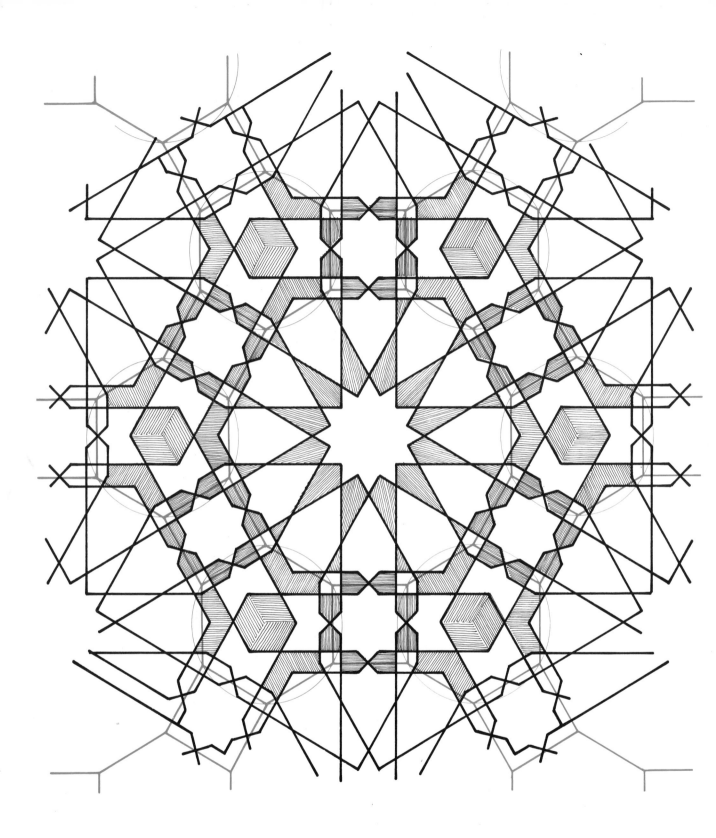

The third pattern in this sequence has a North African flavour and origin, also being found in Spain. This is characterized by six of the central petals which point to the six star octagons (shown within the squares of the coloured grid); these petals have a small pointed feature at the apex, giving them eight sides, whereas the alternate neighbouring petals have six sides. The pattern is generated from the central cross-over points of the squares which become the star octagons.

[B. 91]

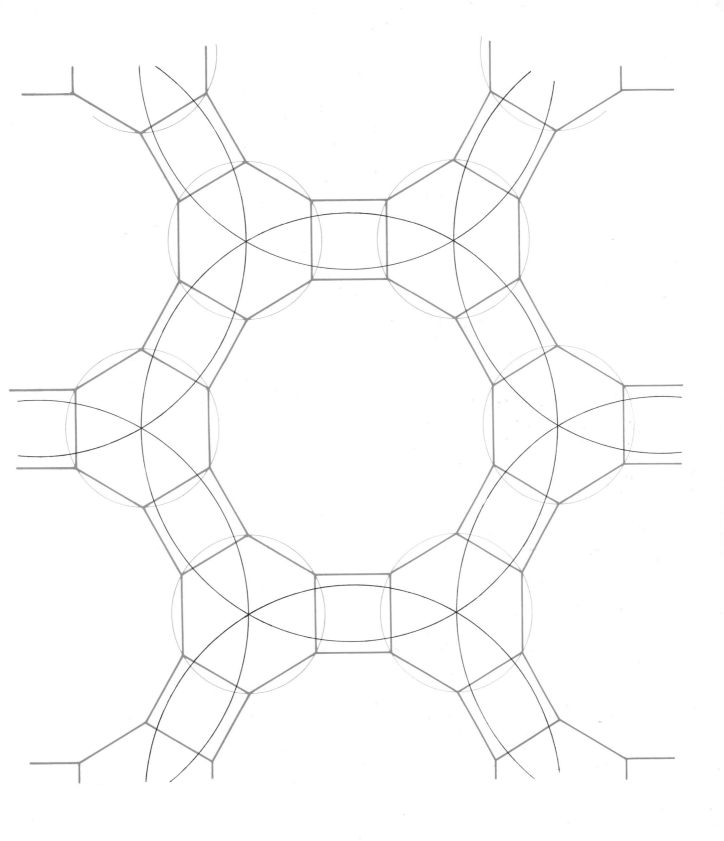

This diagram links the centres of the hexagons of the coloured grid, recalling the hexagon visualized in the pattern on p. 22 and one stage in the six-fold creation sequence in Chapter 1.

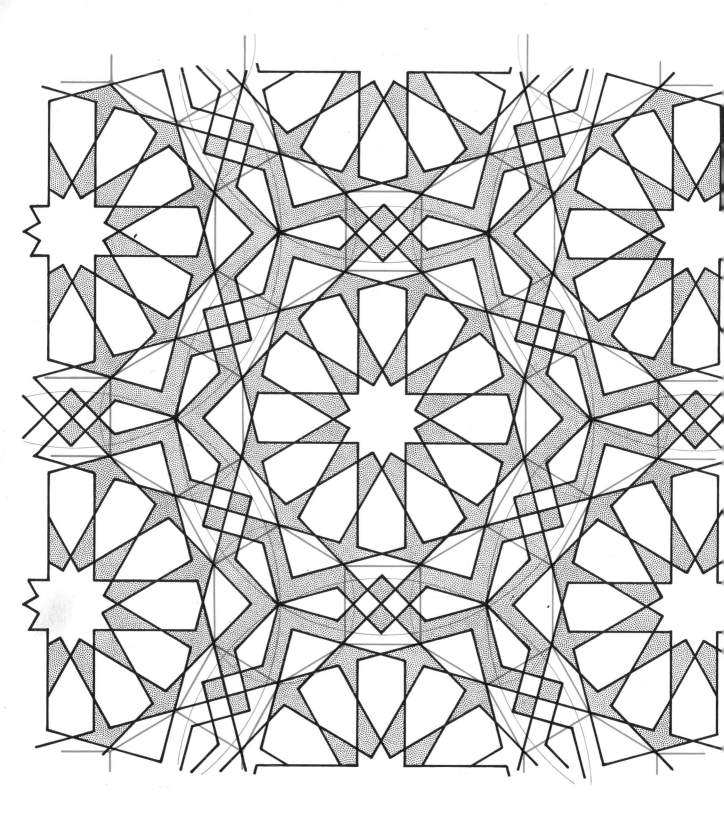

We now utilize the previous diagram to demonstrate its determining value to our fourth pattern. This [B. 81] can be seen to relate to the tessellation at its points and to the arcs as interwoven twelve-pointed stars. The thickness of these stars is determined by parallel lines which are the difference between the star determined by the dodecagon of the tessellation, and the star which fits within the circle. These largest twelve-pointed stars overlap within the squares of the tessellation to become a smaller set of squares (shown in alternate tone). The remainder of the pattern follows quite logically within the convention of the woven pattern.

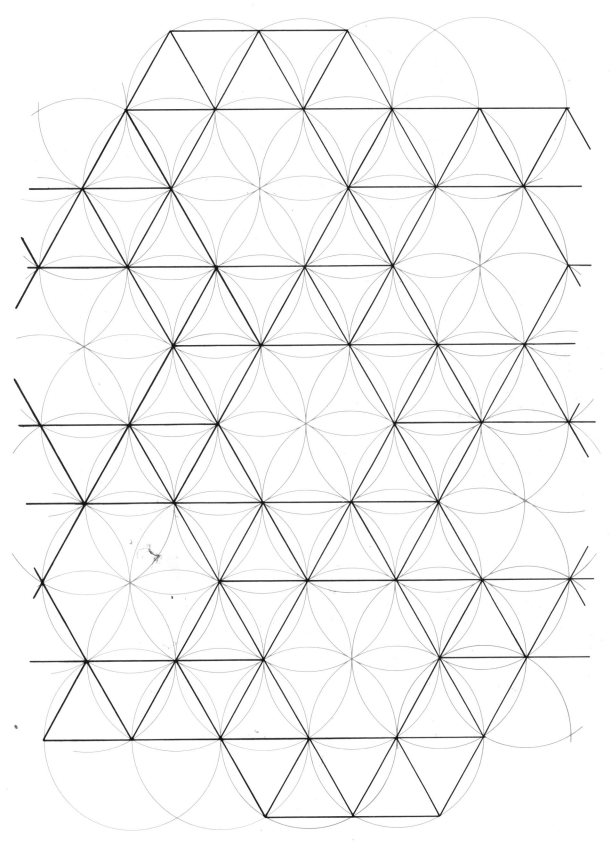

This is an extended version of semi-regular pattern no. 5 (R), with its underlying construction shown in colour. This pattern can be drawn with a right- or left-handed bias.

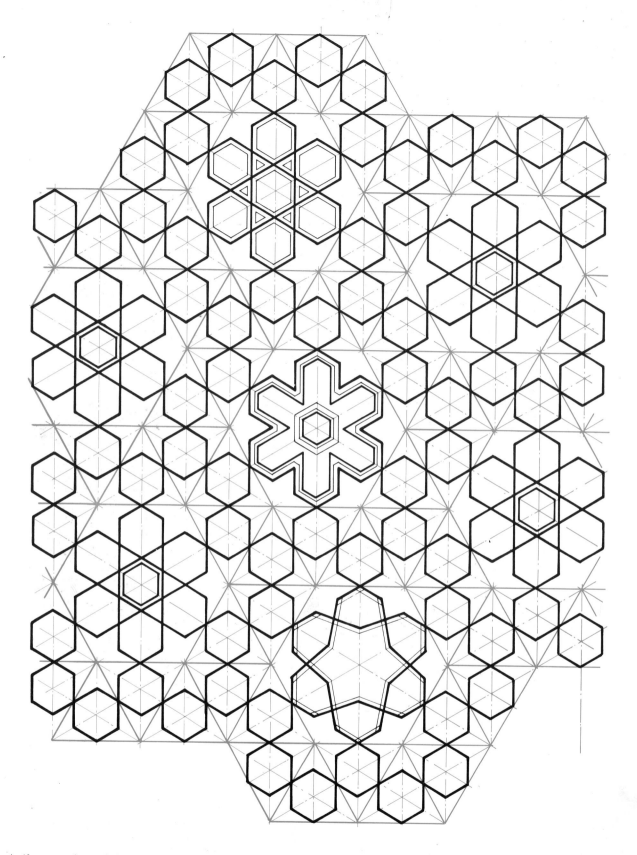

The half-way points of the edges of the grid when crossed over at 60° set up this pattern of six-pointed stars and hexagonal petals, which are traditionally related in a variety of ways, some of which are drawn here. This may well be the most frequently recurring Islamic geometric pattern both in time and overall distribution.

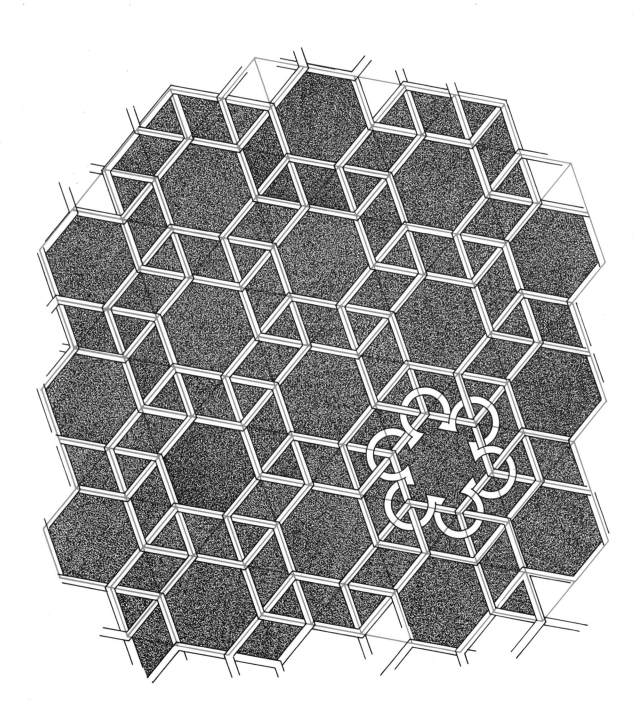

The pattern in black with tone represents a characteristic carved plaster grille found in the earliest mosques in the Middle East. Because of the nature of the plaster and the eroding force of blown sand, these grilles are constantly having to be remade, the traditional patterns being retained. In colour the underlying semi-regular grid obviously tightly controls the design, while at the same time the pattern is seen as interwoven hexagons.

The bottom right hand circular insertion represents one of many secondary themes which are woven into such grilles in various ways and at various intervals.

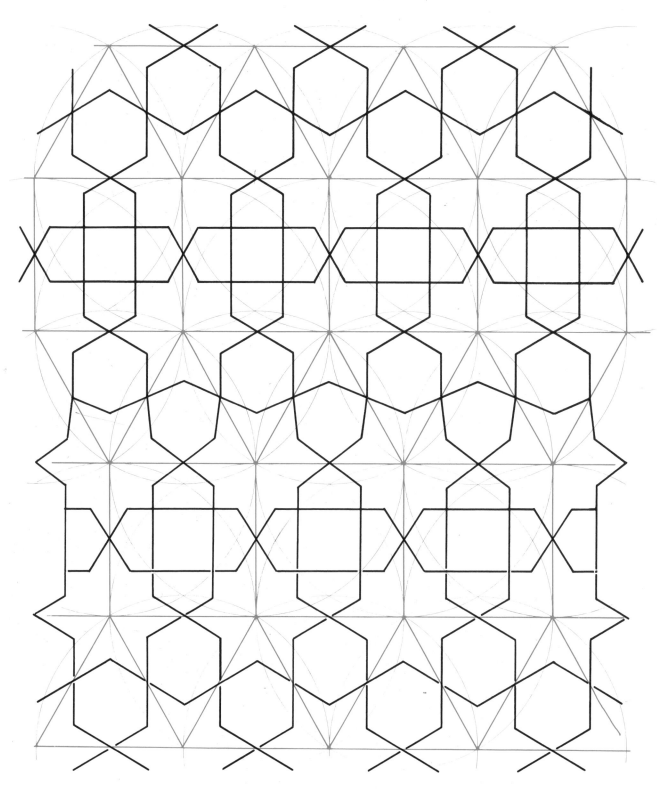

Semi-regular pattern no. 6 (Q²) is shown here (in colour) underlying certain transformations or versions of a particular pattern. Starting from the top, the pattern in black crosses over the centre edges of the coloured triangle to create a set of hexagons. As they cross into the square below, a new four-fold theme is set up, leaving an irregular seven-pointed star surrounding the node of the coloured pattern. This process follows logically downward into the next set of coloured triangles, but changing the angles at the cross-over points and thereby creating new versions as it proceeds. Because of the layered nature of this particular grid, it is more suited to border designs than to use as a repeating pattern.

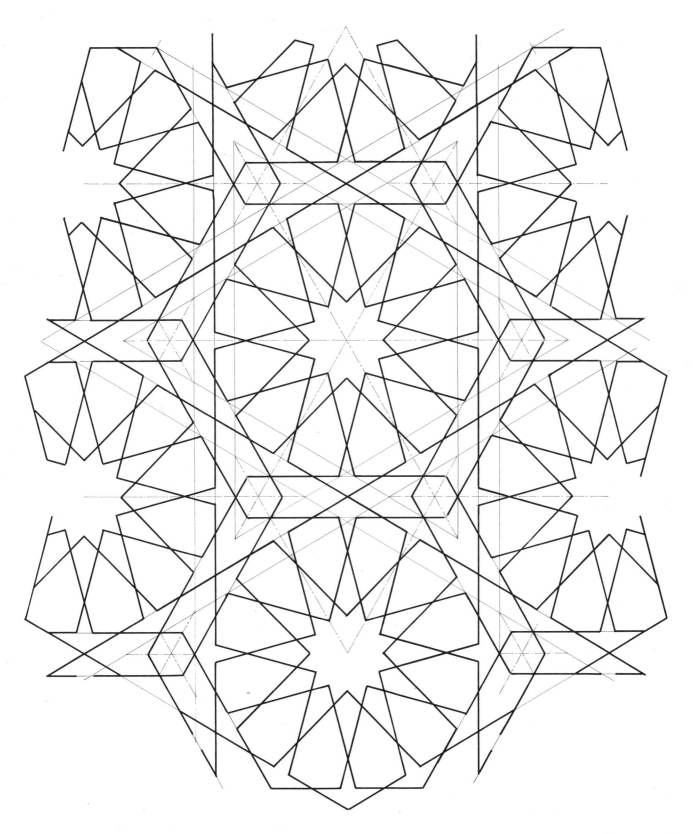

Semi-regular pattern no. 7 (E) is the basis of this drawing. The pattern [B. 76] in itself is composed of six specific shapes. These are: the twelve-pointed star; the adjacent radiating trapezoids; next, the characteristic hexagonal 'petals', fol-

lowed by the twelve 'arrow heads'; the pattern is completed by the regular hexagon and the pointed hexagon radiating three ways from it. Certain important constructional lines have been included in fine and broken line.

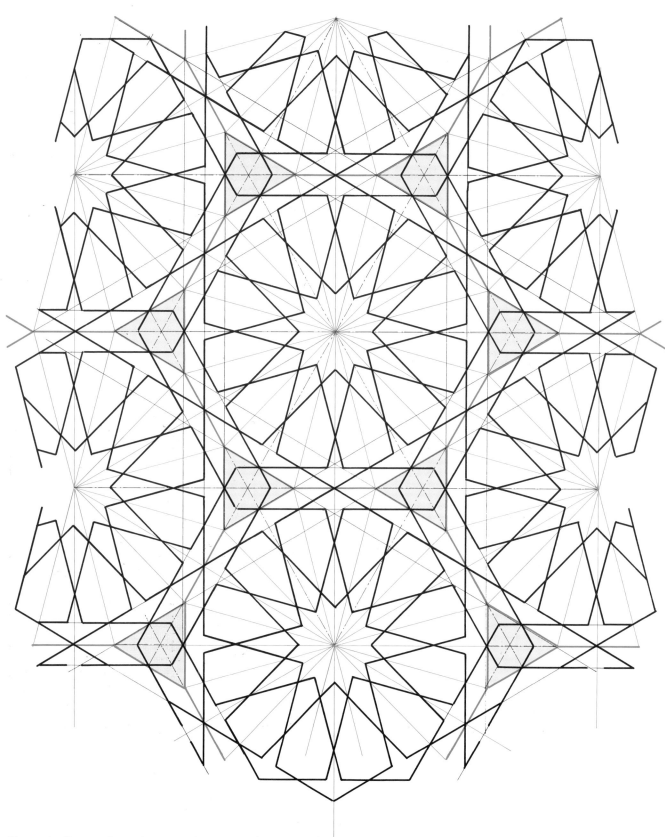

The controlling semi-regular pattern is now seen incorporated in colour, with the triangles shown in tone. Also included, in finer line, are the axes of symmetry of the dodecagons.

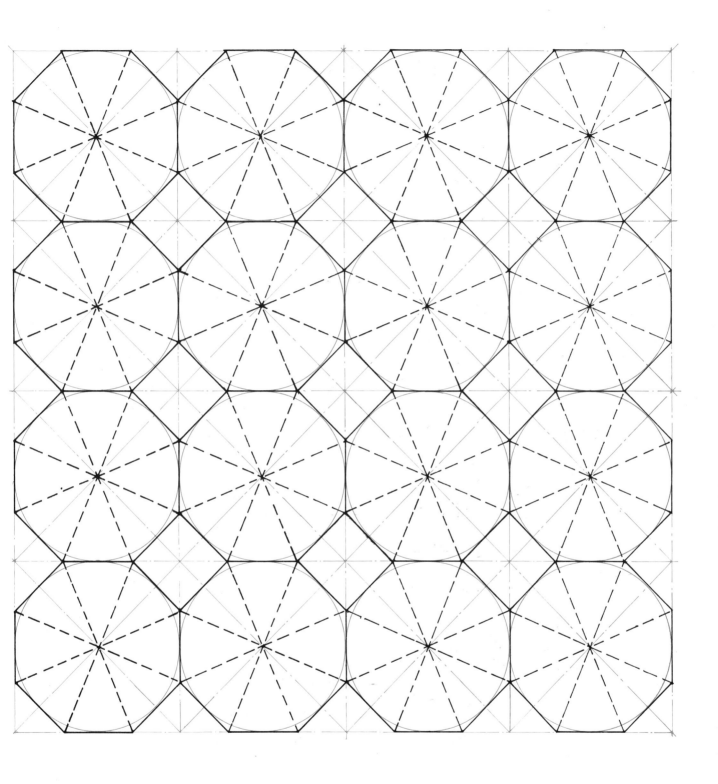

Semi-regular pattern no. 8 (H) is shown here in black, featuring the integration of octagons and squares. Certain axes of symmetry of the octagons are shown in broken line.

The controlling circles of the octagons are shown in colour, together with the full axes of symmetry of the squares which, when extended, complete two more axes of the octagons.

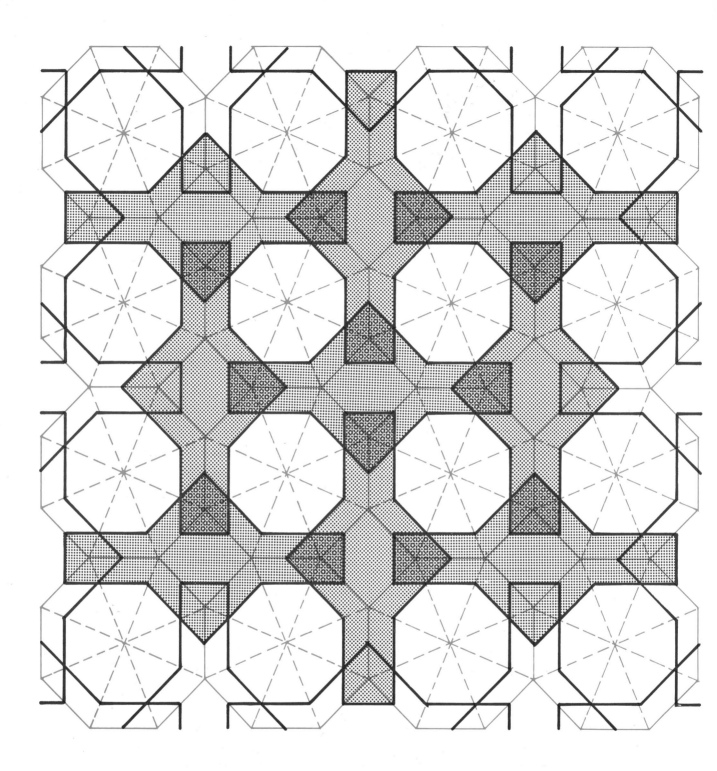

This pattern in black is one that is very commonly found in
the construction of door panels; it is ingeniously derived
from the semi-regular grid (shown in colour) in which the
centres of the edges of the grid also determine the closed-
path constituent forms.

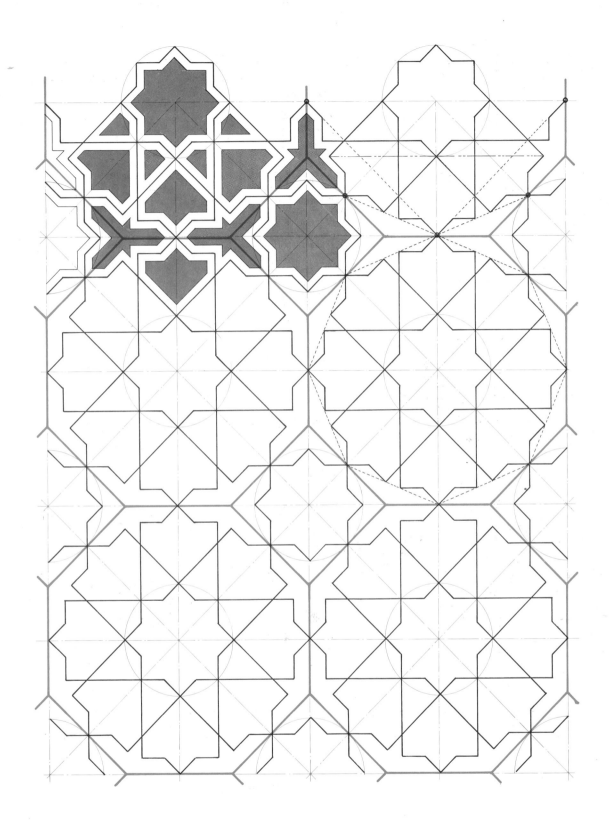

This drawing represents a more complicated interpretation of semi-regular grid no. 8, here shown in colour with constructional circles included in finer line. The pattern in black can be described as containing an independent star octagon within each coloured square, and a 'flowering' star octagon within each coloured octagon. The 90° cross-overs on the half-way point of the grid indicate that the pattern originates in western Islam. Proportional development between line and surface is developed at top left.

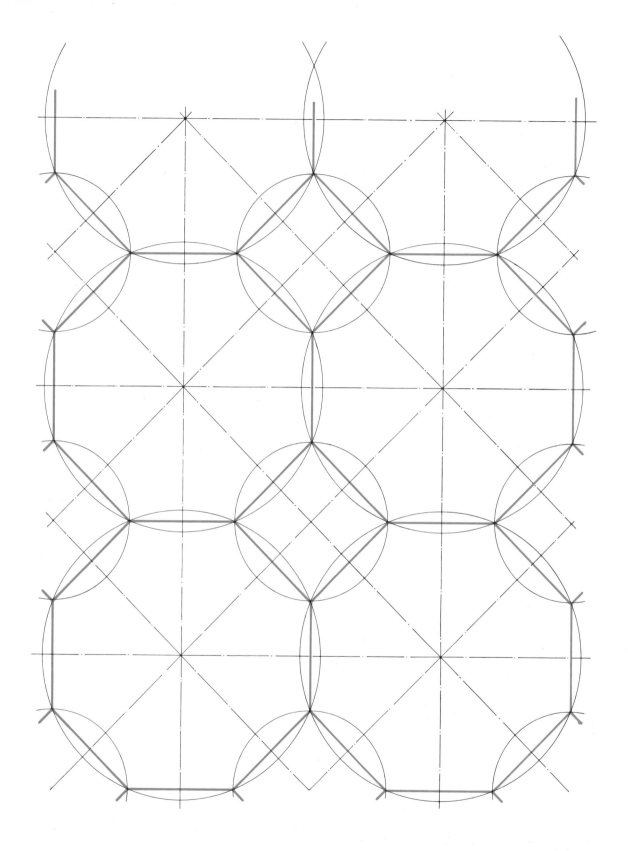

Semi-regular pattern no. 8 (in colour) is shown here combined with the determining overlapping circles of the component polygons with their corresponding axes of symmetry (shown in black).

144

In developing an eventual complex pattern, the next stage is shown here: this involves drawing circles with centres at the nodes of the coloured grid so that they contact with each other at the half-way point of each grid line. Next, at bottom left, a star (in broken line) is created within each octagon. The cross-over points of this star become the centres of smaller circles, each of which is at a tangent to both the central and two peripheral larger circles. To the right of this is another method of finding these centres (ringed) by drawing an octagonal star which is in contact with the inside edges of the eight peripheral circles. These circles lay the ground for the next stages of development of the pattern.

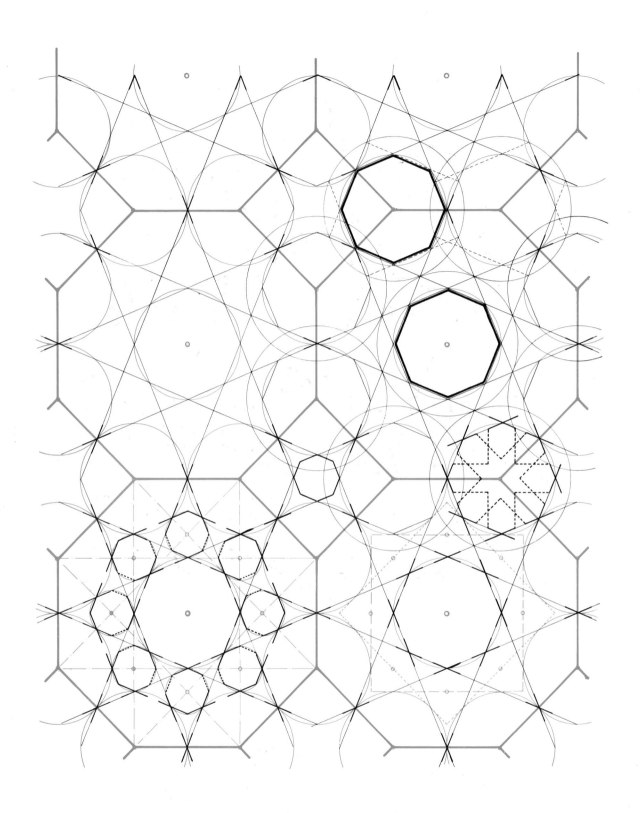

In this drawing the grid and preceding stages are incorporated (in colour) as an aid to visualizing the next stages of construction (in black) of this pattern.

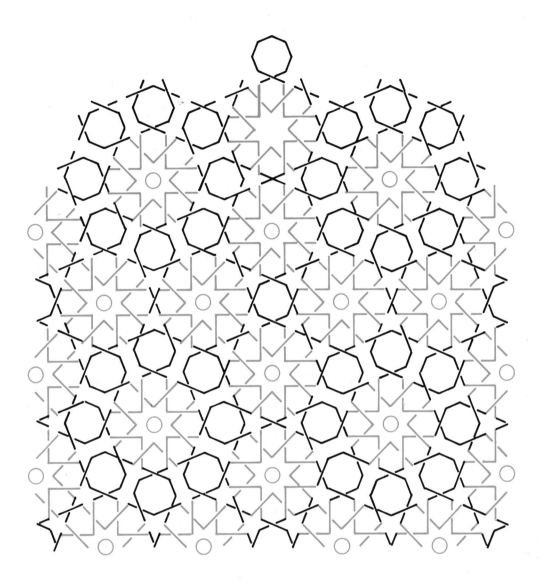

The complete pattern is shown in two colours to differentiate the single octagons from the 'flowering' type and to indicate the woven path which exists in the original Egyptian prototype [B. 143].

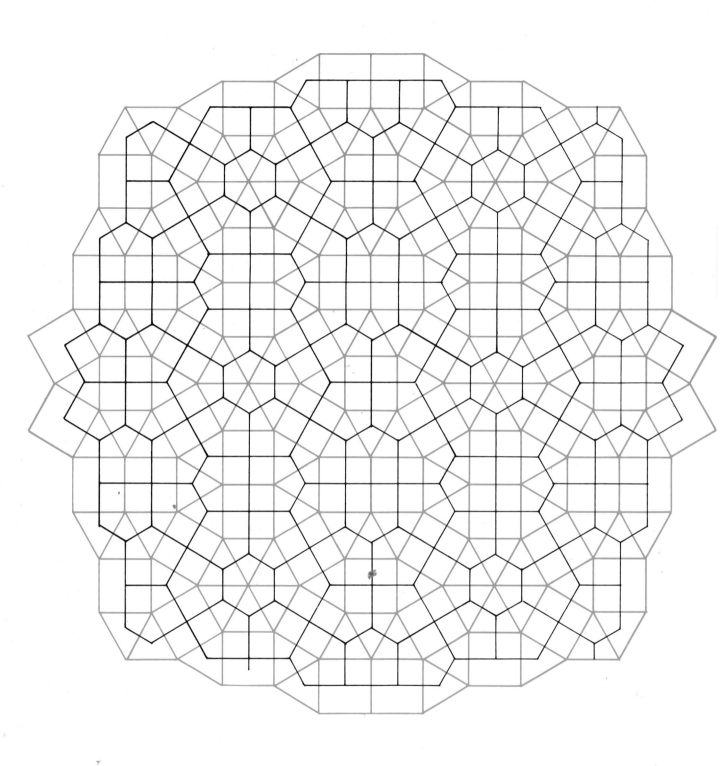

The semi-regular patterns are followed mathematically by a series with a lower order of symmetry — the fourteen demi-regular grids. This illustration shows one such grid in colour with the dual grid in black (a dual grid is one which takes the centre faces of the parent grid as its points and links these to form a second grid). This illustration is not an Islamic pattern in itself, but provides typical outlines used as a guide in developing such patterns.

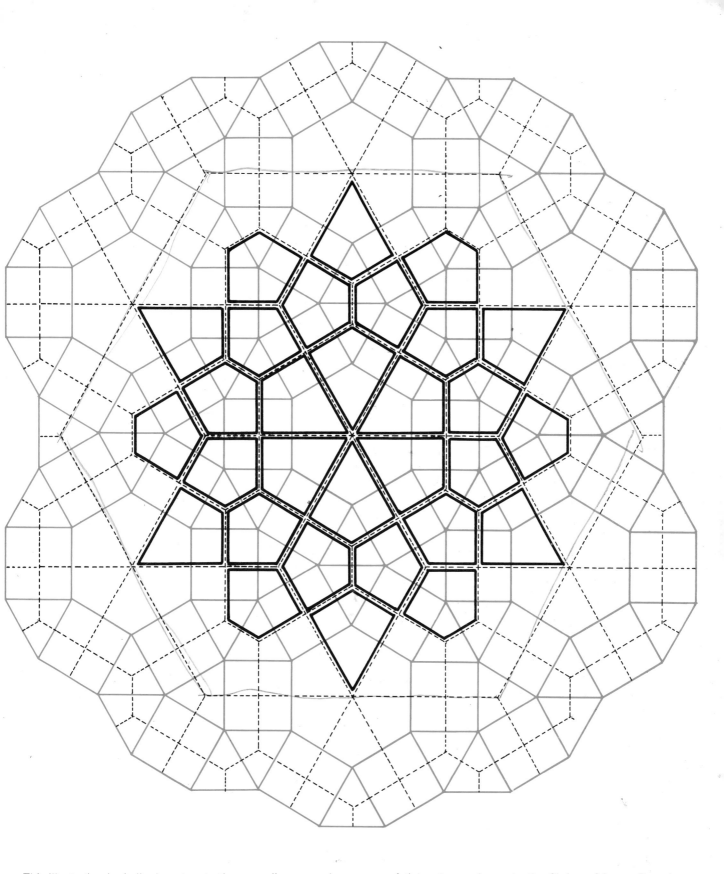

This illustration is similar in nature to the preceding example, the dual grid being shown in broken and heavy line. The coloured demi-regular grid does occur (exceptionally) on one of the entrance *iwans* to the Shrine of Imam Reza in Mashad — the most sacred place of pilgrimage in Persia.

8 The Circle and Cosmic Rhythms

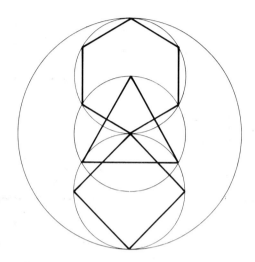

'My companions are stars; whomsoever any one of you follow, you will be rightly guided.' Muhammad[1]

Time is traditionally described as a flowing image of eternity. The circle, as representing the active point of the compasses returning to its own point of departure, is a good symbol of the timeless whole, while the moving point itself represents the passing of time as it describes the circle.

At the head of this chapter three circles are shown within a whole or greater circle. Each of these three circles has within it a shape: a square, a triangle and a hexagon, so placed to represent a traditional form of symbolism. In the bottom circle the square is the representative of the 'earth', or the world of the physical elements: earth, air, fire and water — the solid, liquid, gases and radiation states of energy. The centre circle is the circle of man — the conscious animal. The triangle represents his three-fold nature and the three-fold nature of his consciousness: that is the knower, the known and the knowing; the object, the subject and the conjunctive; or the relationship which links them. The hexagon in the top circle, as the number of perfection, is symbolic of 'heaven'; it is the natural division of the circle as each edge of the hexagon is exactly equal to the radius of the circle which contains it, and can also be taken as symbolizing the six days of Creation, which in itself represents a perfection. This symbolism — Heaven, Earth, Mankind — recurs in slightly varying forms throughout the major religious and philosophical traditions of mankind.

1 Traditional saying of the Prophet.

Opposite

Here we represent the three basic shapes, the square, the triangle and the hexagon. They can be taken to demonstrate the qualitative aspects of the numbers as points or sides of each polygon represented. The triangle corresponds graphically with the number three, representative of the archetype of three; the square with the number four, and therefore representative of the archetype of four; and the hexagon as representative of the number six and therefore the archetype of six. In the first case there are three points, the three edges of the triangle; in the second, four points or corners and four sides to the square; and in the third, the hexagon has six corners and six edges.

If we take the centre column first and move down we have a six-pointed star which numerically can be considered to be three plus three: an equilateral triangle inverted and placed exactly over itself in perfect balance. This symbol alone has infinite potential, far exceeding the bounds of interpretation possible here, or indeed in a whole volume on the subject, but in summary we can say that it represents, in the triangle pointing upwards, the aspirations of man pointing heavenward, and in the inverted triangle pointing downwards, the realm of ideas, towards which man's aspirations are directed.

Below this six-pointed figure we have the number three, three times, arranged as a nine-pointed star or three precisely overlapping equilateral triangles. It can be taken to demonstrate the fact that the number nine has a very special relationship to man both as an archetype and as a tripling of the three primary forces, which, as noted in Chapter 4 on cosmology, are represented in the Islamic perspective by the descending, the expanding and the ascending aspects of the Divine Light. Like the triangle, this nine-pointed star constitutes an independent subject for examination.

Moving to the right-hand column, we have the square representing the number four. If we move down from the square to the image below it, we have one square exactly overlapping another, with the second square pointing upwards. The eight-pointed star thus formed, or the two squares enclosing an octagon at their centre, symbolizes the passive and dynamic aspects of the four elements and relates also to the hot, cold, moist and dry polarities of the archetype of four in combination. The eight-pointed star has also been related to the symbolism of the eight bearers of the throne (from the Quranic source).

Below the eight-pointed star we have three squares overlapping and crossing each other in exact, equilibrium and representing in triple form the number three, as the previous figure graphically represents a dual form, four plus four. In this arrangement we have a twelve-pointed star formed by the squares, and, as we have previously seen, twelve in the Islamic philosophical tradition is most essentially related to the signs of the Zodiac and their symbolism. In this case the squares can be considered to be three groups of four or those groups of four signs which are 'square' to each other, in other words at right-angles across the circle of the heavens or the circle of the Zodiac.

In the column on the left we have first the hexagon and, below it, two hexagons placed over each other in equilibrium. Once again we have an arrangement of twelve points, in this case obtained by turning the second hexagon by 30°. This result can represent six plus six, but we have also placed within the figure an equilateral triangle demonstrating the relationship between the triangle and the hexagon. In the zodiacal symbolism of twelve this holds a special value to

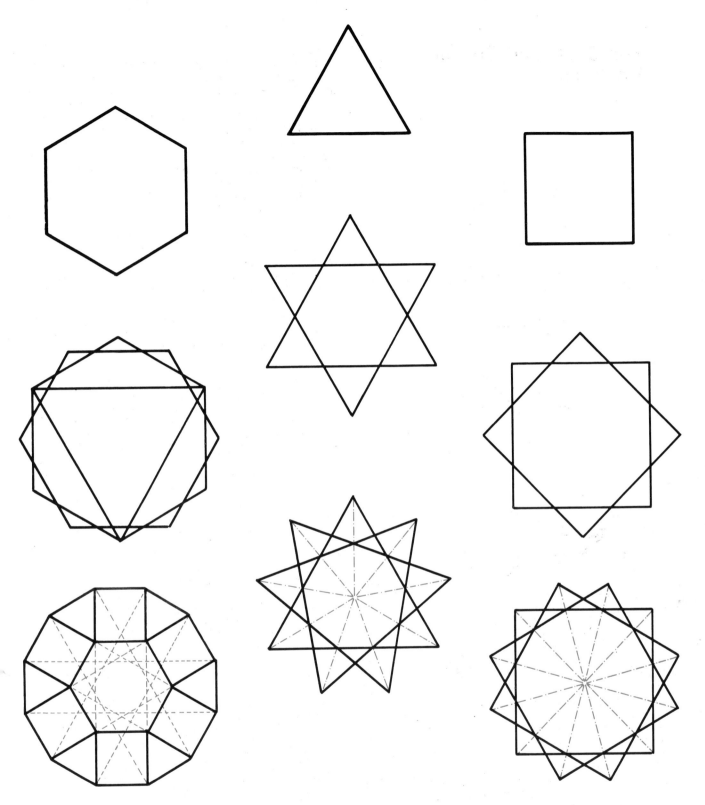

the astrologer-scientists of Islam and signifies special values in the relationships between the zodiacal signs or mansions.

Below these paired hexagons we have the co-ordination of the hexagon, square and triangle inside a twelve-sided polygon. In this case we have the hexagon and, radiating from its edges, a series of six perfect squares, and in between each pair of squares a perfect equilateral triangle. This demonstrates the beauty of both the numerical and arithmetical factors and the geometric co-ordination of the number twelve. The square fits inside the twelve-sided polygon six times in this particular pattern. In the dodecagon we have three times four, four times three, two times six and six times two, all represented in the shape, form and as properties of the archetype of twelve.

So far we have been looking at number patterns and suggesting symbolic interpretations. We shall now examine number and geometric patterns as archetypes expressed within the cosmic system.

This page represents the solar system or a section through the solar system in which the planetary orbits are shown for the sake of graphic convenience as concentric circles. The black circles are sun-centred. This represents the mechanical model of the solar system with the planets (in this case, only the visible planets) rotating around the sun. The circles in colour, arranged as concentric rings around the planet Earth, represent the perceptual or human-centred solar system. It can be seen that the physical facts, when the planets are at their furthest from the Earth, are identical and it is quite unnecessary to level the accusation of naivety or ignorance against the medieval scholars of Islam (or for that matter any other civilization) when they took the model of the system to be Earth-centred. There is evidence from the Pythagorean tradition that in antiquity it was known that the 'mechanical' centre of the universe was the sun, but what is of philosophical importance is that this model represents the traditional psychological model and a direct perceptual response to man's actual experience of the universe. In other words, its accuracy in terms of the ascertainable facts from Earth are not in doubt (except mechanically speaking). As far as we are concerned, and from the viewpoint of human consciousness and perception, we live in an Earth-centred solar system and for that matter an Earth-centred universe. It adds not one jot to the beauty of a sunrise or sunset to insist that the descriptions are incorrect in mechanical terms.

It was the aim of Islamic philosophers, as it was of the Christian medieval philosophers, to make a cosmos — a coherent whole — of their own experience or the experience of mankind. In other words to find truths about one's perceived environment which were at once wise, helpful and accurate, in considering the human condition.

When we look at the solar system, from either the mechanical or the perceptual point of view, we see a series of concentric rhythms; from the point of view of the sun these rhythms, i.e. the paths of the planets around the sun, are in fact elliptical. From the point of view of the Earth, the planets travel in other kinds of rhythm, that is to say they appear to make orbital loops in the sky; this is due to the fact that we observe these orbits of the sun from our, i.e. the planet Earth's, position within this system. Because of the nature of the rotation certain planets — all the planets in fact, except the moon — 'pause' in the sky at a certain point in their orbital path; in practice they make a small reverse and then proceed again. There is a consistent rhythm to these small loops in the paths of the planets across the heavens. These 'retrogrades' were explained by the ancients by means of a geometric model known as an epicycle; a planet was believed to be orbiting in a smaller circle around the larger circle of its own orbit, thus producing this effect. Mechanically it was an ingenious solution although not, strictly speaking, accurate from the point of view of modern knowledge. Nevertheless, the character and number of these orbital loops, when related to the annual cycles, gave rise to specific rhythms and associations with the particular planet.

Over a certain period of time the ancient observers would note when these loops came back to the same part of the sky or starting point. When these are charted 'outside moving time' in the manner described at the beginning of this chapter, the orbital loops will be seen rather as beautiful flower patterns, with a particular symmetry of their own. With the Earth at the centre, the variation in distance from it during each orbit accounts for apparent differences in brightness of, say, Venus, the Morning Star.

Another aspect of these relationships between the planets which in antiquity were regarded as significant concerns their conjunctions. When two planets are seen in the same part of the sky, their paths were charted on a circle over a period of time and showed themselves to have fundamental recurrent symmetries. Such conjunctions were considered as qualitative values in themselves. An example is the recurring relationship between Jupiter and Saturn over a 60-year period: if connected within a circle, the conjunctions produce a geometrical polygon (see p. 155).

In order to appreciate the significance that these relationships held for the ancients as they tried to fathom the connection between all things, we will examine these rhythms and co-ordinations expressed in geometric form. The philosophers considered the loops in the orbits of the planets to have a two-fold aspect. On the one hand they represent the perceptual facts of the manifest universe (and we must remember that philosophically the manifest universe is the furthest from the divine source in the hierarchy of creation), and on the other the archetypes are recognized, of which the patterns are reflections in 'perfect' geometry. The perfect geometry of a circle embraces the imperfections that occur with the passage of time. Hence the strict pattern of Jupiter is eleven, but Jupiter is sometimes associated archetypally with the number twelve. The eight points at which the planet Mars swings in towards Earth are not in a regular octagon but are taken in archetypal form to be expressed by the star octagon or the octagon.

There is a particular beauty about the way in which Venus maintains its five-fold pattern every eight years and, quite understandably, it relates Venus to the world of growth and vegetation by the connection with the Fibonacci series (see p. 76). A five-pointed star with its golden mean characteristics is thereby associated in the mathematical unfolding of the world of vegetation, as a prime base for a logarithmic spiral.

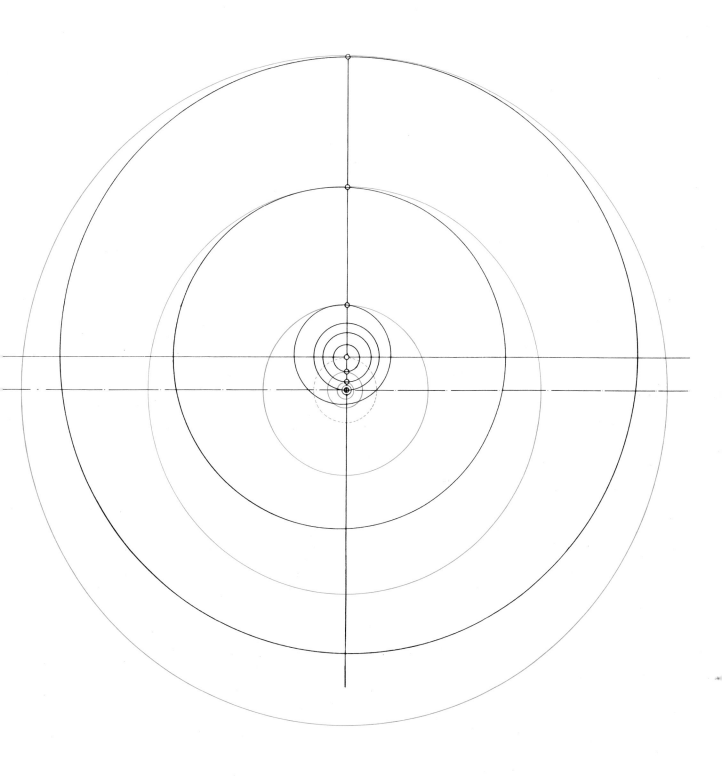

In this page we have a set of seven drawings which describe one of the most important astronomical events, according to the ancient astronomer-philosophers, particularly in Islam but also in Christianity and continuing to Johann Kepler (1571–1630) who placed so much value on the meaning of the 60-cycle of the co-ordination between the planets Jupiter and Saturn. We have taken one such period of time in recent years, from 1901 to 1964. In drawing A we show how this trigonal relationship, this great triangle in time, in the circle of the Zodiac is caused by the conjunction between Jupiter and Saturn in the sky. Starting from their positions in 1901, these two planets next returned to the same position in the sky in 1914, after which they were visible in the same part of the sky in 1921 and again in 1961. In this particular case the constellation or area of the sky or the zodiacal belt in which the planets met were Capricorn (top), Taurus (bottom left) and Virgo (bottom right), thus forming when linked a triangular pattern called a 'great trigon'. Taking the same 60-year cycle, we see in drawing B that the two planets are in time relationship, i.e. 120° from each other, with Saturn in Aries (left) and Jupiter in Leo (bottom right). In 1928 Jupiter was in Aries and Saturn in Sagittarius (top right), again in 120° relationship; similarly in 1948 Jupiter was in Leo, with Saturn in Sagittarius. By connecting these time relationships we produce another triangular pattern.

Next in drawing C, starting in 1915, we find the time relationship between the planets to be that Saturn was in Gemini (bottom left), while Jupiter was in Aquarius (top left). Then in 1934 Saturn is in Libra (right) and Jupiter in Gemini (bottom left). In 1934 Saturn was in the same position in the sky as Jupiter was in 1915, that is within Aquarius on the left, whereas Jupiter in Libra was in a time relationship, or 120° away, within the circle of the Zodiac.

In drawing D we have superimposed all three sets of relationships from 1901 to 1961 (after which in principle they will be repeated). From this schematic diagram we can observe the intimate connection between the 60-year cycle and the nine-pointed star, that is the triangular relationships which relate symmetrically in a nine-fold arrangement.

In drawing E we trace out sequentially the significant positions in the sky that Jupiter held in relation to Saturn during this 60-cycle. The pattern proceeds by seven-year intervals, starting (top) in Capricorn in 1901 and moving down to the right to be in Leo in 1908, and thence across to appear in Aquarius in 1915, then moving down to Virgo in 1922, and up to the left to Aries in 1928. The next moves are to the right again to Libra in 1934, thence down to the left to Taurus in 1941, up again to the top right to Sagittarius in 1948, down again into Gemini in 1954, and finally in 1961 back once more in Capricorn. Thus we see that during the 60-year cycle Jupiter in its special triangular or trigonal relationships to Saturn has moved 'backwards' in a configuration of a nine-pointed star, in this case the 'sharpest' of the nine-pointed star patterns.

Next, in drawing F, we trace out the path of Saturn over this same 60-year cycle; Saturn, which moves more slowly than Jupiter, has arrived in Aries in 1908 after its first time relationship to Jupiter in 1901 in Capricorn (top). From Aries (top left) the planet moves down to the right to Gemini in 1915 and from here across to Virgo in 1921, thence up to Sagittarius in 1928. The next moves are from Sagittarius across to Aquarius in 1934, from Aquarius down to Taurus in 1941, then back across to Leo in 1948, up to Libra in 1954, finally returning to its starting-point in Capricorn in 1961. Thus we see that this planet has produced a configuration of a nine-pointed star in its most 'blunt' version or a 'slower' version, missing only one point at each edge as it moves around the nine divisions of a circle. From these macrocosmic patterns we can begin to understand why this type of relationship was significant to the ancients, and especially the fact that they occur over a 60-year cycle, 60 being the most significant of all numbers in the 'geometry of factors' of the circle, as we will see shortly. In this particular case we see that the relationship between Saturn and Jupiter can be charted as a nine-pointed star with the intervals determined by a seven-year rhythm over a period of 60 years. It is quite in order to accept that these patterns were studied and accorded special values of which we are all but ignorant today. In terms of a tradition based on the unity of all existence, such cosmological patterns confirmed the validity of the symmetries found in the traditional Islamic patterns.

Drawing G demonstrates the geometry of 'oppositions', between Saturn and Jupiter, i.e. when the two planets are opposite (or at 180° to each other) in the heavens. Over the same 60-year period this can be seen to describe a star hexagram or a six-pointed star; the oppositions occur in 1931, 1951, 1911 and 1971.

In the next illustration sixty equidistant intervals are placed around a circle; here we find the number of divisions which links by multiplication the perfect number six with the other perfect number, ten. We see that this division of sixty, while in a cosmological sense relating to a 60-year cycle we have seen, also belongs to a traditional division of time and space — 60 seconds and 60 minutes. This number of divisions of the circle is the smallest which enable the basic geometric polygons to co-ordinate — the equilateral triangle, the square, the pentagon and the hexagon. In each case the points of the polygon 'sit' within the regular intervals which are shown subdivided into twelve groups of five. As we have seen, all these shapes are primary, both geometrically in terms of the laws of space division and as representatives of numerical archetypes. The only line which has no beginning and no end and which will enclose all the regular shapes is the circle; hence it is the prime symbol of unity. The points of the triangle, the first polygon, are marked by the letter T. The second regular shape, the square, has its points marked S; with the number of sides increased by one, this shape is qualitatively very different from the triangle and represents the polarizing archetype of four, relating to the seasons, the points of the compass etc.

Next, the pentagon (with its points marked P), which has a special significance in terms of the relationship between the second and third dimensions and is exemplified in its twelve-fold nature in the dodecahedron (which Plato, in the Timaeus, equated — in archetypal geometric form — with the Universe). The number five has a special relationship to man in the sense that 'perfect' man exists in and exemplifies the five Divine Presences (see p. 70).

The hexagon (points marked H), as already noted, is related archetypally to the six days of the Creation, and the six groups of ten intervals around the circle reflects the tetractys. All the representative polygons can be seen to originate at the apex of the circumscribing circle.

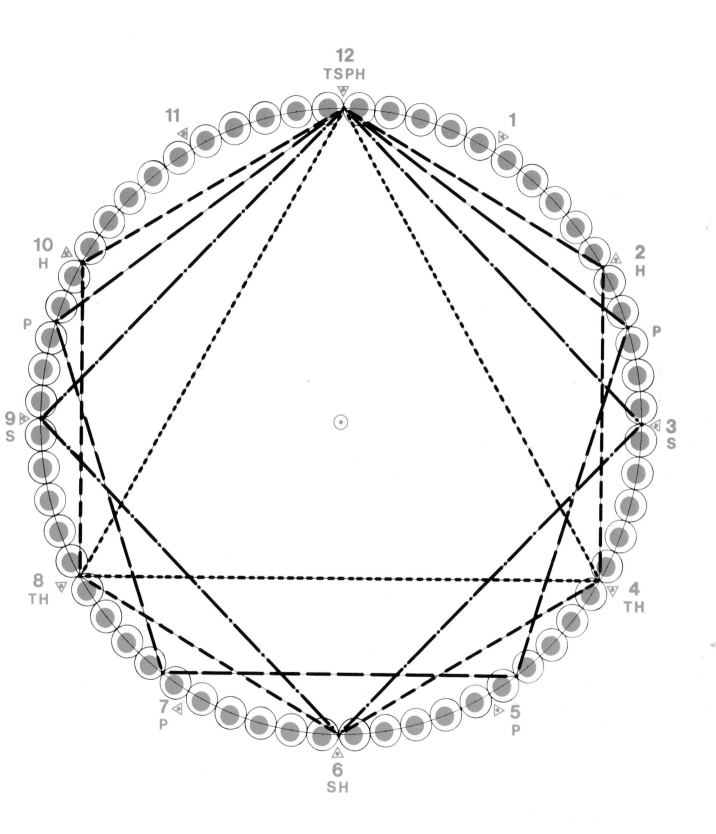

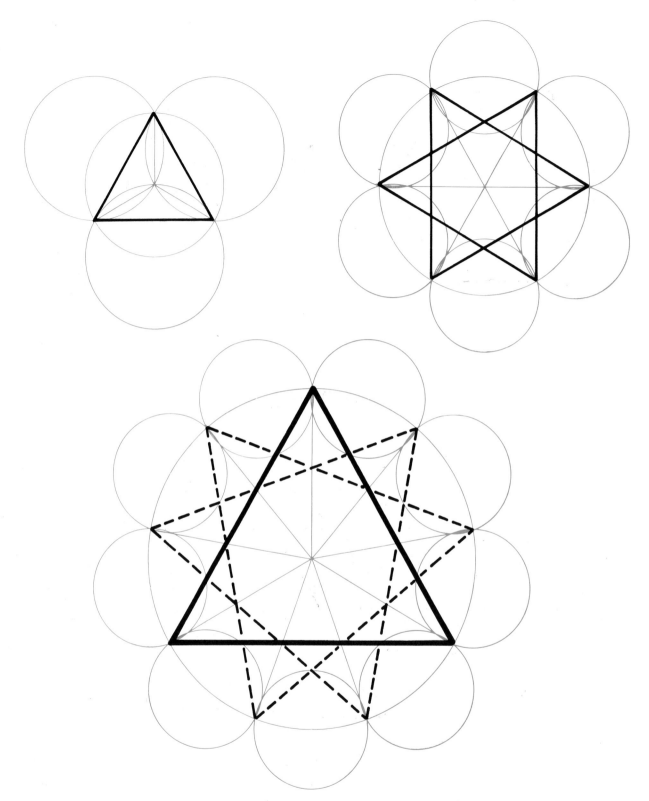

Three : six : nine

This illustration returns to the principle of three doubling to become six and tripling to become nine, shown in graphic form. In each case we have drawn circular intervals around the enclosing circle, their numbers being equal to the number of sides of a polygon formed by joining the points on the circle bounding respectively the triangle, the hexagon and the enneagon (or triple triangle) with its nine-fold circular division. Each of these demonstrates certain properties and qualities of the shape concerned. In this case the figures are presented so as to show their intrinsic qualities as well as their particular associations in the evolution of the harmonic patterns created in the heavens between Saturn and Jupiter over the chosen 60-year cycle.

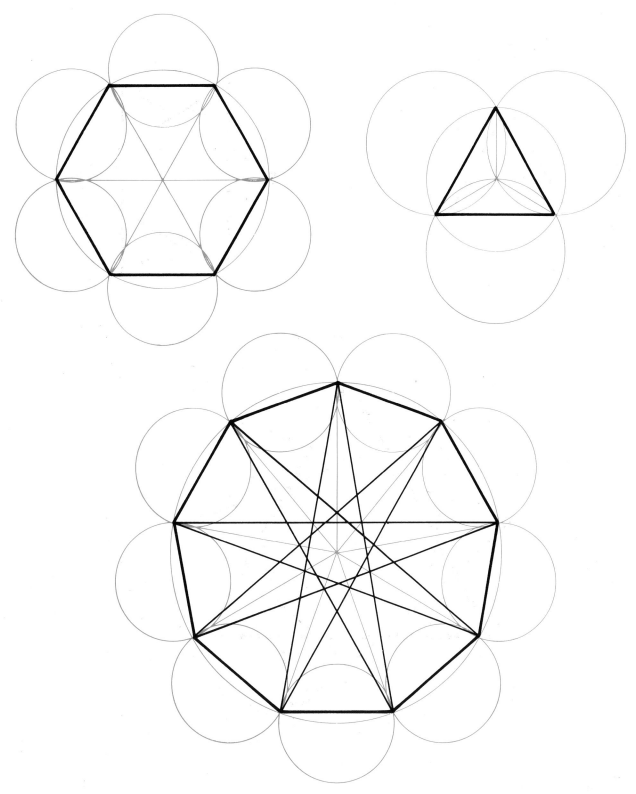

Here we have presented the simplest pattern of six, a regular hexagon, together with an equilateral triangle and an enneagon below. In this case we show the 'sharpest' version of the nine-pointed star (which we previously related to the pattern of Jupiter over the 60-cycle) and it will be noticed within this version that there are two other nine-pointed stars, one at the first cross-over point within the outer bounding polygon, which is slightly less 'sharp', and inside that another, even blunter, star similar to the nine-pointed star produced by the cycle of Saturn in its conjunctions with Jupiter during the 60-year cycle (see p. 154). Thus we see that the characteristic of the sharpest pointed star that can be drawn within any regular polygon engenders or contains all stellar patterns which can be made from the polygon.

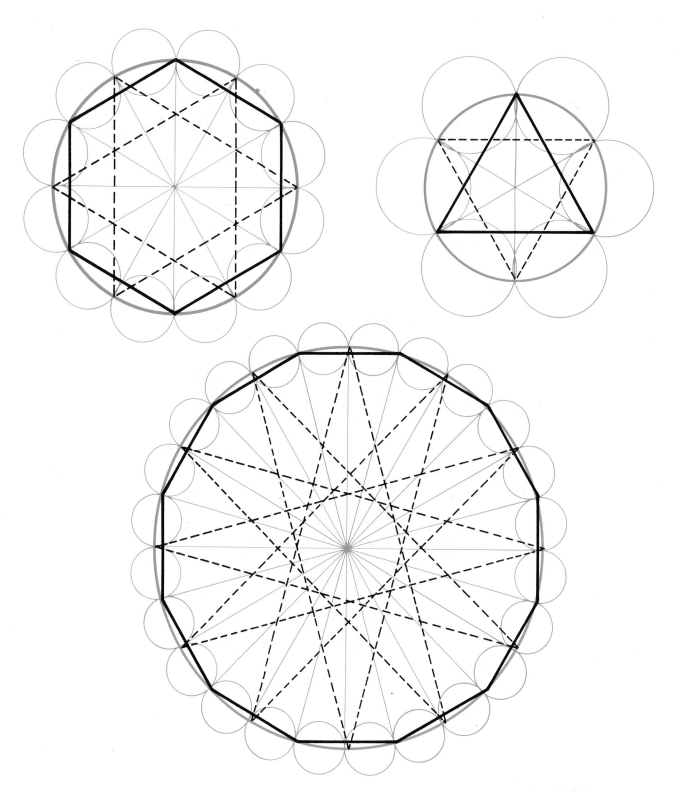

Three : six : twelve : twenty-four

In this case we show three circles (in heavy coloured line) which have been subdivided equally (in light coloured line) by the intervals of six, twelve and twenty-four. The cosmological significance of six and twelve has already been elaborated, but twelve is also significant in that, by the process of doubling discussed earlier, it gives the number of hours in a full daily cycle, one half being dominated by the sun,

the other by the moon. In this example we have also drawn lines directly between the points on the circle to give us first a six-pointed star, in heavy and broken line (in black); second, the hexagon with a six-pointed star in broken line superimposed to show the relationship within a twelve-fold division of these two patterns; and, below, a twelve-pointed star in broken line interpenetrating a twelve-sided polygon.

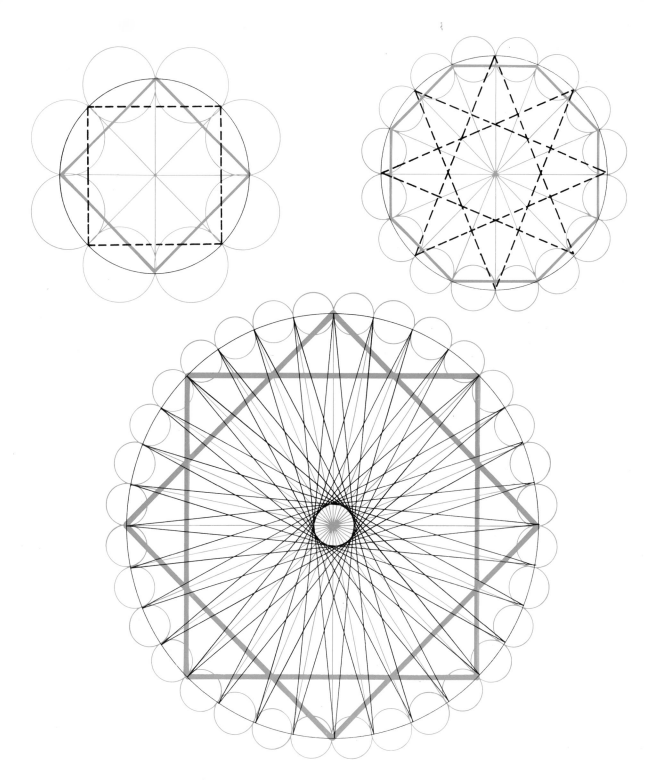

Four: eight: sixteen: thirty-two

In this illustration using the same principle of doubling we have taken the square (as a four-fold division or rhythm of a circle), the octagon and the sixteen-fold division of the double octagon and, finally, the division of a circle into 32 equal parts. These can be taken to be cosmically related on the one hand, the four-fold division to the seasons etc., the eight-fold division relating to the orbital cycle of 'retrograde' loops as seen in the orbit of Mars (see p. 152), and the

subsequent divisions by multiples of the primary archetype of four and eight. Another philosophical significance lies in the fact that the doubling of thirty-two produced the number of phases of a complete universal cycle according to the ancient Chinese system known as the classic of change, the *I Ching*. There can be no doubt that Islam with its silk-route connections with China would have known of this philosophy and system.

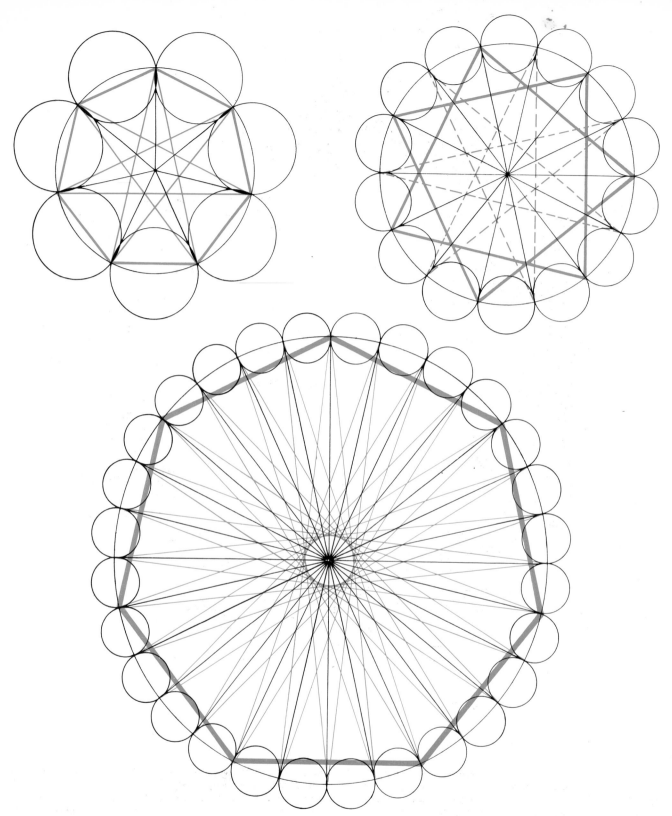

Seven : fourteen : twenty-eight

Here we demonstrate the seven-fold division of a circle in the Islamic perspective; this is particularly associated with the seven heavens or planets and the seven days of the week. There are in addition other correspondences including the seven metals, colours etc. The seven-fold division gives rise by doubling to fourteen in a fortnight and the fourteen Pure Ones of the Shi-ite branch of Islam: Muhammad, Fatimah, and the twelve Imams. Below these is the 28-day lunar cycle, which is also the basis of an emanation doctrine of creation developed by Ibn 'Arabi in particular.

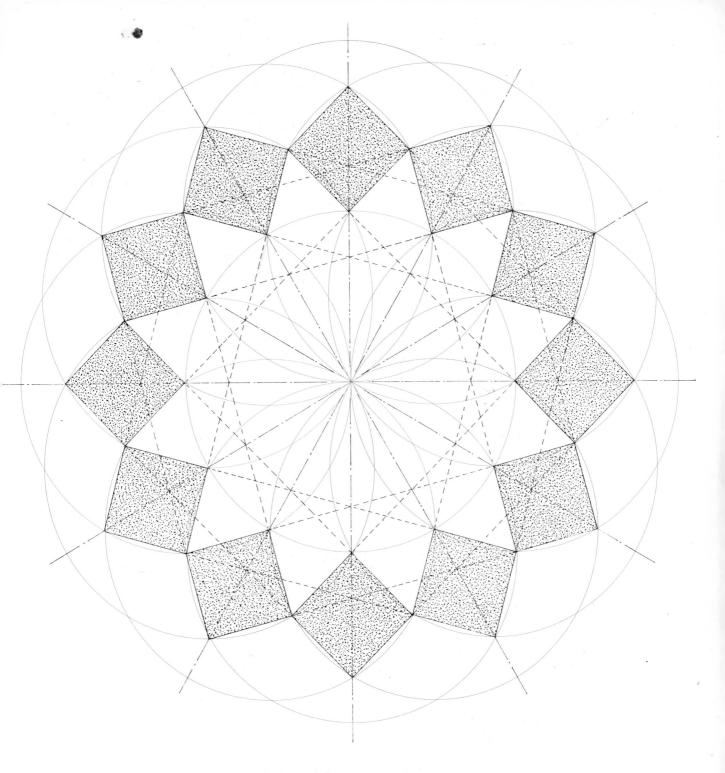

Here we return to the archetype twelve in geometric form to demonstrate some of the ramifications and subtleties of its properties; in colour below we show the natural six-fold division of a circle produced by taking the same radius as that of the centre circle and placing the compass point anywhere on the circumference and then inscribing a series of circles around it. By halving this six-fold division one can inscribe a further six circles dividing the original circle into twelve equal parts and producing a beautiful twelve-petal 'flower' within it. By joining up the key cross-over relation-ships with straight lines basic patterns emerge: the outer set in our drawing are twelve squares in accord, and each square can be taken to represent one of the 'mansions' or signs of the Zodiac. The angular relationship between these squares is 60° in each case, and in turn gives rise to trigonal or equilaterally triangular relationships between the squares or across the whole configuration. The broken lines and the lines of symmetry show some of the properties which constantly recur in Islamic geometric patterning.

In this drawing we see the same twelve-square arrangement shown as a harmonic growth pattern which can be taken as a master diagram, or archetypal proportioning diagram, used by the craft schools of Islamic art down the ages, to demonstrate controlled proportional decrease or increase; in this the very smallest circular arrangement of twelve squares relates proportionally by nine stages to the largest outer group. Each set of squares is harmonically larger than its predecessor by $\sqrt{2}$. In other words if the smaller square of any two consecutive sets has a side of 1 unit, the volume of the next square is two, using the same unit of measure. Or again, the diagonal of the smaller square, which is $\sqrt{2}$ if the edge is 1 unit, is the edge length of the next larger square in each case; hence the apparent spiral of growth, analogous to the unfolding of plants, is on a harmonic progression, of $\sqrt{2}$. Viewed in this way, this diagram can provide, by harmonic diminution or augmentation, a proportional guide for the design of an entire building or a single tile.

It is one thing to demonstrate the properties of the simple polygons which, by definition, are also simple to construct, e.g. the triangle and square; even the pentagon is relatively simple to construct. However, in the case of the seven-sided polygon and the nine-sided polygon the method of construction is less obvious — hence the mystery associated with them in the minds of the ancients; this was directly related to the fact that there is no known method of drawing them with absolute precision using only a straight edge and compasses. However, certain working approximations are known, and when it comes to practical application by a craftsman or the making of a tile of such a shape, the approximations are valid inasmuch as they may be accurate to within a few 100ths of an inch.

This page is concerned with applied methods, first to achieve a heptagon or seven-sided division of a circle. Starting top left, if we take it that we begin with a circle and we want to inscribe a heptagon within that circle or divide that circle into seven equal divisions to obtain a symmetrical shape, for whatever purpose, we first divide the circle into six equal parts by using the compasses with the same radius as the original circle. We then place the compass point at position 1 on the circumference and, with radius 1–3, we draw an arc, *ab*. We then place our compass point on position 2, where the arc cut the original circle, and (using the same radius) draw a second arc, *bc*. By the same method, we place our compass point on position 3, where the second arc cut the initial circle, and draw a third arc, *ac*. This gives a three-lobed pattern. We then draw the three central axes of symmetry of the three-lobed pattern (shown in broken line) which divides our initial circle into six. We then place our compass point at the apex of our circle (*d*) to make a tangent at points 4 and 5 of the two central axes of the bottom two lobes of our three-fold division; an arc is now drawn to cut our initial circle at points *e* and *f*. By drawing the lines *de* and *df* we produce two sides of our seven-fold division. Using the same distance as *d–e* or *d–f*, we can proceed to divide the circle by means of compasses to obtain a good working approximation to a symmetrical seven-fold division of that circle.

The next drawing (top right) shows a second method of obtaining a working approximation for dividing a circle equally into seven. In this case we take *AB* as our given edge-length, on which to construct a regular heptagon. First we construct an equilateral triangle, which is the easiest of geometric operations: by placing the compass point at *B*,

with radius *BA*, inscribe an arc, followed by another starting from point *A*, to intersect at *H*. Inside this equilateral triangle we now produce a right-angled triangle by placing the compass point at the mid-point of line *AB* and, with radius $\frac{1}{2}AB$, finding point *S* on the central vertical axis; this point becomes the apex of the desired right-angled triangle. From points *H* and *S* we then draw two arcs of radius *HS* and join the two points of intersection to divide this distance equally at *P*. This point *P* is the centre of a pentagon with base *AB*, just as point *S* will be the centre of a square with edge-length *AB* and point *H* will be the centre of a hexagon with edge-length *AB*. We know that distances *S–P* and *P–H* are equal, therefore if we add this same distance above *H* to cut the centre line at point *O*, this point would be a fair approximation once again to the centre of a seven-sided polygon; its circumscribing circle will have a radius *OB* or *OA*. We have drawn a circle and cut off the divisions of seven to illustrate this approximation. In the craftsman's working situation once a fair approximation has been arrived at, whatever the final short-fall, all that is needed to perfect the equal division of the whole is to divide the remainder by the number of intended divisions, in this case seven, and adjust the intervals accordingly. Any discrepancy can usually be quite easily corrected by trial and error using a good sharp pair of dividers.

The main illustration (bottom) shows one of the simplest methods of dividing a circle into seven and in its construction rather beautifully links the archetype of three and four, thereby lending a particular subtlety to the previously stated relationship by the addition of three and four. In this case we take the circle in which we are going to inscribe a heptagon. First we place our compass point at *A*, taking the same radius as the original circle, and draw an arc which cuts the circle at *B* above and *C* below. We connect these by drawing a line, *BC*, which gives us an upright. By extending the radius of the circle, *AO*, to the full diameter, we have a line *AOG*, and from point *G* we can inscribe a second arc and, by joining the points of intersection, produce a line parallel with *BC*. We next find the apex point of our initial circle, *F*, immediately above the centre, *O*, by constructing a right-angle *AFG*; the line *AF* intersects the line *BC* at point *D*. By placing our compass point at *B*, we draw (with radius *BD*) an arc cutting our initial circle at *E*. The distance *E–F* is a fair approximation to one-seventh of the circle. A high degree of accuracy can be achieved by carefully following this method.

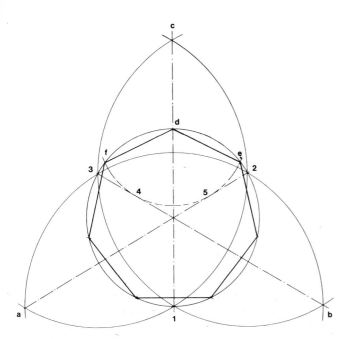

Geometric method of developing an approximation to a regular heptagon in a given circle.

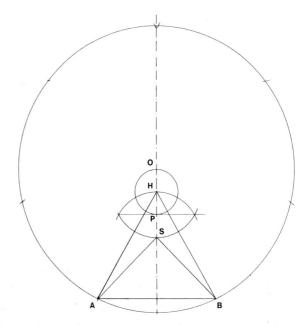

Geometric method of developing an approximately equal seven-fold division of a circle, based on unit increments arrived at by dividing the distance between the centres of square (S) and hexagon (H) to obtain the centre of the pentagon (P) and the heptagon (O).

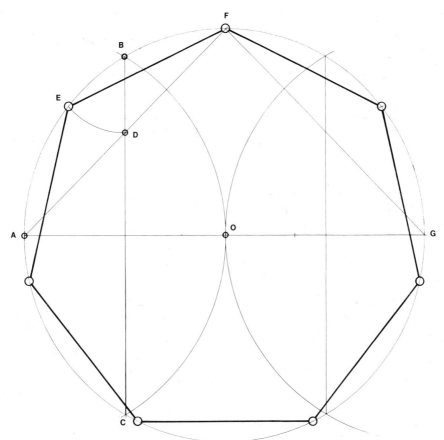

Method of developing a seven-sided polygon with approximately equal sides within a given circle by use of the vesica.

If, following the seven-sided polygon we go on to consider polygons with 8, 9, 10, 11 and 12 sides, we see that the octagon and the dodecagon are the only polygons in this group which can be drawn with theoretically absolute precision. If we begin, in drawing A, from the square within the octagon, we take this square as our guiding factor; in other words, the side of the square is equal to the side of the eight-sided polygon. If we place our compass point in the centre, C (obtained by drawing in the two diagonals of the square DEFG), and draw a circle joining these four points, this circle gives us a basic dimension. In fact the diameter of that circle is the $\sqrt{2}$ if the unit edge-length is 1. Now place the compass point on point D and, without changing the radius, inscribe the circle, and repeat for points E, F and G as centres. Where these circles cut the extensions of the sides of the original square an eight-sided division will result if we link each point of intersection. Returning the compass point to the centre, C, and taking one such extension at the top, the distance C–H would be the radius of a circle circumscribing the octagon. This is a pattern that can be done with great accuracy and demonstrates the inherent harmonic relationship of $\sqrt{2}:1$ which is intrinsic to the octagon.

If we now take drawing B, the enneagon or nine-sided polygon, we can demonstrate a method of drawing this figure with a fair degree of accuracy, given the initial edge, ab. By drawing a fish-shape (or vesica piscis as it was called in medieval times), that is an arc which is one-third of a full circle centred first on a and then repeated with b as centre, and extending these arcs to become exactly half a circle on each side, we then take the centre line from the lower intersection, c, to the upper d, and extend this line upwards. If we halve the distance between a and b and measure that distance from point d, going up the centre line, we can mark point o, which will be the centre of the nine-sided polygon; we can then place our compass point on o and, with radius bo, inscribe the circle of which the initial line ab will be one-ninth. It is now possible to mark the nine-fold division of the circle and draw a nine-sided figure. We have drawn (in broken line) the characteristic equilateral triangle which resides within the enneagon and we can also see that the extensions of the first two arcs we drew, centred on a and b, provide two points of intersection which determine the sides of the polygon adjacent to ab, the original edge.

We now proceed, in drawing C, to examine a ten-sided polygon or decagon. It will be remembered that in the Pythagorean tradition the tetractys had a special significance (see p. 104); the arrangement of ten points within a circle is related to the tetractys. In constructing a regular decagon we again begin with a base line, ab, which will be the unit edge-length. We then draw our two arcs, radius ab, from points a and b and extend them just beyond a half circle; as in drawing B, we can now join the two points of intersection, c and d. We now extend the centre line cd upwards, and from the midway point, e, of line ab we measure off the unit edge-length to point f and connect f to point b. We now take the distance b–e as radius and place our compass point on point f and mark off an arc (1); we next place our compass point on b and, taking the distance along bf from b to the point of intersection made by arc 1, we draw a second, tangential, arc (2) and extend it to point g on a line extended from ab. Now, taking the distance a–g as the radius and with point a as centre, we can draw an arc to meet the vertical extension of line cd at point o which will be the centre of the decagon. We can then take oa or ob as radius

and draw the circumscribing circle. Within this circle, given the original line ab, we can cut off ten equal divisions.

In drawing D, in the centre of the page, we now have a twelve-fold division of a circle. We shall demonstrate two ways of achieving this (see also drawing F). In the first we start off, as in the previous constructions, with the unit edge ab at the bottom. We then draw our vesica arcs from centre a and centre b respectively, and draw a centre line linking the intersections c and d and extended beyond. We then take the distance ab and, without changing the radius, place the compass point on d and mark off the centre line at point o, which becomes the centre of our twelve-sided polygon or dodecagon. We can now draw a circle (radius oa or ob) which passes through points a and b and, using the unit edge ab, mark off an equal division of twelve.

If we pass on to drawing E, we see a method of obtaining an eleven-fold division of a circle (which, like the nine-fold division in drawing B, provides a very close approximation accurate to within 100ths of a basic edge-length). Again we start with the same line, ab, and inscribe our two arcs with points a and b as centres, just as in the previous three drawings. We then link points c and d, as previously, extending our centre line upwards to the top of the diagram. We take the distance c–d (which is $\sqrt{3}$ of unit edge-length ab) and from point e, midway on the base line, measure this length off twice at f and g on the centre vertical; point g is at the top of the desired polygon. We thus have three of the points of an eleven-sided figure. We now place our compass point on g and take the radius ga or gb; taking as centres g, a and b, we mark off two sets of intersecting arcs on each side; these intersections are at h, j, k, and l.

We can now join these points (h and l; and j and k), and the point at which the two lines intersect will be the centre point (just below f) which we will call o. Also the line hl cuts the eventual circumscribing circle at one of the eleven positions, just as line jk does. Given that the original arcs centred on a and b produced two other points of intersection with the circumscribing circle, we now have seven of the eleven divisions. We can now mark off the remaining divisions using the compasses with radius ab. As already noted, this eleven-fold division has a direct association with the cosmic cycle of repetition of the loops of the planet Jupiter.

We now turn to drawing F, which is the second method of achieving twelve-fold division of a circle, and represents possibly the easiest method in geometrical terms; in this case, starting with an initial circle, we then take a point, say a, on which to place the compass point and, using the same radius, draw an arc that cuts our circle at b as well as being extended below and above this point to cut our circle again at c; we now place our compass point on b and with the same radius, cut the initial arc at points d and e (which latter becomes the centre of the dodecagon) and the original circle at point f. From point b we now draw an arc centred on f (with the same radius) to give us point g, and then place our compass point on point c and strike an arc from point a through to h. The centre vertical, from d (the point at which the first two arcs intersect at the bottom) to the centre point e and extended up, meets the original circle at another point, j. Next, by placing the compass on point j, we cut off points k and l between points h and c and points g and f respectively, and finally by repeating this operation with point m (where the centre vertical cuts the original circle at the bottom) as centre, we can mark points n to the left and p to the right, which gives a total of twelve points and the twelve-fold division of a circle.

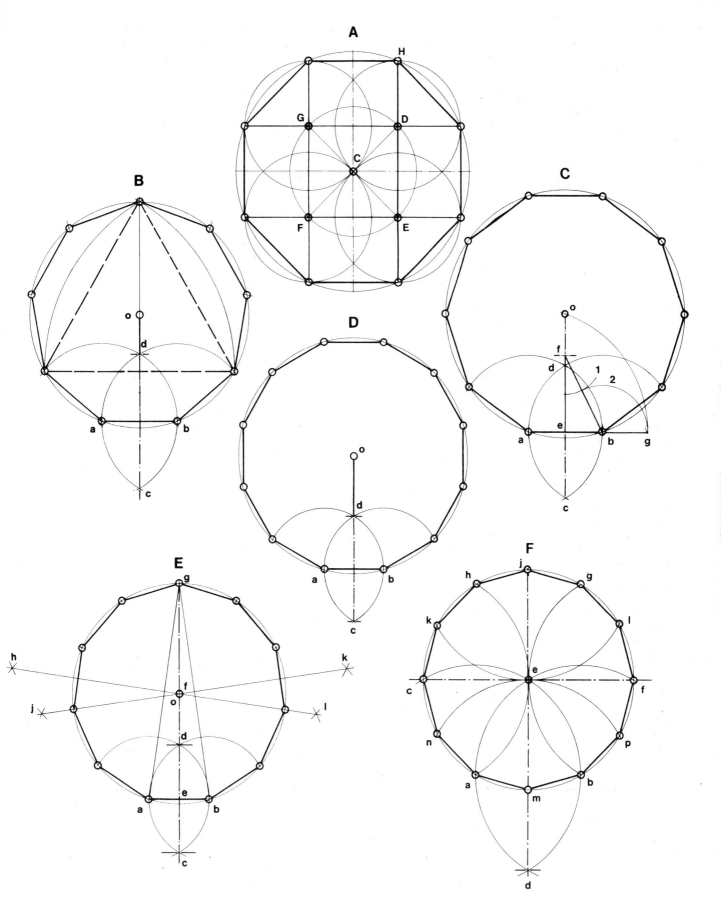

From this page we summarize the thesis of the relationship between fundamental polygons and the underlying characteristics of Islamic geometric design. In the top diagram (A) we have the triangle and, 'flowing' through and within it, the 'way' of the linear aspect of Islamic geometric pattern. If we take any side of the triangle which invisibly controls this pattern to be the hidden inner *aleph* or primary stroke, the ontological line which symbolically connects each and every thing to its source in creation, the centre point of that line (which like every line has, by definition, a beginning and an end) has a mysterious quality of being the point of exact equilibrium — the point at which the line is neither coming nor going — and can be associated with the second letter of the arabic alphabet, *bey*. This point, the diacritical point as it has been called, is the source of two diagonals which are generally of the same angle. It is as if the original 'hidden' line had bifurcated and rotated about this point to take part in its manifestation. This taking on of two manifest aspects — of the positive and the negative — is represented by the positive flowing above and the negative below. This results in the characteristic 'woven' quality of Islamic pattern. Once bifurcation has occurred, the two lines proceed until they meet the centre line of symmetry of the polygon, at which point they change direction. This change of direction is according to the characteristic angle of the polygon concerned. The interior angle of the equilateral triangle is 120°, so in the first example the line changes direction by 120° and proceeds as a negative line, and becomes a positive line when it meets the diacritical point half-way along the next edge of the triangle. This process is reciprocal. This 'woven' hexagon, as it lies within the triangle, is as a manifest symbol of an unmanifest archetype. If we pass through the symmetries and numbers, the second diagram (B) demonstrates the square; here the crossing over of the diacritical point half-way along the edges of the square sets up a right-angle. In this particular case we have taken the point of symmetry (or the point of change) to be such that a change in direction to form a right-angle within the square, and back again to cross the next edge of the square, sets up the characteristic pointed cross which pairs with the star octagon as one of the most constantly used repetitive patterns and, in this sense, 'classical' Islamic geometric designs. It is as if the pointed cross was a contraction of a sixteen-sided polygon, i.e. sixteen changes in direction in a square, just as the star octagon has sixteen changes in direction which are moving outwards. This cross can thus be considered the passive aspect or exhaling of the sixteen-sided polygon whereas the star octagon can be considered to be the expansive and inhaled aspect of the sixteen sides.

Next, diagram C shows a five-sided polygon, the pentagon, and the pentagonal 'flow' with its characteristic pattern. Here the pentagon can be seen to produce the characteristic five-pointed star of a particular character which often recurs in Islamic patterns (as we have noted in Chapter 5).

In the centre, diagram D can from one point of view be seen to be six versions of diagram A clustered around a six-pointed star. But in itself it takes up the characteristics that we see in diagram B — a change in direction within the controlling polygon — and in diagram C. This again is one of the most consistently recurring Islamic themes and can be regarded, without doubt, as symbolically parallel to the six days of Creation with the 'throne' in the centre.

Diagram E is the seven-petalled geometric flower of Islamic pattern. In the centre of the seven-pointed star can be seen a seven-sided polygon of particular beauty and form. Next, in diagram F, we have the eight-petalled geometric flower which has its own characteristic eight-pointed star in the centre, its characteristic rhombuses in the overlap of the 'woven' design and the characteristic elongated hexagons which have occurred in each of the patterns from C to E, and occurs again in the final diagram (G). This eight-pointed star, as has been noted, has a value analagous to the 'eight bearers of the throne', as well as the dual aspect of the primary elemental 'fourness' of terrestrial phenomena and the orbital 'loops' of the planet Mars. In pattern G we see the nine-petalled geometric flower. In this particular case we have drawn it in such a way that the circle contains the second cross-overs, not the first or polygonal cross-overs. This nine-pointed star, similar to the pattern that Saturn made in its conjunctions with Jupiter (see p. 154), is taken at the half-way points of the enneagon, or nine-sided polygon. This emphasizes another of the fundamental characteristics of Islamic geometric patterns, the 'arrow' pointing directly away along the axis of symmetry of each of the geometric stars. Hence there are four properties, one might say, to each of these empty 'centred' flowers of symmetry — the central polygon, plane or stellated in itself; then the little glimpses of rhombuses from the first cross-overs; the elongated hexagons of the actual 'petals' of the flowers; and then, beyond these and on the same axis as the kite shapes, there are the characteristic 'arrows' which point like some form of energetic radiation from the non-manifest centre of symmetry in the centre of the 'flower'. The petals and the woven arms which make the petals seem to retain and rotate this 'energy'; the arrows seem to radiate from it. Between these forces is seen one of the fundamental characteristics of the unity of Islamic geometric patterns, that of precise and beautiful equilibrium between centripetal and centrifugal force, uniting with and complementing each other.

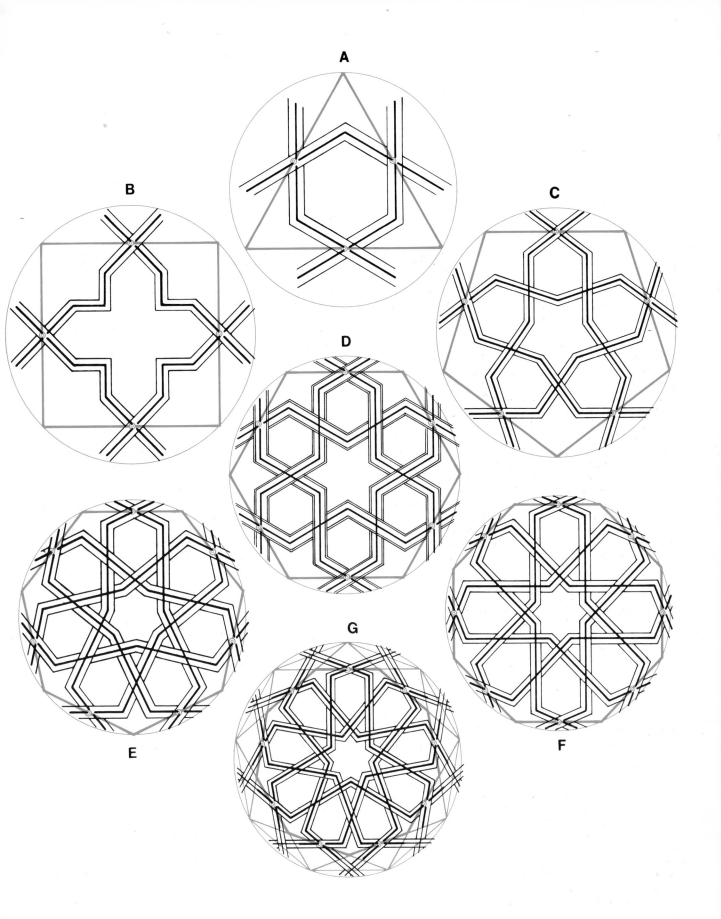

9 Specimen Islamic Patterns

The specimen patterns chosen are examples of the types found throughout Islam which are developed from simple grids with the greatest ingenuity, so as to produce highly complex results. These 'patterns of integrity' feature a 'hidden' internal geometry which only close analysis reveals.

The following analyses of various characteristic Islamic patterns serve primarily as an introduction to their meaning and the techniques employed in their creation. However, in order to gain a qualitative understanding and an appreciation of the way in which such designs are integrated into and contribute to an overall architectural scheme, each must be viewed in the context of the building or part of a building — façade, arch, dome etc. — in which it occurs. In this way the structural and decorative concept of the whole, embracing every detail — windows, doors, perforated screens, floors etc. — can be better understood through being directly experienced by the onlooker, as the Islamic artists clearly intended.

The first illustration (opposite) shows the work of the ingenious Spanish Islamic master who took the square grid and drew within it the diagonals of a square to create a $\sqrt{2}$ pattern flowing through the grid; from this, with the characteristic cross-overs demonstrated above (see, e.g., p. 40), he brought forth a pattern with a special star octagon in the centre of each inner square and a minor star octagon on the node of each greater square, together with a particular kind of six-pointed star on the centre edges of each of the greater squares and covering the nodes of the smaller squares. This pattern also occurs in North Africa, in such places as Fez and Marrakesh.

The second pattern [B.36], which is an unusual one, seems to indicate the integration of the pattern of the 5 × 5 magic square within the overall square of the two-dimensional tessellation which consists of squares, hexagons and dodecagons (these are characteristic of the eight semiregular patterns dealt with in Chapter 7). It is a particularly beautiful and ingenious arrangement of the four right- and left-handed turning points of the 5 × 5 square, set up in such a way as to create areas which integrate and interlock with the six-pointed star and its radiations at the centre of the figure.

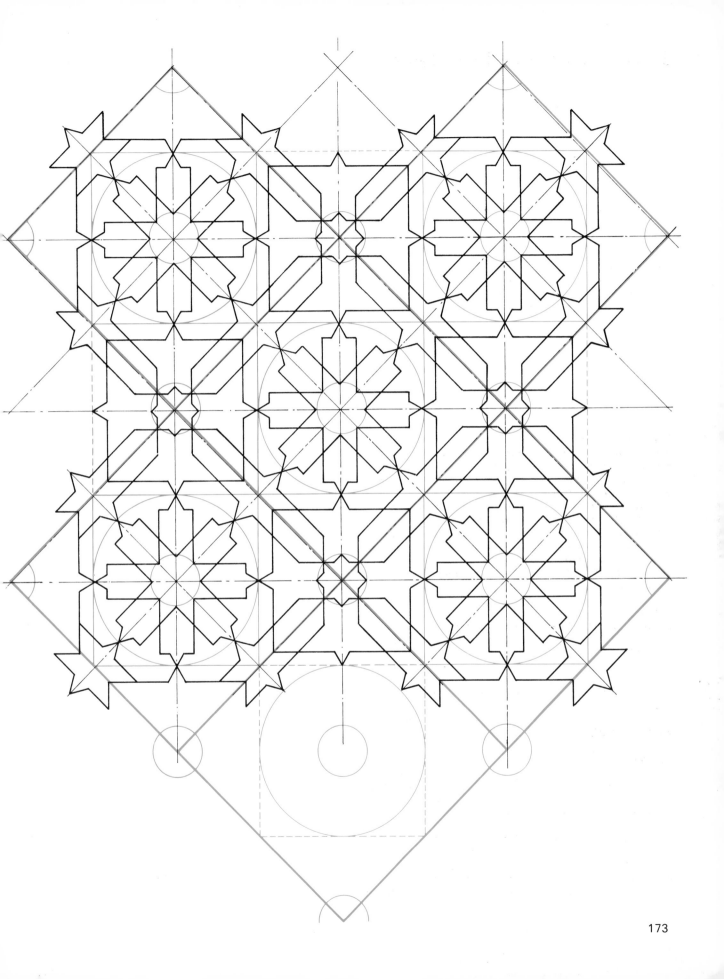

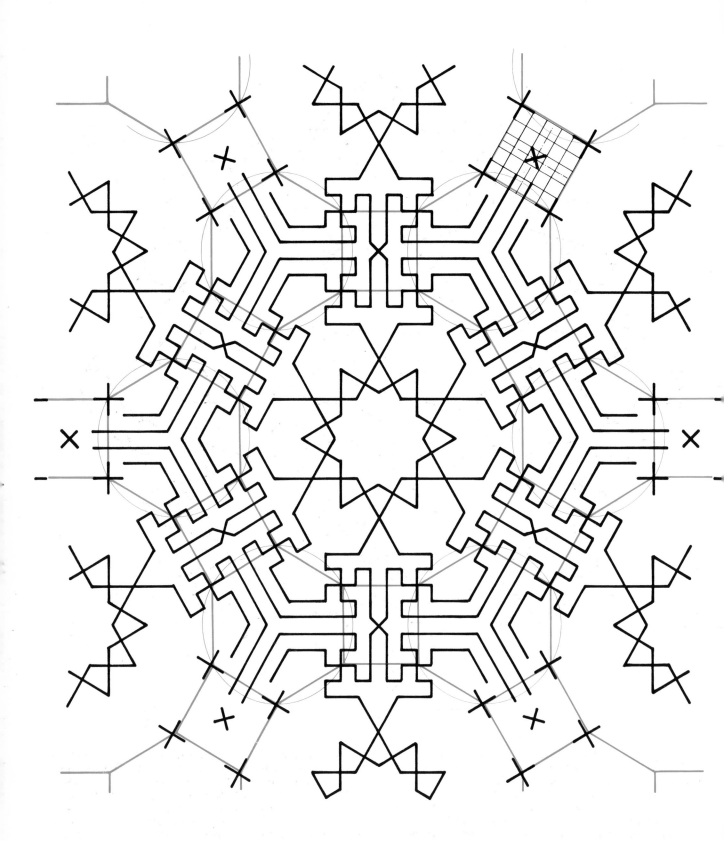

174

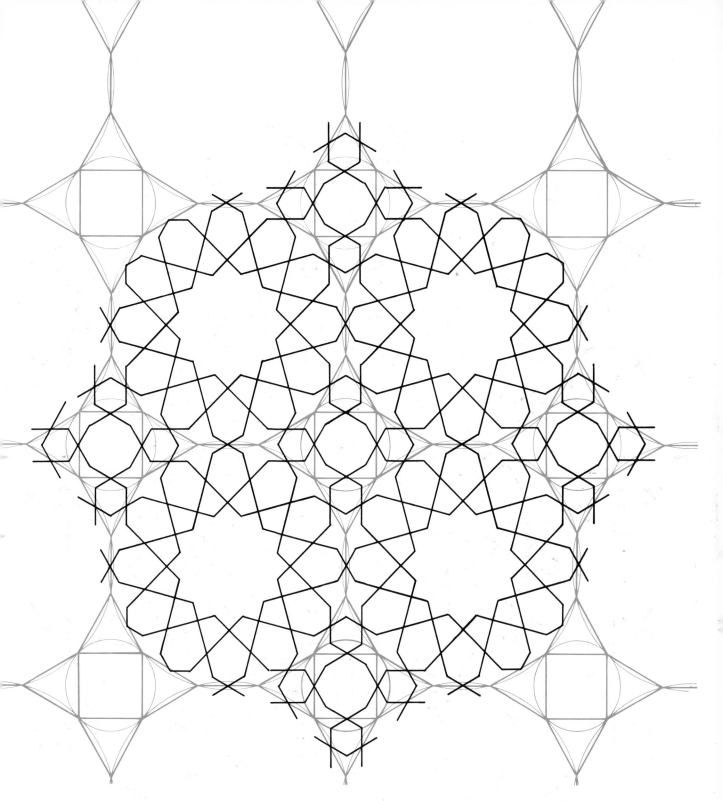

The two preceding illustrations relate to a regular and to a semi-regular grid; the pattern above is related to a demi-regular grid, in other words a grid which is made up in this case of equilateral triangles, squares and dodecagons within a square symmetry. The geometrical structure underlying this pattern, and the way in which the equilateral triangle and the square are integrated to create it, are shown in colour. A practical demonstration is shown in black; in this we take

each of the centre edges of the constituent 'hidden' polygons and make the initial characteristic cross-over. The angles of the cross-over and the angles of the 'spread' of the 'flower' within each polygon are governed by rules which would have ultimately been chosen by the Islamic mathematician-artist as he created the pattern. The element of choice demonstrates the variety of interpretation that is possible within the framework of the hidden archetype.

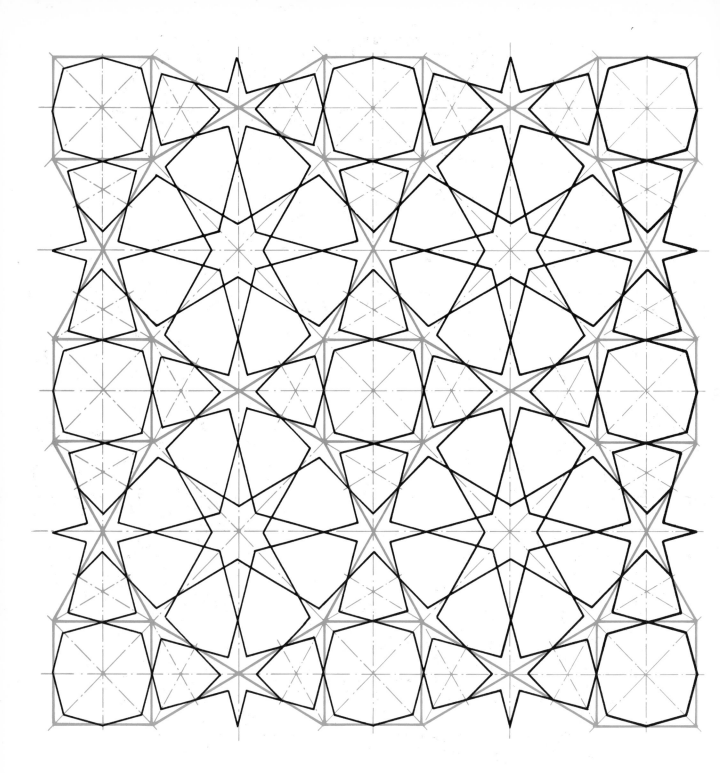

Having seen a semi-regular and a demi-regular pattern, we now see a pattern [B.106] featuring one stage less in symmetry, but still controlled by the same fundamental regular shapes, i.e. a tessellation which in this case might be called 'quasi-regular'. In this example we begin with the square, which is surrounded by four equilateral triangles (shown in colour). The points of the four-pointed star thus formed exactly meet those of a similar four-pointed star within a square grid. Having established this grid, we then demon-

strate in black the characteristic pattern which is produced. This gives rise to a particular kind of 'flowering' of which the petals, in this case of flowering octagons, are not balanced and regular, yet the diagram as a whole is balanced and regular. The five- and six-pointed stars arise over the nodes of the 'hidden' inner geometry and, characteristically, are 'energetic' and pointed in much the same way as the inner stars of the octagons are.

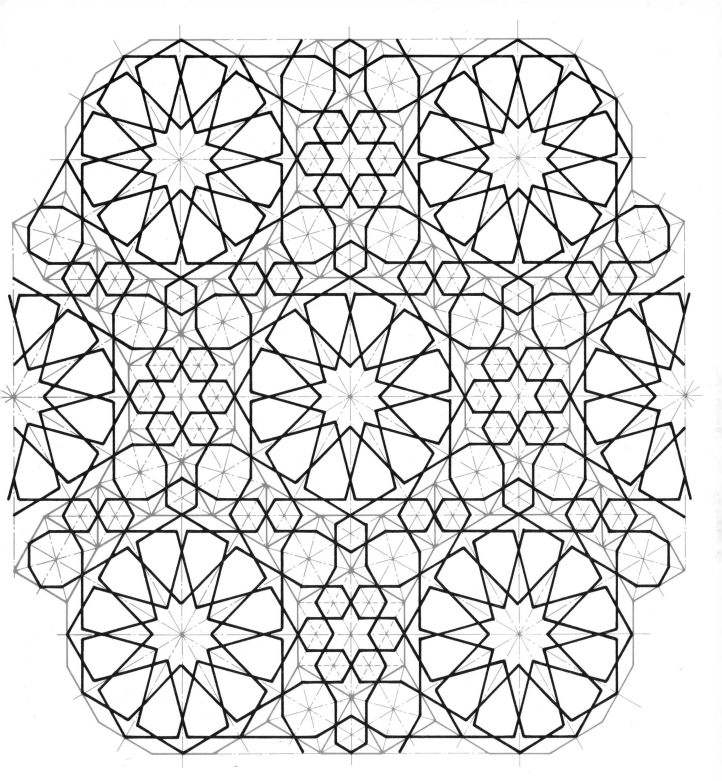

Here we demonstrate what could be taken as a confirmation of our thesis about the 'inner' use of the polygons. This tessellation represents a lower degree of regularity than do the demi-regular patterns, yet it possesses an ingenious two-fold symmetry (shown in colour) employing the same regular polygons as its constituent elements: the hexagon, the square and the triangle, with the dodecagon as the major 'hole' at the centre of each of these assemblies. This pattern has a definite directional axis, taken from the upper and lower points of the hexagon.

Great credit must be given to the Islamic artist who created mathematically the first version of this tessellation; the magnificent pattern [B.142] which grows from it is in itself an indication that the science of mathematics, and the science of geometry — the sacred science — was the key to the ultimate artistic creation. By superimposing one diagram on the other we can observe the beautiful way in which the irregular octagons, regular hexagons, irregular five-pointed stars and beautifully poised twelve-petal 'flowers' inhabit each of their respective areas and integrate within the whole.

Next, we take the North African and Spanish branch of Islamic pattern design and demonstrate another ingenious, mathematical, manipulation of the archetypal polygons to produce new forms of tessellation and symmetry. Here the artist has taken the dodecagon as a central feature and placed it in such a way that the points of that twelve-sided polygon touch those of a similar figure within a square grid (these points of contact are circled in the drawing). The spaces between each of the dodecagons can, in this case, themselves be divided into twelve and give rise to a form of 'Maltese Cross' — four equilateral triangles each having its apex at the centre of the space between the dodecagons within the square grid. As this particular pattern of Andalusian genius has so many subtleties several more stages in its creation are shown.

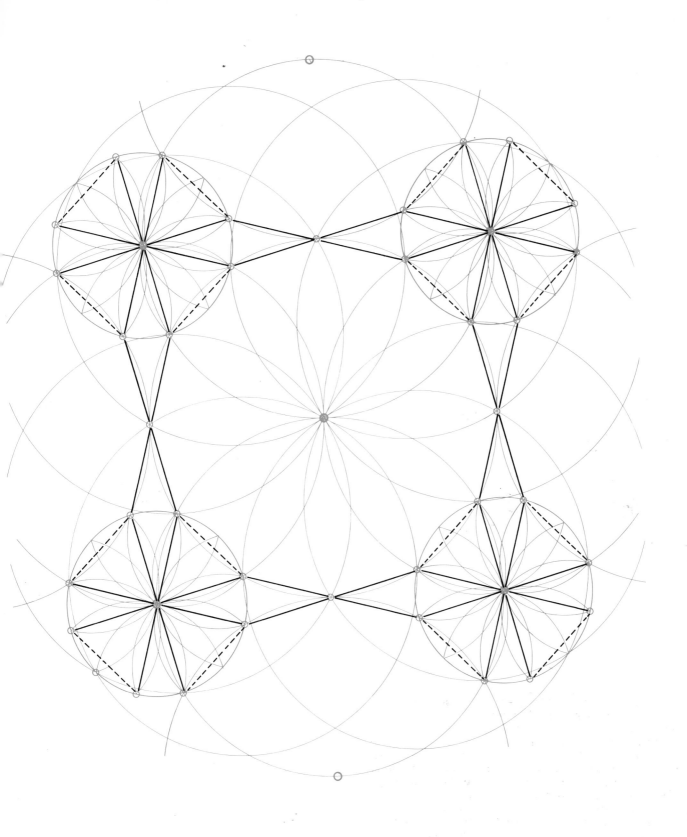

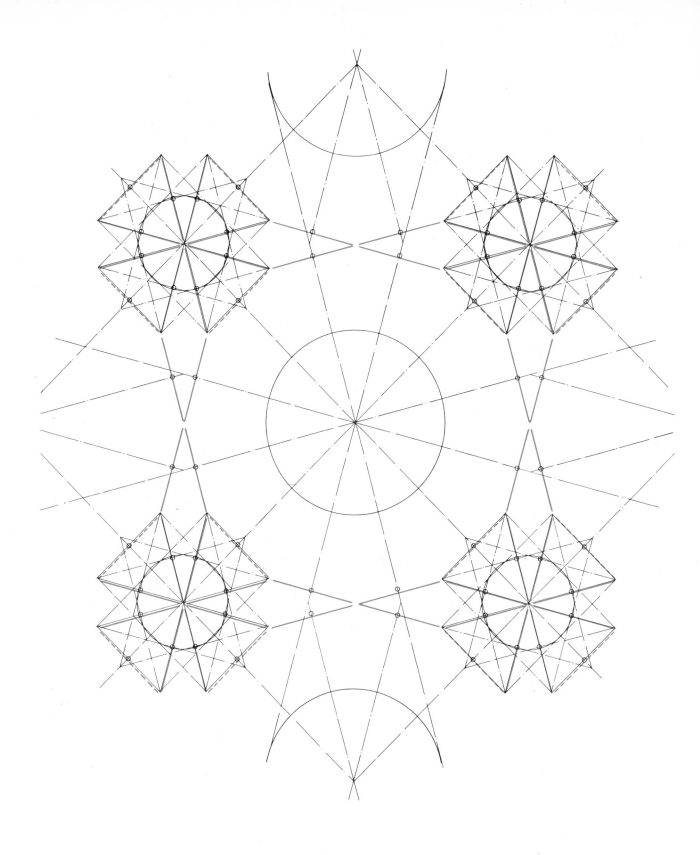

In the first of these stages of development we demonstrate
how the pattern of equilateral triangles with apex points
meeting at the centre and possessing a twelve-fold division
develops a new set of axes.

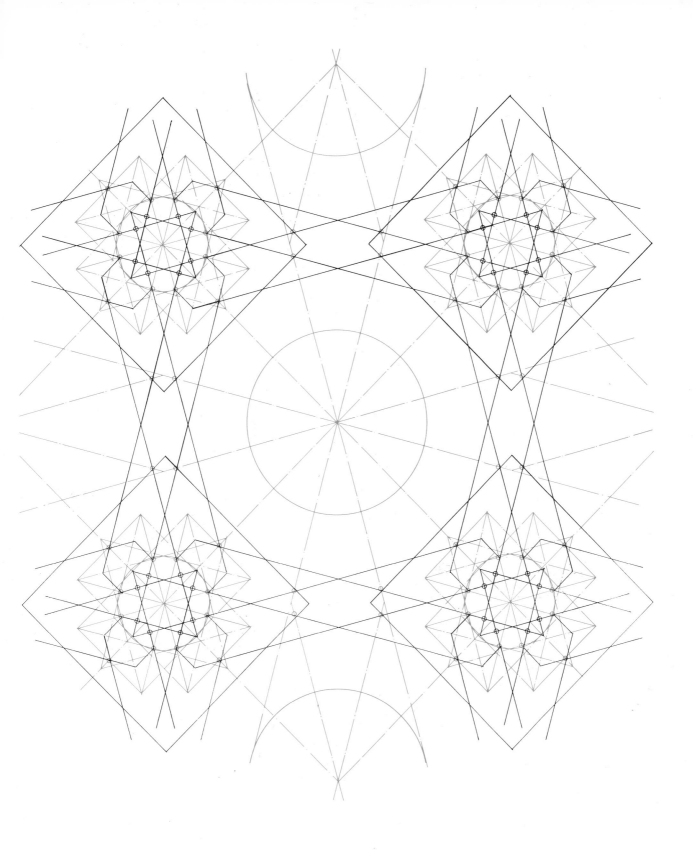

In this next stage we demonstrate how the characteristic little four-pointed 'flower' feature of the final pattern is constructed from the geometrical procedure of the previous illustration and how the extensions of the angles created in this pattern link right through the tangent point to the twelve-petal 'flowers' of the major centres.

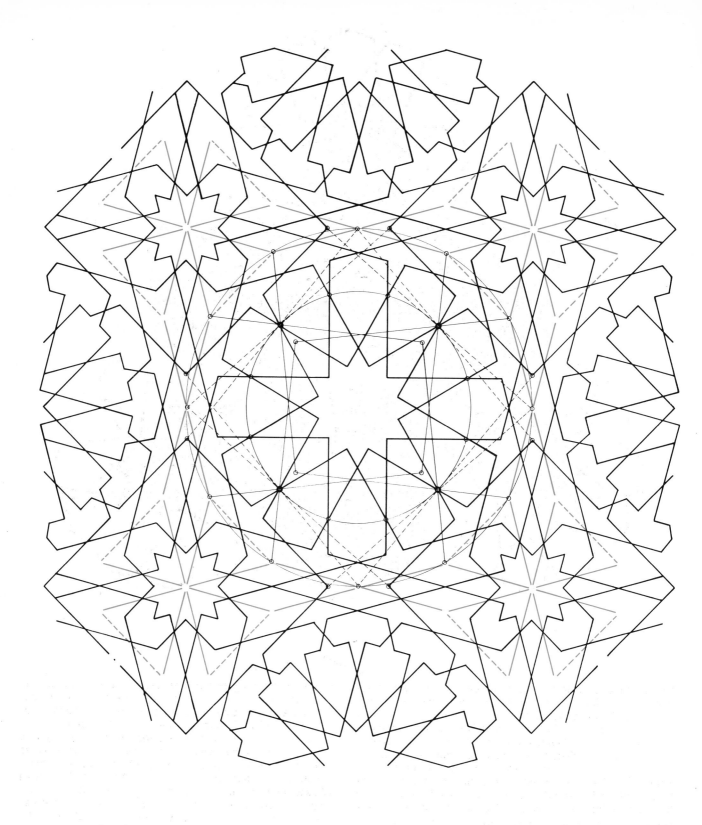

The last of this series shows the completed pattern with (in colour) the same underlying primary grid. Here we can see the way in which the artist of the Alhambra in Granada has been able in a sense to vary the 'pitch' of the musical notes of his compositional pattern. The twelve-petal 'flowers' have changed in character, in the four lateral dodecagons, from that of the central one. This theme is varied many times in the halls of the Alhambra, it is found frequently on buildings in Morocco.

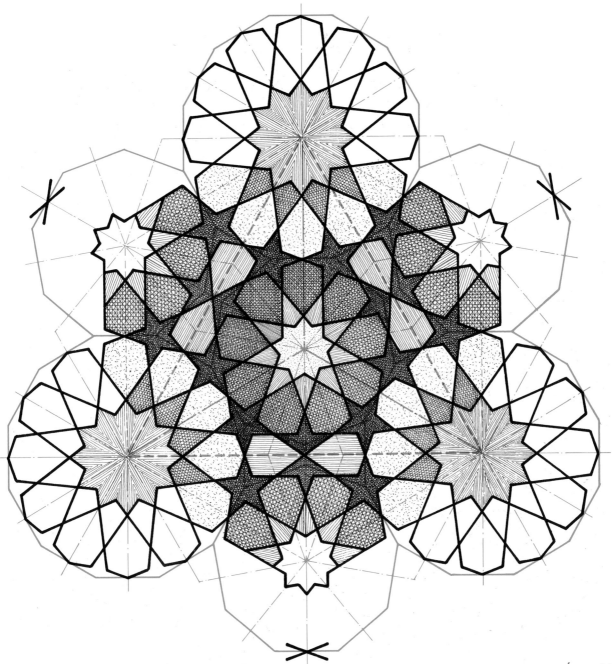

We now move on to the more complex of the symmetries and those calling for the greatest geometric knowledge and ingenuity. A simple triangular grid, shown in colour in heavy broken line, is shown in the centre. Given in these particular patterns a simple grid with a configuration combining twelve- and nine-sided polygons, we might possibly speculate on the possible cosmic symbolism — the twelve signs of the Zodiac and the nine characteristic cycles of conjunction, or trigons, of Jupiter and Saturn. The nine-sided polygon with the same edge-length as the dodecagon sits within the equilateral triangle and leaves a space half-way along the edge of the major triangle which is itself a concave hexagon, all the lines of this grid being equal in length; now, however, both convex and concave shapes are employed within the overall repeating pattern of dodecagons, enneagons and hexagons.

In this example the thesis of the book — demonstrating the way in which we believe these patterns were created from the underlying polygons by crossing over the edge-centres of each and thus setting up the characteristic patterns — is fulfilled [B.120]. A particular feature is the ingenious way in which the designer has created the elongated hexagon or 'petal' within the concave hexagon, i.e. the wedge-shaped space between the major polygons. There is a pair of these 'petals' within each concave hexagon. A variety of hatching is used to recreate one apsect of the ceramic or marble pieces which were cut and inlaid so precisely in these patterns. The aim is to create some of the visual impact by isolating certain characteristic shapes. It will be seen from this how the less obvious aspects can be emphasized, e.g. the five-pointed stars (in darkest hatching), together with the 'arrows'; these details could perhaps be read in an abstract symbolic way as referring to man — a five-fold being — within the universal cosmic cycles.

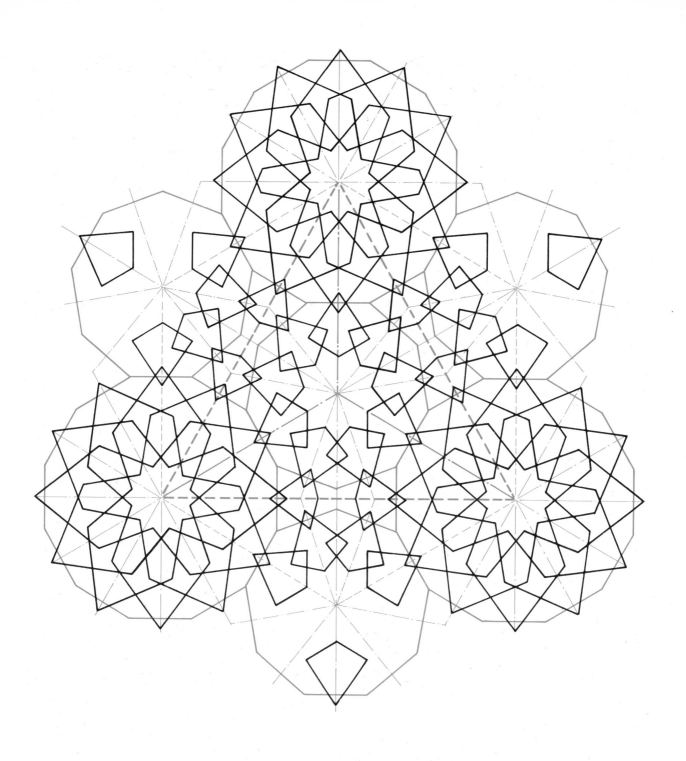

In this illustration we take the same basic grid and demonstrate a completely different approach to the final pattern [B.124]. The cross-over point has itself become a small rhombus, or diamond shape, which gives rise to the possibility of four-sided links, and woven closed circuits. Nine rhombuses are interwoven in the centre of the diagram and these also overlap with an extra pair along each edge of the

major determining equilateral triangle (in broken lines); they are then woven into a complete closed system which produces a twelve-sided 'flower'. This kind of pattern is again associated with the Egyptian centre of Islamic design and the North African coast; it is less in evidence in Spanish, Turkish or Persian designs.

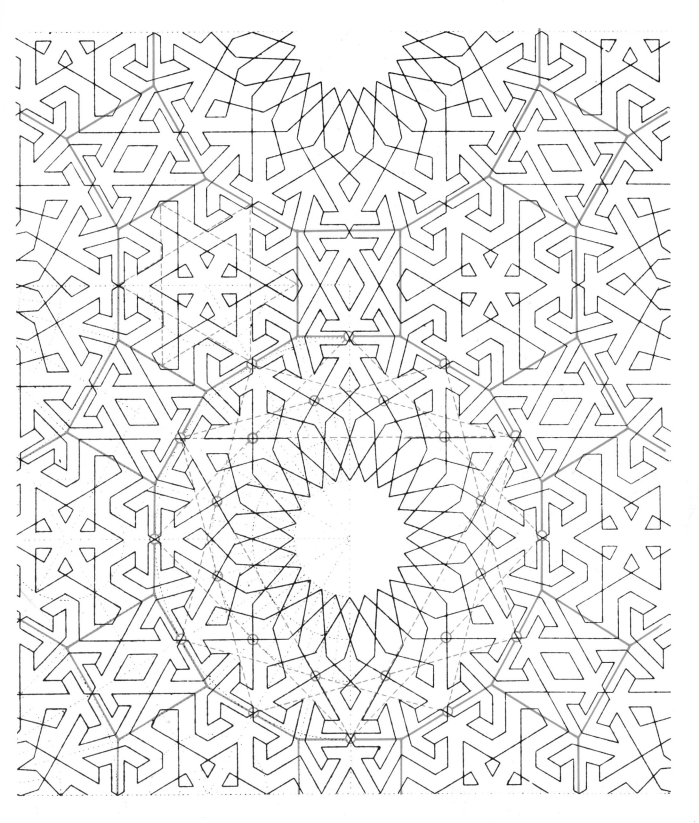

In this illustration we demonstrate the relatively simple semi-regular grid (discussed at length earlier) as it is used to produce an eventually highly complex pattern [B.139]. The full ramifications of this pattern are not developed but it is possible to visualize and discover the ways in which the designer utilized key archetypal patterns to lead to a highly individual final design.

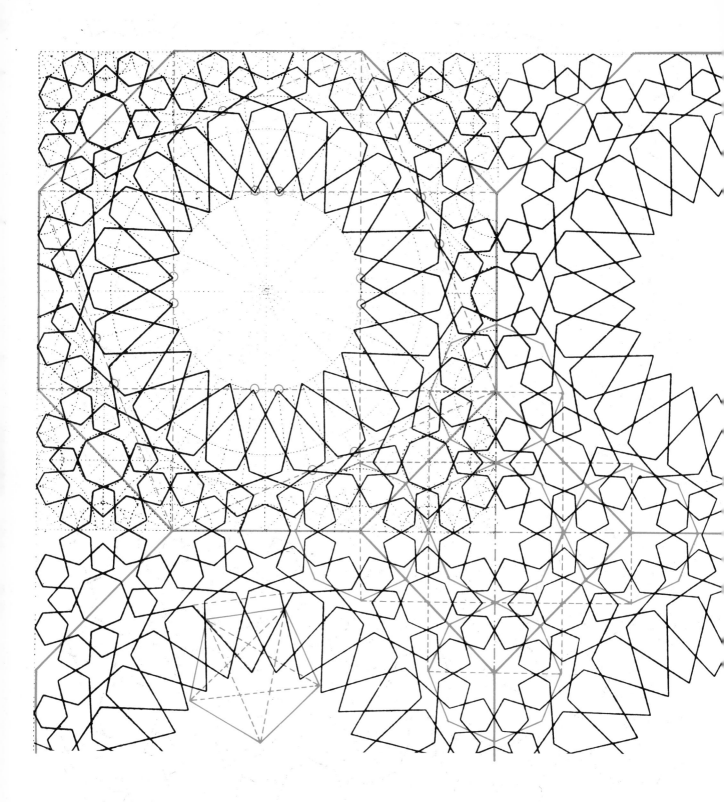

Next we see a similar simple basis — the octagon and square grid — being used to create a very beautiful and highly complex 'musical' elaboration [B.150]. We also see (in the detail below) how the centre angle of the pentagon has been used for the petals of the major central 'flower', thereby integrating one symbol and system into another.

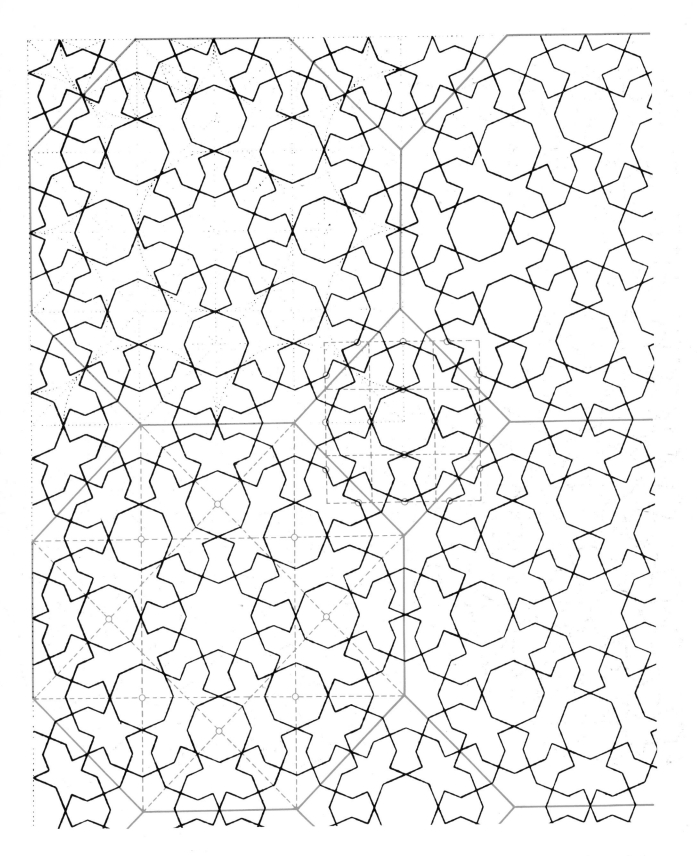

Once again, to demonstrate the other extreme of variety that can be obtained from the same semi-regular grid [B.144], we show the octagon and square grid adapted to create an extremely characteristic and poised symphony of shapes derived and elaborated from the octagon and the star octagon.

187

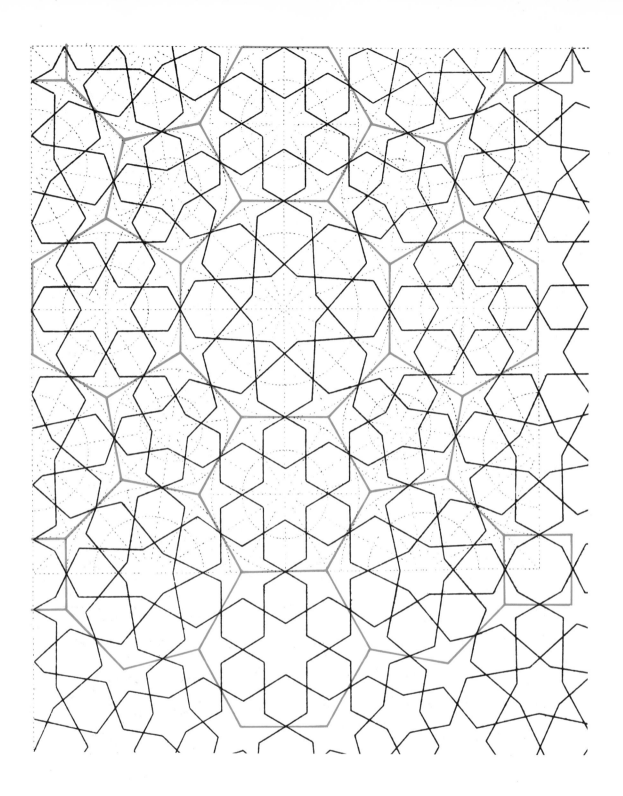

In this pattern we see great ingenuity exhibited. The designer has achieved, with a remarkable degree of accuracy, what is in the regular sense a mathematically impossible tessellation, i.e. a square grid which includes close-fitting polygons with four, five, six, seven or eight sides and with no spaces in between. I am grateful to Dr Ensor Holiday for placing this particular design before me, and thus stimulating me in my attempts to solve some of the basic rules underlying Islamic design. Here is a magnificent example of the symbolism and power of these basic archetypal arithmetical sets or polygons integrated with great ingenuity and subtlety to produce an 'impossible pattern' and yet presented to the eye as apparently possible. The very subtle adaptations from the pure regularity of the five (pentagon) and seven (heptagon) are the key to making the pattern 'work' [B. 163].

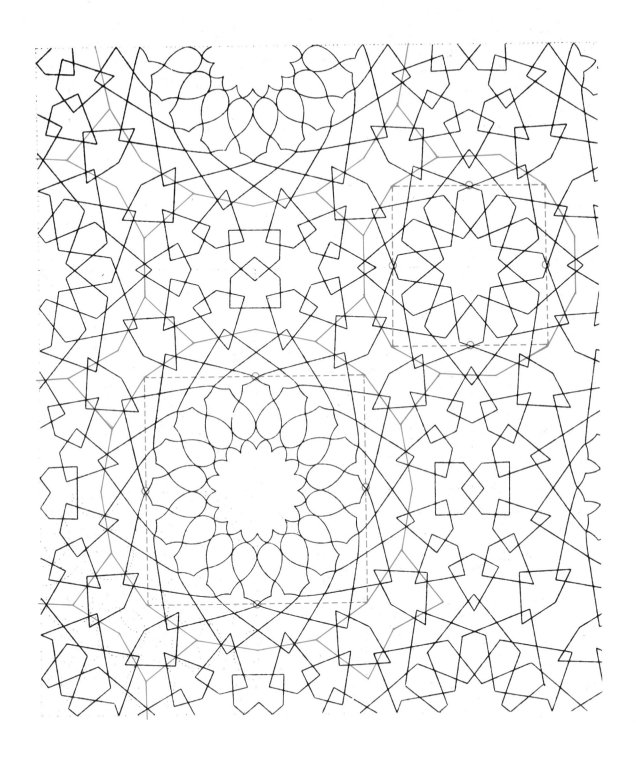

Here we have yet another pattern originating in Cairo — a characteristically Egyptian variety in which twelve- and sixteen-sided polygons are integrated by means of the curious marriage of a pair of overlapping heptagons and a strange form of irregular inverted hexagons inserted between them [B.135]; this is another magnificently ingenious feat — arriving at a mathematically 'impossible' result in pattern making, and giving rise to a beautiful motif which appears on the side of one of the mosque *minbars* in Cairo. We have here a design which explores one of the most difficult of all sets of relationship to resolve in terms of design, that is the challenge presented by two seven-sided polygons as the basis of an indefinitely repeating pattern. After the solution has been demonstrated, the sense of its rightness and in-evitability makes it difficult for us to realize the nature of the geometrical feat, itself a victory of integration and unification.

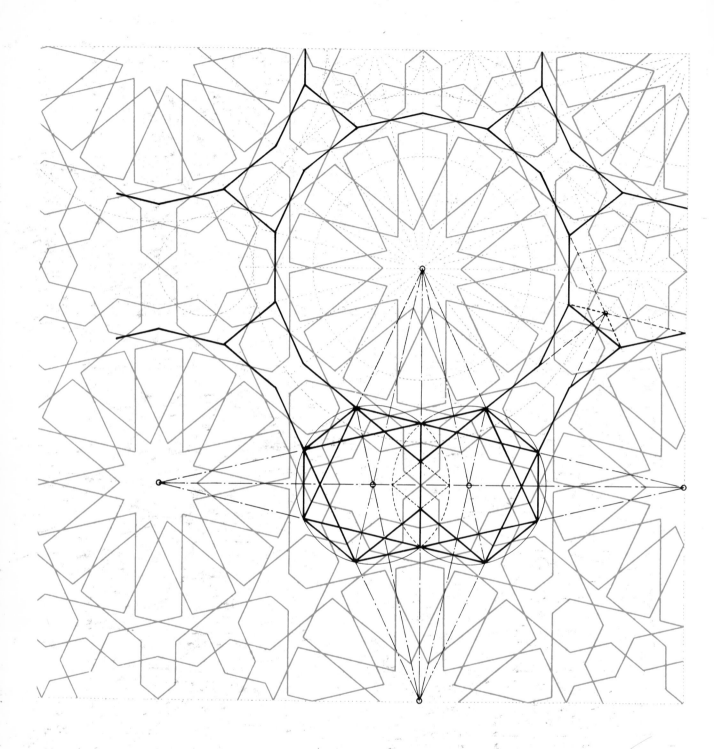

In the next drawing we see the diagram [B.167] in colour; the two overlapping circles in black demonstrate the key to understanding how this remarkable pattern was achieved. It consists of a fourteen-petalled 'flower' in the centre and, within the black circles, there are two seven-pointed stars, these being pairs of heptagons. There are thus, in the overall pattern, four pairs of heptagons laterally round the fourteen-sided 'flower'. This illustration shows the initiation of this pattern, in which it can be seen that, once the generating lines are established from the heptagons, the fourteen-fold symmetry of the larger 'rosettes' falls into place.

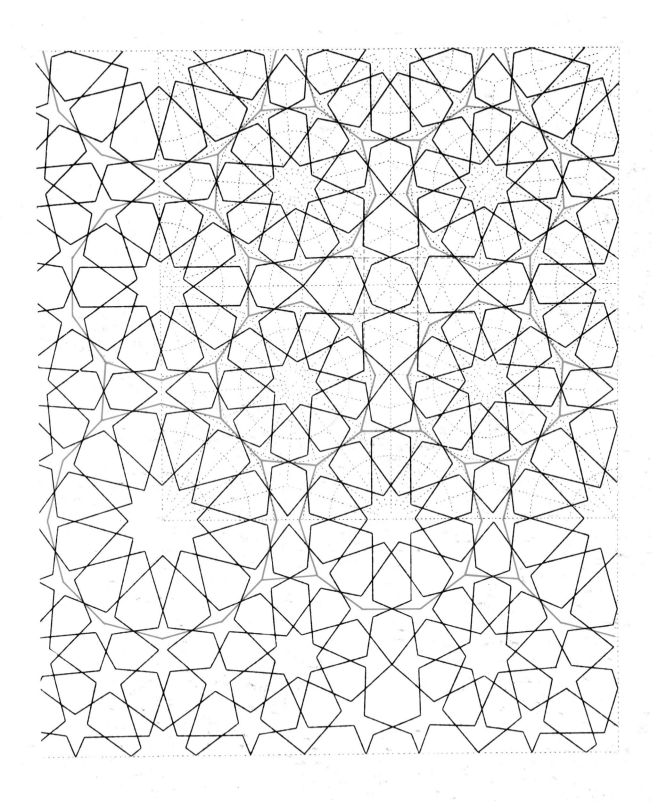

This drawing demonstrates the arrangement of tens, twelves and nines in a square pattern, with an octagon in the centre [B.159]; again close study will lead to an appreciation of the full ingenuity of its composition. It is helpful to bear in mind the nature of archetypal numbers, which reveal different levels of meaning and bring into more subtle perspective the realization of the unity achieved here.

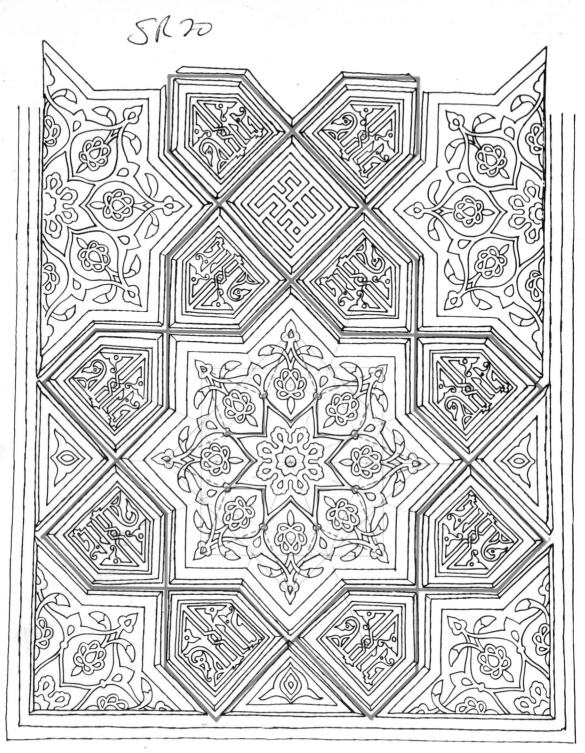

As already noted, there is in the Islamic perspective a fundamental symmetry of existence revolving around the four-fold axes of heat and cold, moist and dry. This polar symmetry can be seen as underlying the most fundamental aspects of Islamic pattern; there are thus crystalline, 'frozen', shapes, or conversely 'warm', fluid, outlines (arabesques). Although space does not allow a full examination of the implications, the next drawing illustrates the thesis that 'frozen' and 'moving' shapes are complementary, reflecting the concept that time is a flowing image of eternity. In this example — a tile — the star octagon is related to the geometry of the overall design and 'controls' key points in that design. These points have a value analogous to that of the *marmas* in the Hindu tradition or the sacred points of geometric intersection essential to the laying out of temple plans or ritual areas.

This particular pattern is from the shrine of Imam Reza at Mashhad in Iran, and reflects the magnificent qualities of balance, poise and economy of expression found in the jewel-like mosaic characteristic of the Safavid period. If this drawing is 'read' with care, the subtlety and precision of the controlling $\sqrt{2}$ harmonics generated by the star octagon can be seen to create a spontaneous 'flow' within the pattern.